W9-APA-147

MAR

RICHARD ESTES

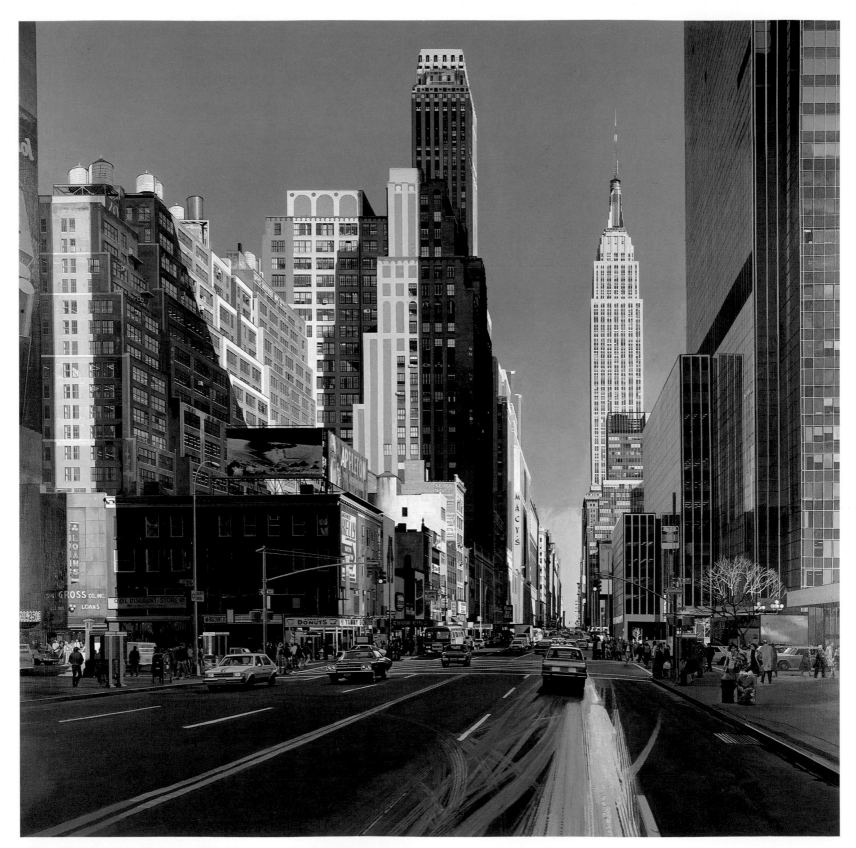

1. *View of 34th Street from 8th Avenue*. 1979. Oil on canvas, 91 x 91". Collection the artist

RICHARD ESTES

THE COMPLETE PAINTINGS 1966–1985

By Louis K. Meisel

With an Essay by John Perreault

HARRY N. ABRAMS, INC., PUBLISHERS, NEW YORK

This one's for Ari

Project Director: Margaret L. Kaplan
Editor: Margaret Donovan
Designer: Dirk Luykx

Library of Congress Cataloging-in-Publication Data
Meisel, Louis K.
 Richard Estes : the complete paintings, 1966–1985.
 Bibliography: p. 140
 Includes index.
 1. Estes, Richard, 1932– —Criticism and
interpretation. 2. Photo-realism—United States.
I. Perreault, John, 1937– II. Title.
ND237.E75M45 1986 759.13 86–3356
ISBN 0–8109–0881–6

Times Mirror Books

Printed and bound in Japan

Contents

Acknowledgments

I have attempted to illustrate in this monograph all the paintings created by Richard Estes as a Photorealist during the period from about 1966 to the present.

There are no major works missing; a few small, minor efforts from the first four or five years may turn up in the future, but certainly nothing significant. I have also included a number of earlier and/or very minor works as well as some early illustrations and even an unfinished work, because they have in one way or another become known to the public. I have not illustrated any of the very loose watercolors nor any of the sketches, drawings, and studies done in the early years, which may be subject matter for another kind of book someday.

I actually began documenting Estes' work in 1969. The documentation became intense and fairly complete from 1977 to 1979, while I was preparing for the publication of *Photorealism* in 1980. During that time I received much needed assistance from the artist and from Joan Wolf and Allan Stone of the Allan Stone Gallery, where the artist has been represented for his entire career. I also wish to acknowledge and thank my registrar, Terri Coppenger, for her documentation work, Melvin Shecter and Margaret Donovan for their editing, and Dirk Luykx for the design of the book.

D. James Dee, Aaron Miller, and Keith Jones did most of the new photographic work.

Preface

Richard Estes is almost synonymous with Photorealism. During the formative years of the movement, he shared a position of leadership with Chuck Close and Audrey Flack. Together the three typified the major traditional branches of representational art: places, faces, and things; or, more formally, landscape, portrait, and still life. While Close and Flack now share prominence in their subject areas with Frank Gertsch (portrait) and Charles Bell (still life), Estes stands alone, far above all others, in his depiction of the late twentieth-century urban landscape. And his subject matter is most likely to be the one that future generations will identify with Photorealism.

For an artist so central to a major trend in contemporary art, Estes has had very little notice in the popular press; in fact, aside from a few reviews, there has never been a magazine or newspaper article completely devoted to Estes' art. This lack of attention is probably related to the sort of thinking once described by Ayn Rand in *The Fountainhead:* "Don't deny the concept of greatness. Destroy it from within. The great is the rare, the difficult, the exceptional. Set up standards of achievement open to all, to the least, to the most inept—and you stop the impetus to effort in all men, great or small. ...Don't set out to raze all shrines—you'll frighten men. Enshrine mediocrity —and the shrines are razed."

The handful of so-called critical reviews, primarily negative, probably diminished the credibility of the so-called reviewers far more than that of the

artist. One prominent reviewer seemed so threatened by and jealous of New Realism, Photorealism, and Estes in particular that she "set out to raze a shrine." I doubt that she frightened anyone, but she did draw great attention to Estes. At the same time, her emotional, subjective, reactionary, and inaccurate review in a popular magazine began her loss of credibility.

That same year, John Canaday, art critic for *The New York Times*, spent an entire column reviewing four contemporary academic painters from France. He sang the praises of their accomplished but ultimately mediocre work, yet also took time to denigrate the then-rising American Photorealists. If it was his intent to "enshrine mediocrity" and damage Photorealism, he could have done it far more effectively by ignoring Estes et al. (Canaday did eventually come to appreciate Estes, as witnessed by his introduction to *The Urban Landscape*, the catalogue of the artist's retrospective in 1978–79.)

Happily, there are several writers who are able to see artistic and historical value wherever and however it appears. One of these was the late Gregory Battcock, who was among the first to compile a book on New Realism and who wrote the foreword to my 1980 book on Photorealism. Another who early on had the vision to see the promise of New Realism is John Perreault. He has written a great deal, including a number of catalogues, about the New Realists, and I have asked him to write the major essay for this book.

Finally, I would like to state that I don't consider Estes a modernist in the usual sense of the term. In an amusing exhibition and catalogue in 1984, the Greenville County Museum of Art in South Carolina tried to prove that Andrew Wyeth is a modernist. They showed and illustrated Wyeth works alongside those of Kline, Rothko, Pollock, Leslie, Frankenthaler, and even Salle and Estes. These far-fetched comparisons were an attempt to point out that Wyeth's work is similar to, and earlier than, the works of the others and that he is therefore a modernist leader instead of a fine regionalist rural painter akin to the nineteenth-century American realists.

Similarly, Estes is discussed here in context with many other so-called modernists. Yet, just as there was no need to prove a thesis about Wyeth, I do not wish to prove anything about Estes. This volume should illustrate purely that Richard Estes is one of the finest painters of our time. He *is* a realist. He *is* contemporary. He *does* use the photograph as a tool. And he is unique in his imagery, technique, attitude, and vision.

Louis K. Meisel

RICHARD ESTES

By John Perreault

for Jeff Weinstein

Richard Estes is commonly held to be one of the half dozen or so important artists in the Photorealist category of contemporary art, a category that, although popular with the public, is still controversial. As a critic, I would also put Estes at the top of the list of the larger, also controversial category of Contemporary Realism, comprising artists who began exploring the realist mode in the sixties, with or without the aid of or emphasis on photographic sources. Furthermore, I would count him as one of the most important artists of his generation, regardless of mode, medium, or style of art.

In some sense, the art itself must be the proof of this judgment: Estes' paintings convince and engage the sophisticated viewer far beyond what one would normally expect from the carefully limited subject matter and the studied—I would say ingenious—modesty of the execution. His works are easel-sized; no giantism for him. He does not paint on broken dishes, dried leaves, or TV screens. He requires no unusual media or materials, no sensational subject matter. And yet the artworks, for all their plain and straightforward painting, are rich and satisfying.

Why is this so? Estes' art is firmly grounded in the matrix of contemporary art production; his influences, both art historical and contemporary, are available to all artists. Yet his paintings have a timeless quality to them, in spite of or perhaps because of his commitment to the look of things as they are. Paradoxically, in light of this commitment, he alters the structural relationships that his camera records, moving buildings as well as cars, com-

9

Richard Estes (left) in his studio with Susan Pear Meisel and Jose Saenz, 1985

pounding vanishing points, and playing with perspective in paint. Only in these ways can he produce an image that is faithful to reality as he perceives it. Truth may be in the details, but in order to be perceived and savored, these details need to be clarified and arranged. Estes' paintings have a sense of the particular that, no matter how illusionistic the results, no matter how inventive the clarity, no matter how playful the "realism," satisfies the need for concreteness.

As in the work of Edward Hopper and Vermeer—two art heroes to Estes—light is central to the paintings. Estes is the poet/painter of New York City. He has painted Venice, Chicago, and Paris, but most of his paintings are of Manhattan, his home. One can recognize the Ansonia Hotel, Lincoln Center, certain streets on the Upper West Side and in the Village, even the Guggenheim Museum, and this is fine. But it is really New York City light that is the true subject and the key. Estes' Manhattan is a city of pristine, virtually vacant

Sundays. He avoids night scenes. He avoids the sentiment and angst that haunt Hopper's Depression streets.

There are no lonely figures in an Estes painting. In fact, aside from a blurred pedestrian or two and an image of the artist himself reflected in a storefront window, people do not exist. Finding those few pedestrians becomes a game equal to finding the artist's signature on a license plate or a tiny sign in a shop window. Estes jokingly claims that he finds people just too hard to draw. But, since his paintings are based on photo-notes he himself takes, it may simply be that taking photographs of strangers in the street is far too aggressive an act for someone so definitely shy. People would also add an unnecessary narrative element.

Certainly the virtual absence of people allows the artist, and the viewer, to concentrate on the streetscape itself: the architecture, the storefronts, the street furniture, the parked cars, the signage, and the reflections within reflections that compound space and crystallize the unpolluted, dustless, almost palpable New York City light. There is rarely garbage, which in reality there always is. "I only eliminate garbage because I can't really get it to look right," says Estes. "It's really a technical deficiency on my part. I really try to make things look dirty, but it's interesting because even in a photograph it doesn't look as dirty as it really is."[1]

In many ways, Estes' New York is an ideal city: always fall or always spring, no slush or grime. And everything is in miraculous, preternatural focus. "There are certain things that have to be fuzzy that are naturally fuzzy," he explained to me when we were talking about his paintings. "The eye sees like that. When I look at things, some are out of focus. But I don't like to have some things out of focus and others in focus because it makes very specific what you are supposed to look at, and I try to avoid saying that. I want you to look at all. Everything is in focus."[2]

Focus, Estes seems to be saying, like certain forms of composition, one-point perspective, or even the presence of the human figure, can create a hierarchy of forms that imposes a directive upon the viewer's gaze. Allover sharp focus may be the surprising equivalent of allover composition in abstract painting and of efforts in contemporary dance to break down the privileged box-seat point of view by activating the entire performance space. Estes may not be the conservative artist he is too often assumed to be. On the other hand, it may be that antihierarchy runs very deep within the American way of looking at things, may even be its definition. Democracy makes strange bedfellows.

In the hands of a less skillful artist, the absence of the milling crowds that

define a great city might produce a neutron-bomb effect. Where are the people? In an Estes painting, however, the empty streets communicate serenity rather than loss or tragedy. The crispness, for all its hard-edge clarity, is delicious and bracing, almost mind-clearing. The lack of human figures to identify with is an advantage. The viewer scans the complexity of these cityscapes from a disembodied point of view, becoming the details, becoming the structure, becoming the light.

"I've always considered light to be the real subject·of painting, which is another reason to work realistically, illusionistically," Estes told me. We were sitting in the room he uses as a studio in his apartment, Central Park visible at an angle below and overcast sky above. "You give an illusion of light. The lightest light is nothing compared to the gray sky outside. The deepest black is nothing compared to reality. You give the illusion of light. You condense it to a small scale."

Approaching the Art

This entire text is meant to be an afterword; the art is the important thing. The reader should begin with a careful examination of the reproductions that are the center of this book. If one is already familiar with the art of Richard Estes, the reproductions will refresh the memory. If one is not familiar with his serene yet startling vision of the urban landscape—or knows the work only in passing—the reproductions will give a fairly good idea of what the paintings are like, by offering a broad view of the development of the artist's work over the years and the range of his subject matter.

The reproductions, of course, are not really the art. This is a simple fact, but it is good to be reminded of it. It is particularly important in relation to art that has as high a degree of photo-verisimilitude as Estes' paintings have. As we shall see, this "photo look" is quite deceptive.

In the meantime, it is helpful to remember that, no matter how serviceable and necessary reproductions are, they are rarely the same size as the artworks they picture, so scale is lost. With the help of listed dimensions and a great deal of experience, the reader can approximate scale through the imagination, but that is never quite the same thing as seeing a real painting in a real room in relationship to one's own body, in relationship to other objects, and sometimes in relationship to other artworks.

In a book of reproductions it is also much too difficult to make the scale— the ratio of the dimensions of the paintings to the dimensions of the repro-

Sundays. He avoids night scenes. He avoids the sentiment and angst that haunt Hopper's Depression streets.

There are no lonely figures in an Estes painting. In fact, aside from a blurred pedestrian or two and an image of the artist himself reflected in a storefront window, people do not exist. Finding those few pedestrians becomes a game equal to finding the artist's signature on a license plate or a tiny sign in a shop window. Estes jokingly claims that he finds people just too hard to draw. But, since his paintings are based on photo-notes he himself takes, it may simply be that taking photographs of strangers in the street is far too aggressive an act for someone so definitely shy. People would also add an unnecessary narrative element.

Certainly the virtual absence of people allows the artist, and the viewer, to concentrate on the streetscape itself: the architecture, the storefronts, the street furniture, the parked cars, the signage, and the reflections within reflections that compound space and crystallize the unpolluted, dustless, almost palpable New York City light. There is rarely garbage, which in reality there always is. "I only eliminate garbage because I can't really get it to look right," says Estes. "It's really a technical deficiency on my part. I really try to make things look dirty, but it's interesting because even in a photograph it doesn't look as dirty as it really is."[1]

In many ways, Estes' New York is an ideal city: always fall or always spring, no slush or grime. And everything is in miraculous, preternatural focus. "There are certain things that have to be fuzzy that are naturally fuzzy," he explained to me when we were talking about his paintings. "The eye sees like that. When I look at things, some are out of focus. But I don't like to have some things out of focus and others in focus because it makes very specific what you are supposed to look at, and I try to avoid saying that. I want you to look at all. Everything is in focus."[2]

Focus, Estes seems to be saying, like certain forms of composition, one-point perspective, or even the presence of the human figure, can create a hierarchy of forms that imposes a directive upon the viewer's gaze. Allover sharp focus may be the surprising equivalent of allover composition in abstract painting and of efforts in contemporary dance to break down the privileged box-seat point of view by activating the entire performance space. Estes may not be the conservative artist he is too often assumed to be. On the other hand, it may be that antihierarchy runs very deep within the American way of looking at things, may even be its definition. Democracy makes strange bedfellows.

In the hands of a less skillful artist, the absence of the milling crowds that

define a great city might produce a neutron-bomb effect. Where are the people? In an Estes painting, however, the empty streets communicate serenity rather than loss or tragedy. The crispness, for all its hard-edge clarity, is delicious and bracing, almost mind-clearing. The lack of human figures to identify with is an advantage. The viewer scans the complexity of these cityscapes from a disembodied point of view, becoming the details, becoming the structure, becoming the light.

"I've always considered light to be the real subject·of painting, which is another reason to work realistically, illusionistically," Estes told me. We were sitting in the room he uses as a studio in his apartment, Central Park visible at an angle below and overcast sky above. "You give an illusion of light. The lightest light is nothing compared to the gray sky outside. The deepest black is nothing compared to reality. You give the illusion of light. You condense it to a small scale."

Approaching the Art

This entire text is meant to be an afterword; the art is the important thing. The reader should begin with a careful examination of the reproductions that are the center of this book. If one is already familiar with the art of Richard Estes, the reproductions will refresh the memory. If one is not familiar with his serene yet startling vision of the urban landscape—or knows the work only in passing—the reproductions will give a fairly good idea of what the paintings are like, by offering a broad view of the development of the artist's work over the years and the range of his subject matter.

The reproductions, of course, are not really the art. This is a simple fact, but it is good to be reminded of it. It is particularly important in relation to art that has as high a degree of photo-verisimilitude as Estes' paintings have. As we shall see, this "photo look" is quite deceptive.

In the meantime, it is helpful to remember that, no matter how serviceable and necessary reproductions are, they are rarely the same size as the artworks they picture, so scale is lost. With the help of listed dimensions and a great deal of experience, the reader can approximate scale through the imagination, but that is never quite the same thing as seeing a real painting in a real room in relationship to one's own body, in relationship to other objects, and sometimes in relationship to other artworks.

In a book of reproductions it is also much too difficult to make the scale— the ratio of the dimensions of the paintings to the dimensions of the repro-

duced image—consistent. A three by four foot painting and a six by eight foot painting might both be reproduced as three by four inches. In order to be properly read, a detail of a painting is sometimes shown at the same size as the reproduction of the full painting from which it is culled.

With a loss of scale, there is also a change in color and color relationships. Reducing an area of any color alters that color in itself and in its interrelationship with other colors. This is so even if we assume an absolutely perfect match of color. Ink on paper can never exactly duplicate paint on canvas; the texture and the physicality of the latter are just not there.

In regard to the loss of physicality, it must always be remembered that a painting is not, like a photograph or printed page, a totally flat object. Stretcher bars and frames or stripping give paintings depth—albeit minimal —as well as height and width. This thickness affords paintings an entirely necessary objectness that emphasizes their frontality and flatness, which in turn are foils to the illusionism involved.

The reproductions in this book—or in any book—are at least four times removed from the paintings they stand for. The original visual information has been translated into, and therefore been transformed by, four separate codes in succession: from reality through the camera lens, to the developing of the color transparency, through the color separation process, through the technology of printing. Since Estes' paintings are, to a large part, based upon his photo-notes (mediated by memory), the reproduced images of the paintings are in fact five times removed from what one might see with the naked eye. (Slide projections used in art classrooms or as lecture material are, since they are most often pirated from printed reproductions, *seven* times removed.)

Bearing all the above in mind, the reproductions will have to do. Although they can never replace the actual artworks, they are more than a convenience. One cannot be certain that there will be a Richard Estes painting on public view wherever the reader is. As long as all the obstacles are considered, a generous representation of an artist's work has many advantages: images not usually, perhaps never, available in one place can readily be compared. It is possible to sample at least some aspects of Richard Estes' remarkable work in considerable depth.

The sections that follow this introduction compose an analytical, contextual, critical appreciation of Estes' art. Words, of course, are also removed from actual artworks but, like reproductions, they have some unique advantages. Unlike naked images, words can summon up, define, and delineate the various contexts that inspire and limit specific artworks. Certainly some

part of the genesis and the meaning of an artwork is contextual, as is its completion and reception within the borders of an art system, itself subject to history, commerce, and the dynamics of taste and aesthetic perception. Neither taste nor aesthetic perception is as transcendent as art ideologues, usually idealists in disguise, pretend.

Words, unlike pictures, are efficient for making comparisons, spelling out possible meanings, pointing out relationships, delineating hierarchies, defining categories, and offering evaluations. Words are also quite suitable for examining theoretical aspects of artworks and their intended or unintentionally implied aesthetic presuppositions. Words are critical.

Estes himself, although he holds some strong opinions and beliefs, is not a theoretician. He eschews theory. He has particular disdain for what I would call simplistic modernism, a pseudo-aesthetic that sees the history of art as an inevitable march to nonobjective abstraction. Although Estes is a man of few words and by nature private, I will quote him as often as I can, so that at least the flavor of his working aesthetic will be apparent.

Contexts

Richard Estes' art emerged in the late sixties; his first one-man show was at the Allan Stone Gallery in New York City in 1968. He had by that time developed the major characteristics of his art and was producing relatively highly finished, realist representations of the urban landscape, clearly based on photo sources. To say that Realism in particular—new, photo-derived, or otherwise—was in the air would be misleading. Everything, in terms of art, was "in the air" or, more correctly, "up in the air."

The explosion of world-class art that occurred in the United States after the Second World War—fed by the pioneering programs of the WPA before the war, the wartime presence of European artists in New York, the postwar economic boom, and other factors too numerous to mention—had been packaged as Abstract Expressionism and had peaked by the end of the fifties. In retrospect, the Neo-Dada of Robert Rauschenberg was in some respects a continuation of the kind of expressionist figuration developed by Willem de Kooning in his Women series and acted as a bridge to the iconography of the nonexpressionist, emblematic art to come. The Neo-Dada of Jasper Johns presaged the hard-edge abstraction of Frank Stella and, one suspects, much of what later was to be called Minimalism. Estes himself has been quoted as saying that, although he didn't know what on earth Rauschenberg was

doing, he had "always admired Johns a bit. He seems to have a nice touch."[3]

By 1961 it was clear that the New York art world was being turned upside down by a new art "movement" finally called Pop Art. Rauschenberg, Johns, and Larry Rivers (another "bridge" artist) were included, but the purest practitioners were artists like Andy Warhol, Roy Lichtenstein, Claes Oldenburg, and James Rosenquist, whose cool appropriations of already coded mass-media images assaulted the sensibilities of those who had labored so long and profitably for high-art abstraction. Simultaneously, other kinds of figurative art debuted—the highly stylized representational art of Alex Katz and the somber realism of Philip Pearlstein—but in truth, at the time, only Hard Edge and perhaps Post-Painterly Abstraction impinged the tiniest bit on the Pop Art spotlight.

In 1972 Estes told Linda Chase, Nancy Foote, and Ted McBurnett, who were interviewing him for a special Photorealism issue of *Art in America*, that he always liked Pop because it suggested a way of using subject matter. "But, the trouble with Pop," he continued, "was that it made too much comment. A very sophisticated intellectual game type thing. You get tired of it very quickly. The joke has been made and that's it, you can't laugh forever."[4]

Pop Art, for better or for worse, upset the apple cart. Although clearly it was not the only serious art being offered, it opened up the art situation to a pluralism that was disconcerting and liberating. Personal expression and painterliness were no longer the order of the day, perhaps as a reaction to some of the excesses of latter-day Abstract Expressionism: not all splashes and sloshes of paint had proved to be equally authentic and existential. Otherwise, almost anything was allowed—as long as there proved to be a market. Given the expansion of the art world and the public interest in art—as status symbol, as investment, as entertainment—there was a market for almost anything.

Curiously enough (or perhaps not so curiously), at a time of great political upheaval—assassinations galore, the Cuban Missile Crisis, the Black Power struggle, the war in Southeast Asia—not much political art was acknowledged in the galleries or art magazines. Art, with the exception of Barnett Newman's barbed-wire sculpture splattered with red paint, some of George Segal's sculptures, and group exhibitions of protest art, seemed to function as antidote or escape. Nevertheless, the permissiveness signaled by Pop allowed a proliferation of styles that will keep art historians (and younger artists) busy for decades. Minimalism begat Anti-Form and Earth Art and Conceptual Art. And there was Video Art and Performance Art, not to speak of out-of-New York styles such as Chicago's Hairy Who and San Francisco Funk.

Richard Estes came to artistic maturity during all of this. He was living in New York City, which was then, as now, the art world center. He claims that he always preferred going to museums rather than to art galleries. He now claims disinterest in every style of contemporary art except Realism. Galleries remind him of the anxiety he experienced, and the rudeness, when he was first bringing around his slides.

Nevertheless, one can safely assume that even in the sixties he must have had some inkling of art world events, through talking to other painters or the commercial artists he worked with when he made his living as a freelance graphic artist. Like every good New Yorker, he must have looked at least occasionally at the Entertainment Section of the Sunday *New York Times.* Influences can be inferred but rarely proved.

Could it be that whatever caused the general tenor of critically and commercially successful art to be cool rather than hot, hard and removed rather than rough and emotional, also influenced Estes? This is most likely the case. We must, however, also factor in temperament. Estes, like his art, is reserved, is not outgoing. Fortunately, receptivity to new art in this period favored this trait, and it accounts to some degree for his remarkable success at flying in the face of the persistent high-art taboo against Realism.

Yet Estes has never been the kind of artist to give any thought to marketing or his public image. "If I had been thinking of the market, " he told me, "I would never have chosen to paint what I am painting. It was something I had never seen in the marketplace, so I had no idea if it would sell or not. I was very surprised when I started selling paintings. I couldn't believe it. I still can't believe it."

This leads us to another major contextual consideration. Although it is the seventies that are most often characterized as pluralist, the legitimization of multiple art styles began in the sixties. The difference between the decades in regard to pluralism is that in the sixties proponents of each art style or mode, whether critics or artists, refused to admit the validity of any other art style or mode. The notion that there could only be one valid form of high art died hard; in many ways it still persists. The market was pluralist in the sixties but the criticism was not. In the seventies, critics and artists caught up or caught on. Within this situation, how did what can be called non-Pop representational art fare?

In terms of solid achievement, it fared very well indeed, but in terms of critical recognition, it did poorly. If the truth be known, no major critic came forth with a consistent defense; no art journal offered consistent support. Realism, if not ignored or disdained, became just another style later in the

seventies. Or, as I recently overheard one art student explain to another, Realism is just another way of looking at things. The battle for Realist art was not won; it was not even seriously fought—it was sidestepped.

On the other hand, perhaps the lack of critical discourse concerning contemporary Realism has been a blessing in disguise. "I think it is a great period for Realism, perhaps because the Realists have been on the outside of the art establishment," Estes wrote not so long ago, "and are more free to be themselves. Realism has not fitted easily into the modern mythology of art history and therefore has been left alone by the dogmatists."[5]

Nevertheless, if we are to discuss Estes' art with any degree of non-dogmatic seriousness, we must discuss contemporary Realism in general and then Photorealism and attempt to place his work in these contexts. The seeming paradox is that in order to describe the unique qualities of his work, we must find what it shares with other art of the same or similar type. We must delineate the type.

Already it seems that Estes' art shares some qualities with kinds of art that at the time of his debut seemed entirely opposite. Like Minimalist sculptors such as Dan Flavin and Carl Andre he has consciously limited himself: "What's wrong with doing the same thing over and over again? I think the silliest thing is to try to come up with some new gimmick each year. It's better to really develop and expand on one idea."[6] Also like the Minimalists, and other nonexpressionist artists, Estes downplays any possible emotional content in his art: "I don't think my paintings have much emotion. They are rather straightforward. They have the emotion of the subject. Does a Monet water lily painting have emotion? Not really. It's just the water lilies. Very pretty. But emotion is not really what the painting is about."

What then are the paintings about? Like many artists of a classicizing bent, Estes believes his art is primarily about order and form. "I'm not trying to save the world," he says. "I don't think painting ever changed the course of history. Its function is to do something positive to our lives. I guess it would involve pleasure and satisfaction, a sense of completeness that life itself doesn't have. Order. You take the elements of reality, but you eliminate the chaos."

In some sense Estes is a formalist. He was once quoted as saying that making people see things differently was not his intention, nor was he particularly interested in his chosen subject matter: "I don't enjoy looking at the things I paint, so why should you enjoy it? I enjoy painting it because of all the things I can do with it. I'm not trying to make propaganda for New York, or anything. I think I would tear down most of the places I paint."[7]

Estes shares a great deal with abstract painters of the formalist mold. However, his brand of formalism, if these attitudes can be so labeled, is expressed through representational imagery.

Although the shock of Pop reminded us that modernist art need not be abstract, it did not totally clear the field for illusionistic representation in painting—that is, painting that attempts to portray three-dimensional entities in space. Most Pop painting, after all, involves flat representations of already flattened images: Warhol's silkscreen impressions of celebrity or disaster-newsprint photos; Johns's American flags; Lichtenstein's blowups of comic strip frames. The picture plane, so sacred to abstract formalists manqués, had not been "broken" after all. Pop's achievement was a witty rather than an earthshaking one.

As already mentioned, a non-Pop form of representation emerged simultaneously with Pop in the work of Katz, on the one hand, and Pearlstein, on the other. These two very different artists and a host of others were then, and are still, commonly referred to as Realists, Contemporary Realists. (There are also the so-called Painterly Realists, who in my opinion are more or less in the genteel tradition. About them, Estes says, "They're too serious. They think about making paintings too much.")

But what does the term Realism mean? It indicates something different now than when Gustave Courbet used it in France in the nineteenth century. We do not mean philosophical realism. Nor, if we are careful, will we countenance using it to describe abstract art that is supposedly *really* real when it takes the form of a theoretically self-referring object, like a Minimalist cube or an all-white canvas. Finally, not all representational art is realist art.

Ultimately, Realism is a relative term, a matter of degree, and thus it is difficult to define. In contemporary art "Realism" usually signifies a relatively high degree of detailed representation that utilizes all or some of the traditional (and some not-so-traditional) tricks of the trade to portray recognizable and theoretically verifiable entities in three-dimensional space. There is a high order of verisimilitude. We accept some distortion, but in general we expect that the conventions of representation allowing three-dimensional subjects to be portrayed on a two-dimensional surface will be relatively, or at least initially, transparent.

The pretense or the conceit—concepts anathema to most Realists—is that the artist is painting pretty much exactly what he or she sees, sans obvious schemata. The paint application process and the physicality of the medium are minimized. The information level is exceptionally high. A viewer has the sense that the subject portrayed actually exists or existed at one time

and could be matched visually, detail to detail, quality to quality, with a particular representation and no other representation: the representation or documentation at hand. Conversely, there could be no other model or view in time or place that would so exactly correspond. The emotional content, if it exists, is concealed. It is conveyed somewhat through choice of subject—which may have symbolic, ironic, narrative, or even allegorical effect—but primarily through the strictly formal language of color, line, form, and composition. The artist is invisible.

From this definition, which means to be precise, it should be clear that Estes is a fairly pure Realist, in contemporary terms. In fact, his art has helped to confirm (if not entirely to define) the Realist category—surely one sign of his importance. To some, the only kink in this argument will be that Estes unashamedly utilizes photographs as image sources, although he maintains that they are the modern-day equivalents to sketches from life.

Estes described to me how he uses photographs:

It goes through your mind. You know that one tree is ten feet in front of another and you try to get that feeling; you try to get the air around it. One evolves ways of doing this. A photograph is just values. It doesn't have line. When you use the photograph, you are using the values, but you are adding line and space and movement, coming from your experience. That's why, although I work from photographs, I like the subject to be things I'm really familiar with. I don't think I could use someone else's photograph of some place I've never been to and make a painting. Although I could copy the photograph, I really wouldn't have a feeling for the place. You're always remembering, and the photograph is like a reference you use, a sketch.

He is also very much aware that the camera allows him to paint things that would be otherwise impossible to do. Could he paint with the degree of detail he wants, without the camera? Traffic, pedestrians, and weather would constantly interfere. Or as he once said, "It's not possible. The great thing about the photograph is that you can stop things. This is one instant. You certainly couldn't do that if you went out there and set yourself up in front of it."[8]

That Estes has indeed been consistently categorized as a Photorealist is not entirely pleasing to him: "Unfortunately it has been too easy for anybody to take a photograph, trace it, and make a lousy painting. Photorealism, in that sense, has been bastardized. I can sympathize with a lot of people who just reject it outright, because, like anything else, there is so much bad stuff around. I always thought of myself as a Realist painter. The photograph is

just a convenience. I'm sure that if a modern camera were available to Vermeer he would have used it."

To some, the only legitimate form of Contemporary Realism is that which results from painting directly from life. It is true the results are not quite the same, and one who is tuned to such things can usually tell the difference between a painting limned directly from life and one that is derived from a photograph. One technique, however, does not delegitimatize the other.

Furthermore, at the risk of creating even more rarefied categories, there is a significant difference between a painting derived from a single photograph and a painting utilizing several photographs as sources. Considering him as a Photorealist, Estes creates work that belongs in the latter category. He surely does not belong to the wing of Photorealism that can be called a subset of Pop Art, that offers paintings of photographs equivalent in some way to Johns's paintings of targets or flags. Estes actually takes great pains to correct the deceptions of photo imagery, while employing deceptions of his own to make details and information read in an orderly and highly structured way. Photographs in themselves, while excellent sources of information, are often not so very realistic: "It's not a matter of making a painting that looks exactly like the place or photograph. I try to make it as accurate as I can, but usually I have to do otherwise, or it just doesn't look or feel comfortable. . . ."[9]

Like Pop, variously labeled New Realism and Neo-Dada as well as Pop Art, Photorealism ran the nomenclature gauntlet; Hyper Realism, Sharp-Focus Realism, Post-Pop Realism, and the ever-popular New Realism were other labels proposed for it. This initial confusion of names is characteristic of American postwar art "movements." Abstract Expressionism was also called Action Painting and the New York School, names that still serve some use. Minimal Art was also called ABC Art and Primary Structures. The reason is simple: these "movements" are not art movements in the sense that Futurism or Surrealism are art movements. They have no manifestos, no critic or artist house-theoreticians. Instead, these American art "movements" were first identified as a form of analysis or packaging by critics, dealers, and the press. But since there is always a need for terms of reference in any discourse, journalistic and public relations shorthand managed to fill the bill. Many Pop Artists were working independently and did not, in fact, know each other's work until the hoopla began. The same is true of Photorealists: they were artists responding to or working within readily available contexts who only later were brought together under a common rubric.

What do the Photorealists have in common? Clearly it is the unapologetic use of photographs as image sources. At the extreme end of the Photorealist

continuum, the photo source is the subject matter, or at least the equal of the image referent. Malcolm Morley's early deadpan versions of calendar steamship images are very close to Pop, and Chuck Close's giant, head-shot "portraits" are, for different reasons, very close to Minimal, Process, and Conceptual Art.

At first the distinguishing characteristic of the Photorealists was what might be called the "photo look." One had the feeling one was looking at photo enlargements. Subtleties, however, quickly became apparent. Estes' works, for instance, show too much depth and spatial clarity to be actual photographs. His paintings are not photo-flat.

There was a certain naughtiness attached to the overt use of photographs. It was simply not done. Had not one drawing teacher after another emphasized that copying from photographs was cheating? Copying from plaster casts might be all right, but copying from photographs was something only commercial artists were allowed to do.

We now know that the antiphoto dictum was based on a lack of knowledge. Certainly not all representational artists are required to work from photo sources; there may indeed be something to be gained from drawing or painting from life—a certain texture, at least. But researchers such as Van Deren Coke, as early as 1964, had shown that artists in the past have often helped themselves to the shortcuts provided by optical devices, up to and including the unholy camera, the dreadful machine that is still blamed (or praised) for wiping out representational, handmade art.[10] Renaissance artists commonly employed perspective aids; the camera obscura was a widespread studio tool. Internal analysis of Vermeer's wonderful realism indicates evidence of visual information and distortion that could not exist without lens and projection.

After the invention of photography, the data are irrefutable, although the artists themselves tended to be increasingly secretive about using the enemy tool. Delacroix, Manet, Degas, Eakins, and many others all used photography to some extent, but as late as the thirties we find the noted American realist Charles Sheeler denying his obvious use of photographs. Perhaps this was because he was also known as a photographer and needed to separate what he thought of as his commercial work from his fine-art efforts—but one suspects it was guilt.

What then is there about Photorealism, if anything at all, that makes it significantly different from past uses of photography in representational art? Two things: open acknowledgment of photography as source and even, in some cases, as subject, and what I have called the photo look. Now, of course,

with the passage of time, we require more than these two characteristics to evaluate a Photorealist. The superficial dislocation of expectations and perceptions is gone. The various artists have separated out, so to speak, and more difficult criteria have come into play. Skill is a given within the genre, and a highly detailed depiction in itself no longer seems particularly miraculous. Traditional and more subtle criteria are required.

The viewer may be convinced, as this writer is, that Richard Estes has always been head and shoulders above most other Photorealists, and, in fact, can hold his own with the few top direct-from-life realists. He seems to have produced the kind of art that will endure and nourish. But why is this so? It cannot simply be because he uses both his memory and multiple photo-sources to create highly complex and finely constructed cityscapes. Since there is at least one top-ranking photo artist (Chuck Close) who limits himself to one photographic source for each painting, the Estes methodology cannot alone be the explanation.

Perhaps the results can only be savored and never fully explained. Once again, in trying to get closer to the value of particular artworks, one is up against a solid wall. That resistance is most likely linguistic.

I want to use the word quality; quality is the key to evaluation. But quality is, for the most part, a word without meaning, unless its use is fully explained. Perhaps the key to Estes' success is that he is the right person in the right place at the right time, possessing the right skills, temperament, and desires to produce just the kind of art that is required. But this skirts the issue; we want the hows and the whys, although we know that exceptional talent is forever unexplainable.

Richard Estes' place in contemporary art is firmly established. Within the cacophony of post—Abstract Expressionist styles that developed in the sixties and came to full flower in the decade that followed, his location is unique. His art has family resemblances to various style clusters, but the resemblances enrich the texture of his work rather than cancel each other out. What he shares with Minimalism and other "cool" art styles has already been noted. He certainly shares with Pop a use of everyday iconography, though it is important to point out that he eschews irony. It is this latter characteristic, plus his unabashed illusionism, that places him among the Realists. By illusionism I do not mean trompe l'oeil; I mean the depiction of three-

Genre and Iconography

dimensional entities in three-dimensional space on a two-dimensional surface.

Depending on one's angle of view, Estes is a contemporary Realist utilizing some of the techniques of Photorealism—the undisguised use of photo sources, for instance, to create high-information representations—or, alternately, a Photorealist who employs perspective and compositional devices inherited from historical forms of representation.

Although I have argued in the previous section that Estes is undoubtedly open to the same contemporary influences as other artists, his intention has been to aim for the qualities of the art of the past that he admires: "Frankly, I don't pay any attention to anything that is happening in contemporary art. I think it's much better to go look at the old paintings at the Metropolitan. And that's what I'm interested in relating myself to. The great painters, like Vermeer."

Unlike far too many of his contemporaries and far too many younger artists, Estes has never been interested in developing an art product *per se*, nor has he given much thought to marketing or the petty strategies of careerism. As far as I know this is not a moralistic stance on his part; it simply is not in his nature. During his first trip to Europe in the early sixties—he spent some time in Madrid and Majorca and traveling around—he realized he could relate more to New York. "I could talk to people," he told me. "New York seemed where one should be. Paris was passé."

Born in Kewanee, Illinois, he moved with his family to Chicago when he was a teenager. Later he studied at the Chicago Art Institute, then moved to New York City to earn his living as a freelance graphic artist. Although he now spends some part of the year at his house in Maine, he is a full-fledged New Yorker. He likes to paint the things around him in New York, but he now finishes most of his paintings—of New York City—in Maine: "Another inconsistency! There's no straight line in my thinking."

He has never been part of the art scene. He is not the kind of artist one bumps into at every opening. He keeps to himself. Willpower, problem-solving, and creativity are employed in picture making; competitiveness is aimed at the great painters of the past. He would like to make a painting as good as the best of Canaletto or Vermeer or one of Thomas Eakins's river scenes. Perhaps he already has; I think so. He aims high.

The cityscape is Estes' preferred genre, a genre with a curious and rather limited history. One searches, almost in vain, for historical precedents: a panel of a Roman fresco, a patch of fortress here, a biblical tower there. Not until we come to the Dutch town-view of the seventeenth century and Cana-

letto's paintings of Venice do we find much to speak of, much we can really classify as cityscape. All is background or synecdoche, fragments standing for the whole.

Only with the painters of modern life do we again get glimpses of the man-made environment as subject: some paintings by Manet and the Impressionists when they are not being suburban. Finally in the twentieth century, when it is clear that the monstrous city is here to stay, there are more than inklings of what an important subject it can be. In America, the so-called Ash Can School managed to record some aspects of the "feel" of New York; of the "modernists," the Italian Futurists and Joseph Stella, their one official New World disciple, often used images of the modern city in their attempt to depict emotional states.

Estes believes—although when he told me this he may have been using shock tactics—that the Americans from about 1850 on are better painters than the Europeans. To him the Ash Can painters are much more interesting than the Cubists. Unless he wanted to make money on a resale, he would rather own a William Glackens than a Pablo Picasso. Yet the American artists he speaks of with some obvious reverence are Eakins, Edward Hopper, and possibly Charles Sheeler in his Precisionist period.

The few early Estes paintings that survive do indeed have a somewhat depressing Ash Can look to them; whether this is because they are not "finished" or because the human figure does not lend itself to the crystalline elegance only glass and metal can provide is irrelevant. Estes told me, with some humor, that he probably hasn't changed very much; his early paintings look the way they do because he just didn't have time to finish them. In fact, the early stages of a painting he was working on when I visited him were remarkably similar in paint handling and tone to the early works.

Here, for the record, is Estes' own account of his painting process: "I use an acrylic ground. . . . The basic drawing is blocked in with diluted acrylic—an umber wash, very loose, just the general outlines. . . . I find it easier to get the overall effect first, the big areas, then work down into smaller and smaller areas. . . . I don't finish everything individually . . . it has to be finished all at the same time. . . . After the umber wash, I develop the painting in acrylic . . . as it gets more specific, I bring color in. . . . I can do the underpainting in a week. And then two months on the oil overpainting."[11]

Once Estes hits his stride, he invents (or reinvents) the cityscape as a genre all his own: realist, bereft of Hopper's gloom and sentiment, detailed, spatially complex. Not all of his paintings fit into the Car Culture branch of Photorealism; his work is quintessentially urban. Nevertheless, he shares

with the Car Culture cowboys the subject matter of automobiles and signs.

All of Estes' mature paintings are cityscapes of one kind or another, but for purposes of description and analysis there are several subcategories. The ones I can come up with are: vehicle reflections, isolated buildings, single storefronts, street scenes. There are a few "sports" also: two escalator paintings, *Escalator* (1970; fig. 42) and *Escalator* (c. 1971; fig. 41); one painting of the empty interior of a subway car, *Subway* (1969; fig. 43), that is interesting to compare with the unfinished *Subway Passengers* (1966; fig. 16); one painting of wrecked cars, *Auto Graveyard* (1968; fig. 13); and a beautiful but atypical gouache depicting the famous Airstream trailer (1974; fig. 56). In all these mature works, reflections (and therefore light) compound the space. Since the paintings are based on more than one photograph, Estes is able to provide an allover sharp focus in depth that allows us to see—in the case of storefront windows—the surface of the glass, what it is reflecting, and what is behind it. The human eye cannot focus on two planes simultaneously. In a sense, Estes' realism is more than realistic; it is a realism that achieves some of its most startling effects by nonrealistic means.

The vehicle-reflection paintings are close-ups of cars and buses in New York streets, or, more correctly, they are views of New York streets as distortedly reflected in cropped fragments—windshields, rear windows, headlights, hoods, and chrome—of parked vehicles. It was with these paintings, done from 1966 through 1969, that Estes had his first solo exhibition at the Allan Stone Gallery. "I just walked in," Estes told me. "When I started doing the cars, my idea was to do realism but be abstract at the same time; to eliminate the subject that way. In some of them I did; you can't really figure out what it is." Perhaps in this statement and in these paintings we have a clue that will direct us to the formal nature of Estes' oeuvre. Yet his work, no matter how formal in essence, is never strictly that; he enjoys instead the more difficult task of combining formal qualities with depiction.

"It was a way of getting that sort of flatness," he continued, "that quality of abstract painting. Everything is sort of floating around on a flat surface, but at the same time is photographically realistic. It seemed like combining the two things."

I asked him if he had ever done abstract paintings.

"No, not really. I tried it. But I never could get into it. I always got rather bored. It didn't seem like a challenge to me. No matter what you do, it is always right. There is nothing to check it out against."

On the other hand, somewhat paradoxically, Estes sees Realism as the real abstract art. "Even though you might have these ugly structures, nasty,

smelly cars and dirty streets, when you look at it all as a picture you don't think of that; you look at it as visual organization. In a way this is the real abstraction—to abstract the visual from the reality and just look at that without the emotion, without the subject."

In the vehicle-reflection paintings Estes came as close to abstraction, in the normal sense, as he has ever needed to come, and created rather glamorous paintings of what appears to be distorted light. The cityscape is seen through the convex looking glass of the vehicles responsible for its monstrous spread and possible future demise. Estes himself seems to have forgotten that in all but two or three of these paintings there are small patches of unreflected "reality" that anchor the images in recognizable space. These slivers of relatively undistorted space are more than ingenious; they allow the viewer to get his or her bearings.

When it comes to the more straightforward cityscapes—and these form the bulk of Estes' oeuvre—rarely does he isolate one building as a freestanding object in space. Perhaps this is because in the jam-packed actuality of the urban scene the freestanding building is in itself an oddity. His often-reproduced *The Solomon R. Guggenheim Museum* (1979; fig. 145) is one such exception, yet he shows enough of the surrounding street environment —including the late afternoon shadows of trees in Central Park decorating the lower part of Frank Lloyd Wright's old Bendix-washing-machine facade—to implant this ego monument in the context of a grid of apartment houses, cars, and greenery.

This painting also belongs to a small list of paintings that break Estes' rule about avoiding obvious tourist spots and landmarks. *Hot Foods* (1967; fig. 31) features a reflection of the Empire State Building, and when I interviewed him several times for this essay he was working on a painting of Lincoln Center (1984; fig. 156). Otherwise, he avoids landmarks and famous buildings, unless one wants to include his often-painted Ansonia Hotel on Broadway, a personal landmark of sorts; it is within an easy walk of where he lives on Central Park West. Other than the Guggenheim Museum painting, the only painting of a freestanding structure I can find is his remarkable *Circus, Circus* (c. 1971; fig. 164), depicting what appears to be a drive-in merry-go-round.

Single storefronts constitute a much larger category. The earliest seems to be *Food City* (1967; fig. 36). The most striking of these may be characterized as head-on views of single storefronts, filling all or most of the canvas. By "head-on" I mean that the point of view is dead center, and the storefront depicted is parallel to the picture plane. This format allows for some rich

variations on what I take to be the theme of symmetry, if for no other reason than that the key vanishing point is centered. Given the rectangular divisions in most storefronts, what we get is Mondrian's formal plasticity, compounded by recognizable images in overlapping, superimposed planes of reflection/solidity. *Alitalia* (1973; fig. 87), *Teleflorist* (1974; fig. 89), and *Double Self-Portrait* (1976; fig. 88) are all fine examples. Other single storefront paintings include parts of adjacent establishments—*Food Shop* (1970; fig. 39) and *Helene's Florist* (1971; fig. 57)—or are "cornered" at a forty-five-degree angle—*Drugs* (c. 1970; fig. 107) and *Grossinger's* (c. 1970; fig. 120).

Estes, strictly speaking, does not work in serial formats. An overall view of his work to date shows him moving quite freely among possible types of framing and angling of the New York street scene. Nevertheless, the vehicle-reflection format was totally abandoned early on, and in general we see a tendency to do larger, more open cityscapes, encompassing greater variety and more startling vistas. Perspective comes to occupy him a great deal.

He has not abandoned what I call the "sliced"-view device: the canvas and the scene divided vertically by an angled window that reflects some part of the scene. Particularly fine examples from the seventies are the very dramatic *Paris Street Scene* (1972; fig. 118) and *Columbus Avenue at 90th Street* (1974; fig. 123). *Prescriptions Filled* (1983; fig. 151) is a more recent example that is also quite masterful. But as the paintings have become more horizontal they have become less claustrophobic: *Horatio* (1979–80; fig. 158) and *Waverly Place* (1980; fig. 157) are masterpieces that indicate Estes can deal with large views without the formal tricks of reflection "slices." The viewer savors instead his multiple-vanishing-point hijinks and nearly invisible but radical alterations of space and scale.

Estes, of course, makes both drastic and subtle changes while working from his photo sources: "I tend to make things in the background larger. I cheat a lot. When you look at things, you never look at one thing completely. Your eye scans things. You sort of assemble them in your brain. We don't really see things like the camera. We pick out what we see."

I asked him if people should be aware of these changes.

"They shouldn't really, because I don't think that has that much to do with the quality," he answered. "It's not art because I change things. It's not about the changes. You don't make changes in order to make changes; you make changes in order to make it closer to what it really is. The only reason I change things is simply to make what is really happening clearer. And then you change things for composition. I can put clouds or parked cars anywhere I like."

Variations in subject and format notwithstanding, Estes has evolved his own visual language that seems to encompass an infinite range of possibilities. Whether single-image, angled and sliced, or panoramic, the cityscape appears to be his and his alone. The cool and glassy facades may not be reflections of psychological states—I suspect he would prefer them not to be—but their crispness stands for an ideal city. Even the chaotic signage that he documents with such relish is not the handwriting on the wall, but the emblem of energetic activity. The neutrality is expressive. Almost anything can take place on these naturally theatrical streets within the opera spaces of Estes' invention, and it usually does. These, however, are the quiet Sundays of a city of marvels: infinite in its variety, mercilessly lit by blue skies more Atlantic than industrial.

Reception

The reception of artworks within the art system is usually the first stage in their evaluation. This reception moves the art toward completion as a cultural entity and imparts a large part of its meaning. Meaning can never wholly be determined by the will of the artist, good or bad intentions notwithstanding. Artworks that last tend to be open to multiple interpretations; their "meaning" can never be totally resolved or completed. One must understand about the paintings of Richard Estes, for instance, that their meanings—and even the strictly aesthetic pleasures they offer—are subject to change through time. This ability to withstand constant reevaluation and reinterpretation is an important aspect of timelessness.

It should be clear by now that Estes' complex art is likely to last. Although his work is anchored in and inspired by the quotidian and the particular look of things, his demonstrable mastery of formal qualities such as composition, color, and geometric form and his representational subtleties impart a timelessness of a traditional sort.

Artists begin by constructing art proposals; these are either accepted or rejected at a particular time in a particular context as artworks, that is, as material or conceptual entities to be treated as artworks. Treating an entity as an artwork—and, therefore, defining it as such—means, in our culture, displaying it in sanctioned art spaces, offering it for sale, buying and selling it, writing about it, thinking about it as art, and preserving it for posterity.

There are three stages in the life of a work of art: the raw or studio stage, in which no one save the artist has made a judgment; the artwork stage, in

which it is the subject of ongoing and informed debate, evaluation, and analysis; and, alas, the artifact stage. Substandard art proposals never get to the artwork stage; great art resists the transition from artwork to artifact. After all that has been written about Contemporary Realism and Photorealism, Estes' art is still controversial; this is evidence of its continued life.

Nevertheless, once one passes beyond the level of superficial reviewing, the critical/curatorial reception of Estes' paintings seems to be quite favorable. Within the context of Contemporary Realism and/or Photorealism his work has been identified as worthwhile, if not superior. I am of course speaking of curators and critics who do not have a bias against either realism or the use of photographs in art. If one is surveying Contemporary Realism, either in an article or as an exhibition, the sheer labor involved presupposes a favorable disposition. Furthermore, no curator could survive for long within the current art system after perpetuating an exhibition of works he or she labeled as despicable or disqualified as art. In terms of art criticism, given the vehicles for said exercise and their dependency upon the commercial system for their economic survival, negative points of view are usually not allowed. Another argument for excluding negative criticism is that even negative attention is still attention that can be capitalized upon. Silence is the most effective criticism.

Or is it? Despite the fact that not one article devoted to his art has ever appeared in any of the national art magazines, Estes' instantly gained market—"obscene" to at least one critic functioning as a journalist—has held him in good stead. This may mean that there are connoisseurs not dependent upon the art magazines. It may also signal a failure of criticism in general. No wonder Estes has so little use for or interest in criticism that in 1980 he could be quoted as saying: "I believe that paintings are, or should be, their own statements. Their purpose is to be experienced for what they contain visually, and this experience should not be obscured by the static of commentary other than asides, so to speak, such as dates and technique."[12]

But let us now examine some remarks that have indeed been published about Estes, beginning with Linda Nochlin's important 1968 catalogue essay for her *Realism Now* exhibition, an exhibition and an essay generally credited as the first word on the emergence of Contemporary Realism:

Richard Estes' New York seems light-years away from that of John Sloan or the Ash-Can School. Would the stringently controlled reflections in *Coconut Custard*, based on the objective recording of the camera lens, have come out that way if there had not been a Mondrian or hard-edge abstraction? . . . For Estes, who relies on the photo-

graph "as a sketch to be used" rather than as "a goal to be reached," the photographic enlargement of reflections is too fuzzy. "Perhaps the more you show the way things look the less you show how they are or how we think they are," he muses, concerned with conveying the noncoincidence of tactile and visual reality.[13]

Bearing in mind that this is in the context of an essay that not only attempts to outline the general issues of Contemporary Realism but also to mention each of the artists in the exhibition, Nochlin astutely manages to convey a great deal about Estes' art and Estes himself, including his down-to-earth, semi-Warholian, yet ultimately gnomic manner of expressing himself in words. The phrase "the noncoincidence of tactile and visual reality" is more Nochlin than Estes. Even if it is her reconceptualization of something Estes told her, it is a brilliant insight into the work.

Nevertheless, it leaves one wondering if she (or he) means that the cityscape in reality is more tactile than it is portrayed in his paintings or less tactile. I tend to think that Estes in his paintings, through sharp focus and highly selected detailing, conveys tactility more than a photograph ever could: the coldness and the smoothness of his surfaces are accurate metaphors for the coldness and the smoothness of the windows and the building surfaces depicted. From a philosophical perspective, it is probably the human condition that the senses do not coincide—in fact they often contradict each other. Representational art, and to some extent abstract art, are attempts to compensate.

Richard Estes was also included in the first exhibition to concentrate exclusively on artists working from the photograph in an unapologetic way: *Painting from the Photo,* opening at the now defunct Riverside Museum in New York City in December of 1969. Director (and curator) Oriole Farb's brief introductory essay, while a spirited defense of the use of photography in art, does not discuss the artists in the exhibition: Malcolm Morley, Harold Bruder, Howard Kanovitz, Audrey Flack, Joseph Raffael, and Estes. In the catalogue each artist is represented by a black-and-white reproduction, a brief biography, and a statement. Beneath a fuzzy reproduction of his 1967 *Food City* Estes' statement reads: "I use the photograph because I find it gives me the best reference on the subjects I choose to paint."[14]

In my art column in the *Village Voice* devoted to the exhibition, I used this quotation from the catalogue and added: "His paintings are beautiful. Reflections in storefront windows, buildings reflected on shiny cars. He is in the tradition of Sheeler and Hopper."[15]

In 1970 Estes was included in curator James Monte's *22 Realists* at the

Whitney Museum of American Art and at least four other specifically Realist exhibitions around the country. In 1971 there were four more. In 1972 *Sharp-Focus Realism* at the Sidney Janis Gallery in New York City brought considerable media attention. "Sharp-Focus Realism, a natural reaction to the variegated abstract expressions in art, occupies the attention today of a growing number of young painters and sculptors in America and to some extent abroad," wrote Mr. Janis in his catalogue introduction. He places Estes as one of the painters at the center of the movement (his term) and concludes with the statement that "while the public readily accepts the work" the responses of certain critics and artists to this new movement "are more restrained, due no doubt to a surfeit . . . [of] . . . art of the traditional realist with who[m] the present realist frequently is mistakenly associated."[16] Hyper Realism, New Realism, Post-Pop Realism, Sharp-Focus Realism, or Photorealism—the nomenclature was still up for grabs—was, whatever it was, now inside a well-known blue-chip gallery. In certain circles panic ensued.

Harold Rosenberg attempted once again to come to the rescue: "Illusionistic art appeals to what the public knows not about art but about things," he announced in his *New Yorker* column. "This ability to brush art aside is the secret of the popularity of illusionism." Nevertheless, within a rather vituperative attack, he finds room to praise Estes: "Estes, to my mind, is the most consistently satisfying of these artists in that he candidly treats painting as a photographic problem of reflecting objects as they appear, while composing in series of brightly colored verticals and horizontals."[17]

Photorealism continued unabated. In November of 1972 *Art in America* published a special issue featuring William C. Seitz's important survey article called "The Real and the Artificial: Painting of the New Environment" plus interviews with twelve of the artists now identified as Photorealist, including, of course, Richard Estes. Seitz had this to say about Estes:

[Estes] is a straightforward environmental realist, and his work has little affinity with Pop. He begins by taking his own color slides. . . . As did the Surrealist René Magritte, he paints with fastidious care and neatness at an easel placed on an uncovered and unsoiled Oriental rug. There are occasional wraithlike figures in his paintings, but these are usually seen from across the street, inside telephone booths, as distorted reflections on polished metal surfaces and store windows, or in fragments through them. By these devices the figure is dehumanized—trapped within a maze of interlocking artifacts. Estes makes pictures that are superbly realized, patterned with painstaking artistry, icily beautiful and of immense optical complexity. . . . Habitation, even respiration, would be impossible here not because of pollution, but because neither life nor decay can take place within this sterile, glittering labyrinth. . . . [18]

Upon close analysis of Estes' compositional devices, which include the elimination or the insertion of cars *and* buildings, one wonders how "straightforward" a realist he really is. Seitz's otherwise enthusiastic evaluation also seems marred by his undue emphasis on the "wraithlike" figures and inability to see the Estes cityscape more as playful and inventive form than as some sort of inadvertent social comment.

Opening in December of 1972, two Realist exhibitions at the New York Cultural Center provided further exposure, though neither Scott Burton's *The Realist Revival* nor Mario Amaya's supplementary *Realism Now* delineated photo-inspired painting as a separate category among the various realisms represented. Estes, however, was included in Burton's sampling, along with direct-from-life painters such as Philip Pearlstein and Sylvia Sleigh.

Clearly, after his 1968 debut at the Allan Stone Gallery (which is also his point of entrance into the art system), Estes was firmly embedded as both an important Realist and a pioneering Photorealist. He was one of the artists commissioned for the Stuart M. Speiser Collection of aviation-related realist paintings in 1973; the following year, as Commissioner of the First Tokyo Biennale (New Image in Painting), I chose him as one of the ten artists representing the United States.

In 1978, ten years after his entrance, a retrospective of his paintings entitled *Richard Estes: The Urban Landscape* opened at the Museum of Fine Arts, Boston, and traveled later to the Hirshhorn Museum in Washington, D.C., the Toledo Museum of Art, and the Nelson-Atkins Museum, Kansas City, but oddly enough—perhaps not so oddly considering the continued New York art establishment resistance against Realism of any kind—not to any New York City museum. John Canaday, once lead art critic for *The New York Times*, wrote in his catalogue introduction: "Never before have there been cityscapes exactly like these, where the haphazard conjunctions of commonplace details are transformed into a matrix that would be violated if any of its multitudinous bits and pieces were excised from the mass. . . . We are fascinated by his revelation of the world around us. . . ."[19] The bulk of the catalogue text is an excellent "conversation" between Estes and John Arthur; a number of photographic illustrations document Estes' working method and are, therefore, invaluable.

Estes continued to be included in large surveys of new Realist art: John Arthur's *Realism/Photorealism* at the Philbrook Art Center, Tulsa, and *Directions in Realism* at the Danforth Museum in Framingham, Massachusetts, for which I wrote the catalogue essay, were both in 1980. Important exhibitions in 1981 that included work by Estes were *Seven Photorealists from New*

York Collections at the Guggenheim Museum, *Real, Really Real, Super Real* at the San Antonio Museum of Art, and Frank Goodyear's nearly definitive *Contemporary American Realism Since 1960* at the Pennsylvania Academy of Fine Arts. In his book-length catalogue essay, Goodyear states that "the quintessential urban landscape painter is Richard Estes, and it is Estes who has since instilled the urban image with its broadest implications."[20]

For those who care about Contemporary Realism and have a broad enough view to encompass work that utilizes photography, Estes' art is essential. He has been an undisputed pioneer of the unapologetic use of photo sources—of Photorealism, if you will—and is widely considered a leading Realist, per se. One simply cannot write about, or think about, Contemporary Realism or Photorealism and exclude his masterful works.

Nevertheless, as I hinted earlier, Estes' reception has not been completed. What remains to be seen now is his place as a unique artist, beyond stylistic tendencies that are embedded in a moment in local art history. Although it is helpful to place him in a context of his contemporaries—his Realist co-workers, as it were, all having participated in the rebirth of a highly representational pictorial art—we must also try to see his work on several other levels. How does his work stand up to the finest abstract art? How does it stand up to the representational art of the past? It is not too early to attempt these judgments; this writer at least has inklings.

Already it is apparent that Estes, because of the coolness and the hard-edge nature of his style, is very much related to certain kinds of abstract art. Comparing Estes to early Frank Stella or non-Op Ellsworth Kelly is a little bit like comparing apples and oranges, but Estes can hold his own. It is already acknowledged that in terms of Realist art, Estes has few peers.

Estes has a quiet and stubborn commitment to representational painting—and all the complexity it offers—that signals, given his considerable talents, a special sensibility, a special genius that transcends the usual art categories. In his own way he is making paintings, moving from one carefully defined format to another within his cityscape genre, that bear comparison with the greatest representational and abstract art of the past.

Evaluations

In what ways is it possible to evaluate contemporary artworks? This is not a simple question. Some would rather evade the whole issue, or cluster of issues, by claiming that we cannot judge; we must leave the verdict to history.

Yet even a cursory knowledge of how art had been received in the past reveals that most of the art we now value highly was valued during the lifetimes of its creators. There are grave exceptions, but we should not let these exceptions create the general rule. Without some favorable reception, no artwork is saved for later evaluation or revival. In some sense then, what we say about art now helps determine art history. Art history is not some impersonal, abstract force; we create art history.

We want to know what art will last. There are many reasons for this, ranging from purely economic to strictly aesthetic. In the latter case, the assumption is that only good art will last. Here circular reasoning is apt to come into play. What is good art? Art that has stood the test of time, i.e., art that lasts. On the other hand, our deciding what makes good art and utilizing those criteria to judge particular artworks ensures, whether we are later seen to be right or wrong, that those objects will survive. Those decisions and judgments—and the objects to which they are applied—become at least a social record of the time they were made, a quantifiable imprint of values.

History has taught us to have major doubts about any notion of the universality of art. Since the evidence suggests that artworks are culture-bound and time-bound, the belief that some artworks and some art qualities are universal must be understood as just that: a belief. It is a belief I find myself accepting, on the grounds that saying it is so will help make it so.

Philosophical conundrums aside, we do have certain ways of determining if an artwork is likely to survive. All of these are based on past experience: embedment and embodiment; similarity and dissimilarity. By embedment I mean that the art which has lasted has been firmly embedded in the art system of its time and has some sort of continuity with our present system. In the previous section, I hope I have shown that Estes is embedded. No serious survey of Contemporary Realist art, photo-inspired or otherwise, has excluded him. He is usually acknowledged as a pioneer Photorealist, even by those who have no particular enthusiasm for this kind of art. Although all the textbooks surveying American art since the Second World War have not yet been written, it is hard to imagine Estes' work not being included. Furthermore, important paintings of his are in major museum collections, a fact not to be taken lightly, since this is the art that is likely to be on display and available for reproduction.

Embodiment increases the odds for survival. By embodiment I mean the tendency to single out works of certain artists as signifying the best or purest versions of an art style, as emblematic rather than merely first, most original, or most typical. In this regard, there is a growing consensus that, of the

Realists who use photographs and of the Photorealists who use multiple photo sources (at least among those who avoid allegorical, narrative, or sentimental effects), Estes is the best. His work is the embodiment of non-Conceptual, non-Pop Photorealism.

The concepts of similarity and dissimilarity are slightly more difficult to handle in a linear manner, for both characteristics must exist simultaneously. Estes' work is similar to other serious works that emerged in the sixties and seventies because of its cool, relatively impersonal surfaces and emotional content; it is dissimilar because he actively confronts the issues of representation without surrendering to painterly or conceptual compromise.

Estes' art is similar to the great representational art of the past that might be called "cool realism" (Vermeer, Eakins, Precisionist Sheeler, Hopper, and so forth), but dissimilar enough to require its own place. If it were too similar we would not need his art, because, in some sense, we already have enough. Working within a tradition that emphasizes formal arrangement, precise information, and the subject matter of everyday life—a tradition that is discontinuous, but apparently perennial—Estes has updated, if not totally reinvented, the cityscape as a vehicle for visual invention. In this arena he has no peer.

Finally, one more way of judging art needs to be mentioned. It may be the most important way of all, though it is the most difficult to describe. It is personal, but has often been used as the most authoritative. It too, however, is based on past experience. It is the something—often deemed the aesthetic response—that happens when we look at great art; through experience with the best art of the past we learn to recognize it, though it eludes analysis. We learn to separate it from temporary moods and needs; we feel very strongly that it transcends social conditioning. Estes' paintings give me that feeling. Without any excuses, I would characterize his paintings as beautiful. Beauty for me usually means an exact correspondence of clarity and complexity; Estes' art possesses that most important of all art qualities.

When the mood strikes him, Estes does not think of his paintings as realistic, in the normal sense of the word: "It's all a lie. I always like to think that the paintings look very realistic, but the subjects don't actually exist in this way. Everything is constantly changing. There is no such thing as a realistic painting. It's a selection, taking a few elements of reality, of the visual elements—never mind the noise, the smell, the actual dimensions."

Beauty is not his goal. But perhaps the approach to beauty must always be indirect. Estes is more concerned with structure. "One of the reasons I like the paintings," he told me, "is not that they give you all the reality, but they

35

give you an organized sense of reality. A sort of ideal reality. It's not beautiful; it's organized. In a book or a play you have a beginning, a middle, and an end. But in reality it's not like that. It just sort of fizzles out. In art, you have to introduce structure, so we can see in an ordered way because that is what we get our satisfaction from."

He may not intend it, but his cityscapes—pointing toward some elevated but thoroughly material music of space and light—are visionary. The paintings are as much about how things could look as about how they actually appear. Calm and crystalline, Estes' paintings are "abstract" in a representational way.

NOTES

1. Linda Chase, Nancy Foote, and Ted McBurnett, "The Photo-Realists: 12 Interviews," *Art in America*, November/December, 1972, pp. 78, 79.

2. This quotation and all others without citations are from interviews the author conducted with Richard Estes in 1984.

3. John Arthur, *Richard Estes: The Urban Landscape* (Boston: Museum of Fine Arts and New York Graphic Society, rev. ed. 1978), p. 18.

4. Chase, Foote, and McBurnett, op. cit., p. 79.

5. J. Martin, ed., "Kinds of Realism," *Allan Frumkin Gallery Newsletter*, Allan Frumkin Gallery, New York, Winter, 1979, p. 6.

6. Arthur, op. cit., p. 22.

7. Chase, Foote, and McBurnett, op. cit., p. 80.

8. Ibid., p. 79.

9. Ibid., p. 79.

10. Van Deren Coke, *The Painter and the Photograph* (Albuquerque: University of New Mexico Press, 1964; rev. ed. 1974).

11. Martin, op. cit., p. 5.

12. Artist's statement published in *Real, Really Real, Super Real* (San Antonio, Texas: San Antonio Museum Association, 1981), p. 126.

13. Linda Nochlin, *Realism Now* (Poughkeepsie, N.Y.: Vassar College Art Gallery, 1968). Reprinted in *ARTnews*, January, 1971, and Gregory Battcock, ed., *Super Realism* (New York: E. P. Dutton, 1975), pp. 117–18.

14. Oriole Farb, *Painting from the Photo* (New York: Riverside Museum, 1969), unpaginated.

15. John Perreault, "Get the Picture?" *Village Voice*, December 18, 1969, p. 47.

16. Sidney Janis, *Sharp-Focus Realism* (New York: Sidney Janis Gallery, January, 1972), unpaginated.

17. Harold Rosenberg, "Reality Again," in Battcock, op. cit. [Reprinted from *The New Yorker*, February 5, 1972].

18. William C. Seitz, "The Real and the Artificial," *Art in America*, November/December 1972, p. 65.

19. John Canaday, "Introduction" to Arthur, op. cit., pp. 7, 10, 14.

20. Frank H. Goodyear, *Contemporary American Realism Since 1960* (Boston: New York Graphic Society, in association with the Pennsylvania Academy of Fine Arts, 1981), p. 146.

THE PAINTINGS 1966–1985

By Louis K. Meisel

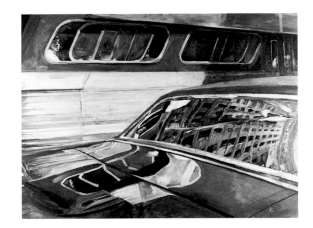

2. *Flatiron Building Reflected in Car with Figure in Bus.* 1966. Oil on Masonite, 36 x 48". Collection the artist (Estes' handwritten caption appears on the back of a photograph of this painting.)

Most artists show creative evolution during their careers: these stylistic changes, identifiable in many ways, can be either subtle or quite exaggerated. They can be conscious, and even forced, or they can evolve in a logical, natural, almost unconscious way. The latter process best describes the stylistic development of Richard Estes.

This book deals with a twenty-year period, 1966 through 1985, in Estes' artistic life. Encompassing the entire body of his mature work, it illustrates all his important paintings—and, in fact, ninety-eight percent of the total he created—during that time.

The pivotal year for Estes was 1967, the year in which all his paintings concentrated for the first time on reflective surfaces. During that year Estes realized that the camera could be used as a legitimate tool to help the fine artist capture and paint elusive reflections. The first example of such use is *Flatiron Building Reflected in Car with Figure in Bus* (fig. 2), a painting that is part of the artist's personal collection and has not been reproduced prior to this publication. *Flatiron*, actually painted late in 1966, was but the first in a series of experiments running through 1967 with a variety of subjects: motorcycles, airplanes, cars, car windows, bus windows, and then finally store windows. In a single year, Estes tried and rejected all these subjects and ultimately settled on the storefront as the territory for further advanced exploration and problem solving. The storefront would remain his favored subject for many years.

37

The enduring importance of an artist is measured not only by his own work and its development but also by the influence that work has on other artists—contemporaries as well as future generations. For this reason, it is especially significant that the various subject matters touched on by Estes in 1967 became career efforts for other Photorealists. A motorcycle by Estes (fig. 5) can be compared with the same subject matter as treated by David Parrish (fig. 6) and Tom Blackwell, who also followed Estes to the storefront. Estes' car sections (figs. 7 and 11) find parallels in those of Don Eddy (figs. 8 and 12), as do his wrecked cars (fig. 13) in those of John Salt (fig. 14). Estes painted a diner in 1971 (fig. 9); John Baeder has since become known for his paintings of diners (fig. 10). Ten years after Estes painted five or six theaters (fig. 3), a young realist, Davis Cone, embraced the theater marquee as a creative subject (fig. 4).

At the end of 1967 Estes created a painting titled *Hot Foods* (fig. 31), his very first storefront. This painting marks the beginning not only of Richard Estes as art history will portray him but also of Photorealism as dominated by the imagery of the urban landscape.

From *Hot Foods* on, Estes' work has continued to evolve through three decades. It will be obvious from the dates of the paintings that once an idea occurred to Estes, it became a permanent part of his repertoire. In some cases, an idea occurred in one or two early works and was not fully developed until many years later. By the same token, years after they have been fully explored, some ideas reappear, either as new works in themselves or as parts of later, more ambitious undertakings.

STRAIGHT-ON STOREFRONTS AND VIEWS

In 1967, Estes stopped pointing his camera down into the windshields and hoods of cars and moved it to the horizontal position, looking straight at and into the windows of stores, specifically restaurants and fast-food places. At this point he was still interested in people—ordinary people. They are visible in all these early works.

The first painting in this series of straight-on storefronts, and therefore the first Photorealist urban landscape, is the previously mentioned *Hot Foods*. Both it and *Coconut Custard* (fig. 32) depict the automat. The next two, somewhat lesser efforts (figs. 33 and 34), both of Nedick's, are significant for the very slight slant in the angle of approach, an idea that was to appear later in a much exaggerated form.

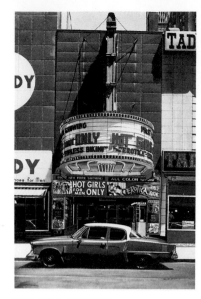

3. *Hot Girls.* 1968. Oil on canvas, 58¼ x 38⅝". Teheran Museum of Contemporary Art

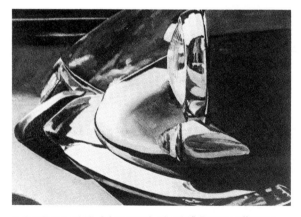

7. *Car Front.* 1967. Oil on panel, 18 x 24". Private collection

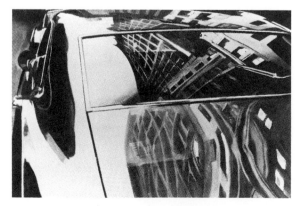

11. *Fastback.* 1967. Oil on board, 17¾ x 23⅝". Private collection

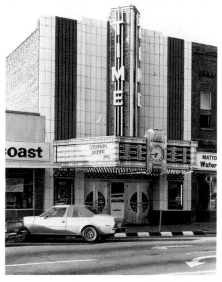

4. Davis Cone. *Time Theatre.* 1983. Acrylic on canvas, 59¼ x 45¾″. The Speyer Family Collection

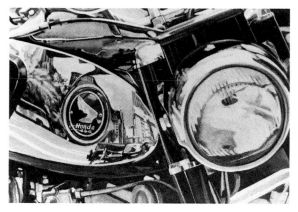

5. *Honda.* 1967. Oil on board, 23 x 35″. Private collection

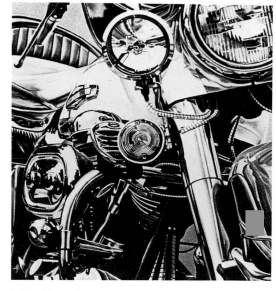

6. David Parrish. *Motorcycle.* 1971. Oil on canvas, 46 x 42″. Collection Ann and Burt Chernow, Conn.

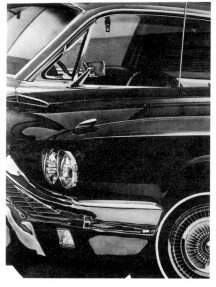

8. Don Eddy. *Untitled (T & M).* 1971. Acrylic on canvas, 95 x 66″. Musée d'Art et d'Industrie, Saint-Etienne, France

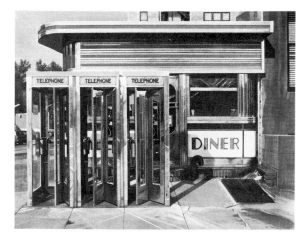

9. *Diner.* 1971. Oil on canvas, 40⅛ x 50″. Hirshhorn Museum and Sculpture Garden, Smithsonian Institution, Washington, D.C.

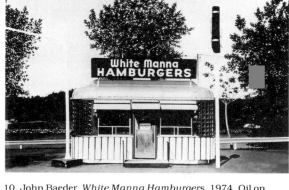

10. John Baeder. *White Manna Hamburgers.* 1974. Oil on canvas, 30 x 48″. Collection Larry A. Belger, Mo.

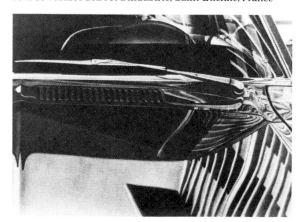

12. Don Eddy. *Ford—H & W.* 1970. Acrylic on canvas, 48 x 66″. Pioneer and Haggin Galleries, Calif.

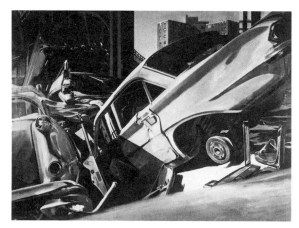

13. *Auto Graveyard.* 1968. Oil on canvas, 41 x 53″. Collection Galerie Isy Brachot, Brussels

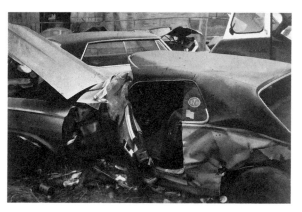

14. John Salt. *Demolished Vehicle (S.T.P. with Trash).* 1971. Oil on canvas, 51½ x 73½″. Collection Galleri Ostergren, Sweden

15. *Automat*. 1967. Oil on Masonite, 48 x 60″. Collection Marie C. Estes

16. *Subway Passengers* (unfinished). 1966. Oil on canvas, 35¾ x 48″. Collection the artist

In this initial series, Estes was looking straight ahead and fairly close-up at a single subject. Though he dealt primarily with storefronts, his subjects sometimes included theaters (figs. 64–67, and 169) or interiors (figs. 41–43, and 166). One of the most famous works in this early series is *Telephone Booths* (fig. 44). *Food City* (fig. 36) and *The Candy Store* (fig. 40) are major orthodox works in this same series, but the three very best, most exciting works from this earliest vision are *Grand Luncheonette* (fig. 35), *Food Shop* (fig. 39), and the incredible 1970 painting *Cafeteria* (fig. 37). In the latter painting, composition, color, image, and technique all came together to lead the art world into the seventies, the decade of Photorealism, and to confirm Estes as the undisputed leader of the movement.

Estes next employed his straight-on approach in a series of paintings I call "blockfronts," in which he positioned his camera on one side of a broad avenue and photographed the blockfront opposite.

The first painting in this series and one of Estes' most famous early works is *Gordon's Gin* (fig. 68) of 1968. This painting and *Apollo* (fig. 66), done while Estes was in the midst of his straight-on storefronts, served as almost visionary predictions of things to come. Not only did they foretell sev-

17. *Bus Front.* 1967. Oil, 18 x 24". Private collection

18. *Car Reflections.* 1970. Acrylic on Masonite, 48 x 30". Indianapolis Museum of Art

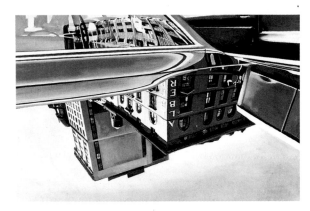

19. *Car Reflections.* 1969. Oil on canvas, 32½ x 49½". Collection Acquavella Galleries, Inc., New York

eral paintings of the early seventies, but in retrospect they appear as precursors of the panoramas of the early eighties.

The third painting in the blockfront series is the best known and, in my opinion, the finest of this group—*Key Food* (fig. 69), done in 1970. In 1972 Estes created *Valet* (fig. 78), the fourth painting in this group and another major effort. In 1973 came a minor work titled *Shoe Outlet* (fig. 105), the final blockfront.

Key Food was pivotal in Estes' career, for it appeared in an important exhibition at the Whitney Museum in 1970. Titled *22 Realists* and curated by James Monte, the exhibition was a starting point for renewed attention to developments in contemporary realism. Seen in this context, Estes' work stood out as clearly exceptional. He then followed through in 1970 with several extraordinary and important paintings, in addition to *Cafeteria,* that served to firmly establish him as a leader of the New Realism and specifically of Photorealism, its cutting edge. Among these were *Drugs* (fig. 107), a major effort and the first of his "slant/reflection" images, *Grossinger's* (fig. 120), also a slant/reflection, and *Nedick's* (fig. 45; probably mistitled by someone other than the artist).

41

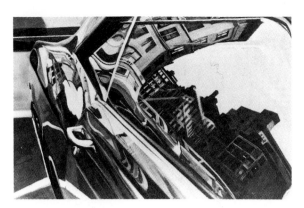

20. *Untitled (Car Reflection).* 1967. Oil on board, 23½ x 35⅛". Private collection

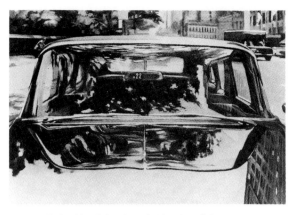

21. *Untitled.* 1967. Oil on board, 36 x 51½". Private collection

22. *Automobile Reflections.* 1969. Oil on canvas, 24 x 36". Private collection

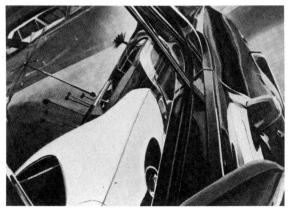

23. *Palm Tree Reflection.* Date unknown. Oil on canvas, 25½ x 35". Collection Roger Travis, New York

24. c. 1966. Other information, including whereabouts, unknown

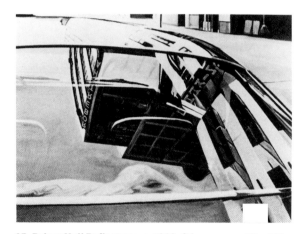

25. *Robert Hall Reflections.* c. 1969. Oil on canvas, 36 x 48". Private collection

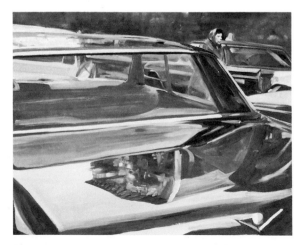

26. *Cadillac.* 1967. Oil on Masonite, 36 x 51". Private collection

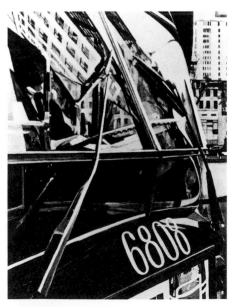

27. *Bus Window.* 1967; repainted in 1973. Oil on board, 48 x 36". Collection Mr. and Mrs. R. A. L. Ellis

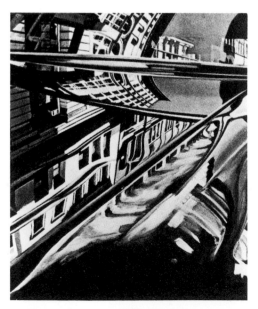

28. *Flatiron Building.* c. 1969. Oil on Masonite, c. 36 x 24". Private collection

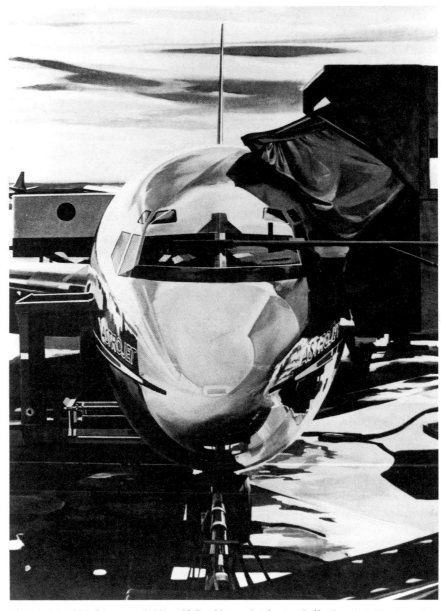

29. *Astrojet*. 1967. Oil on panel, 68 x 48″. Des Moines Art Center, Coffin Fine Arts Trust Fund

COMPLEX STOREFRONTS

In 1972 Estes' work took on its next major stylistic change, one made possible by his increasingly complex use of multiple photographs, including varying focal points and details, as studies for a single painting. His photography and darkroom equipment became very sophisticated, and his information gathering very precise. Most of the other Photorealists at that time were using one photo per painting; those who were not, like Audrey Flack, were not manipulating the photographic material as Estes was.

This use of multiple photographs for a single painting was a necessary prelude to his later panorama series. In 1973, however, it manifested itself in a series I call complex storefronts.

As subjects for this series, the artist returned from blockfronts to straight-on storefronts but with an added dimension. Indeed, the four major works in this series are so complex and confusing to the perceptions—with their multiple levels and planes of interior realities and both exterior and interior reflections—that there was obviously no way they could have been attempted without a very sophisticated use of the camera.

The first painting in the series is *Alitalia* (fig. 87), which I commissioned in 1972 for the Stuart M. Speiser Collection (now a part of The Smithsonian Institution Collection). In accepting this commission, Estes challenged himself to find a new aspect for his already famous straight-on storefronts, and he was ultimately led to more difficult problems and visions in his work.

While it is among the smallest of the four, *Alitalia* is the most elegant and is distinguished by its symmetry and sophisticated color sense. The smallest work is *Double Self-Portrait* (fig. 88), which was given to the Museum of Modern Art by Stuart Speiser. Despite its size, it is an outstanding work and a fitting part of the Modern's collection. Its title refers to the two reflections of the artist taking the photograph, and in fact this is the only time Estes has painted a recognizable image of himself.

The two largest and most fully developed paintings in this series are *Thom McAn* (fig. 90) and *Teleflorist* (fig. 89), both done in 1974. *Teleflorist* is the most complicated single image in Estes' career, and I think its creation ended, once and for all, the arguments as to the legitimacy and need of photographic tools in making fine art.

Years later, as studies for screenprints, Estes returned briefly to this series and did two more complex-storefront paintings. Both were small. One of them, *Flughafen (Airport)* (fig. 131), made it into print form; the other was so confusing that it was never published (fig. 55).

Continued on page 57

44

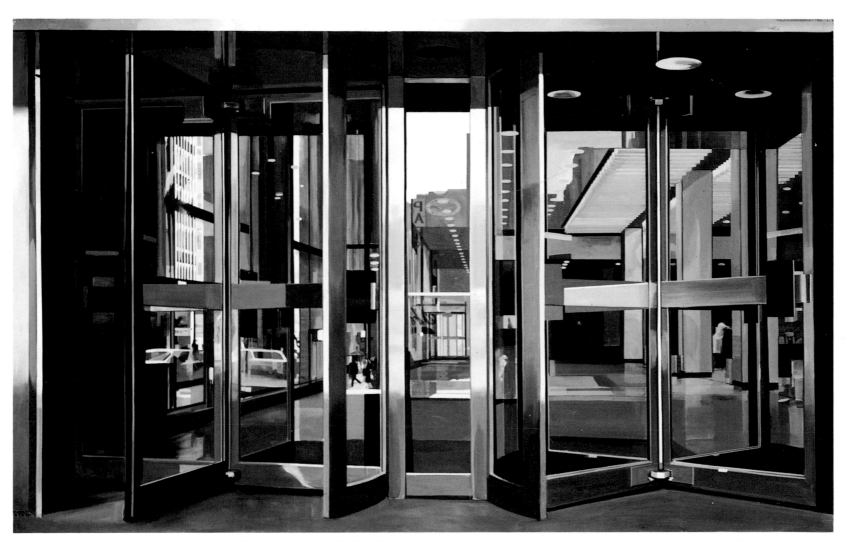

30. *Revolving Doors.* 1968. Oil on Masonite, 30 x 48″. Collection Dr. Jack E. Chachkes

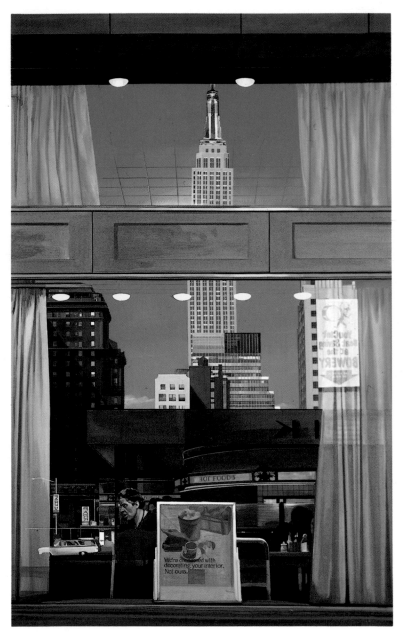

31. *Hot Foods.* 1967. Oil on canvas, 48 x 30″. Private collection, West Germany

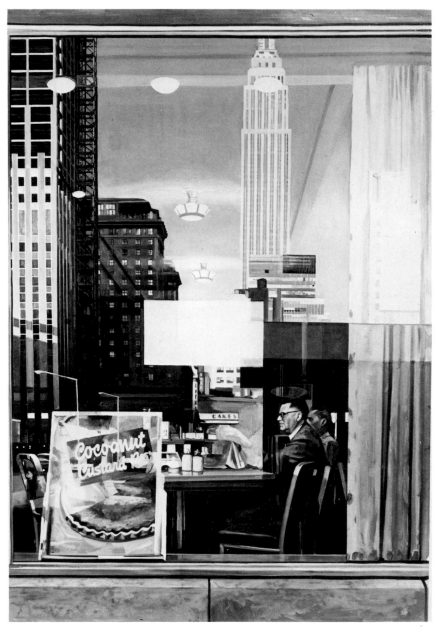

32. *Coconut Custard.* 1967. Oil on Masonite, 69 x 48″. Private collection

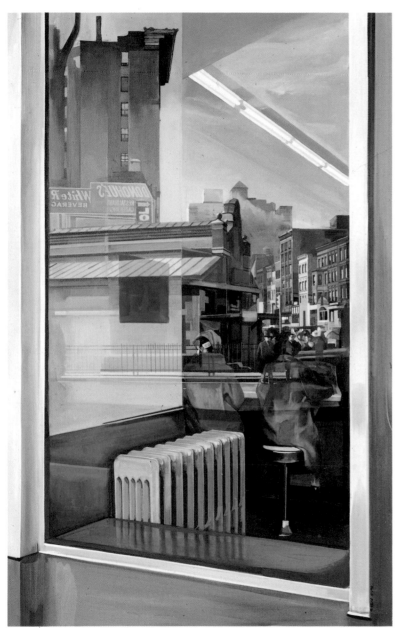

33. *Donohue's.* 1967. Oil on canvas, c. 45 x 28″. Private collection

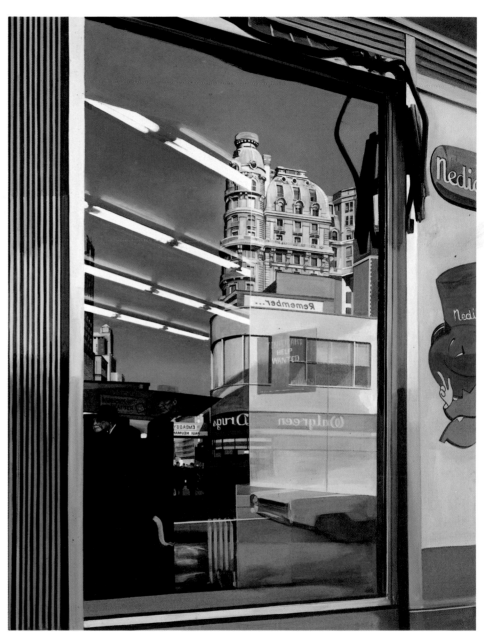

34. *Nedick's.* 1968–69. Oil on canvas, 48 x 36″. Collection Mr. and Mrs. Malcolm Chace, Jr., R.I.

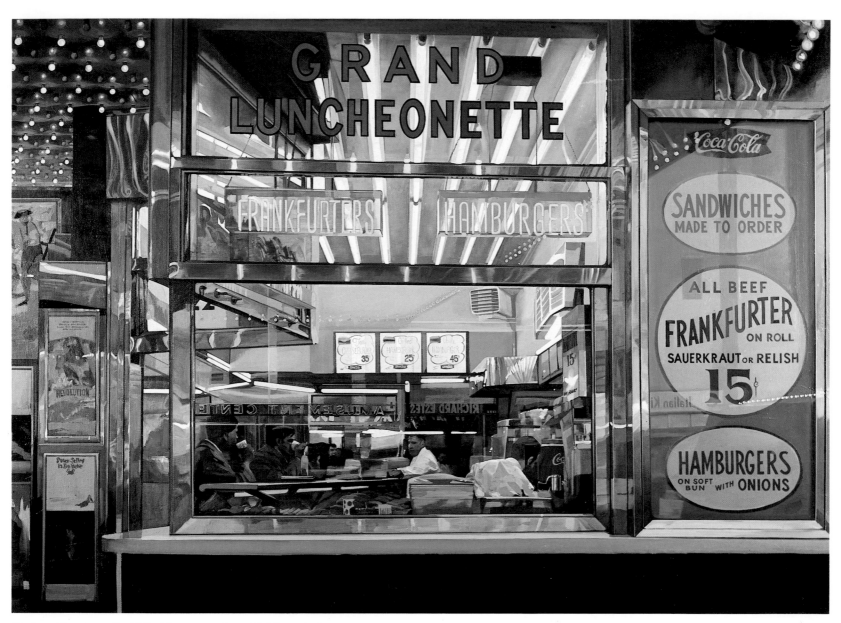

35. *Grand Luncheonette.* 1969. Oil on canvas, 51 x 69¼". Private collection

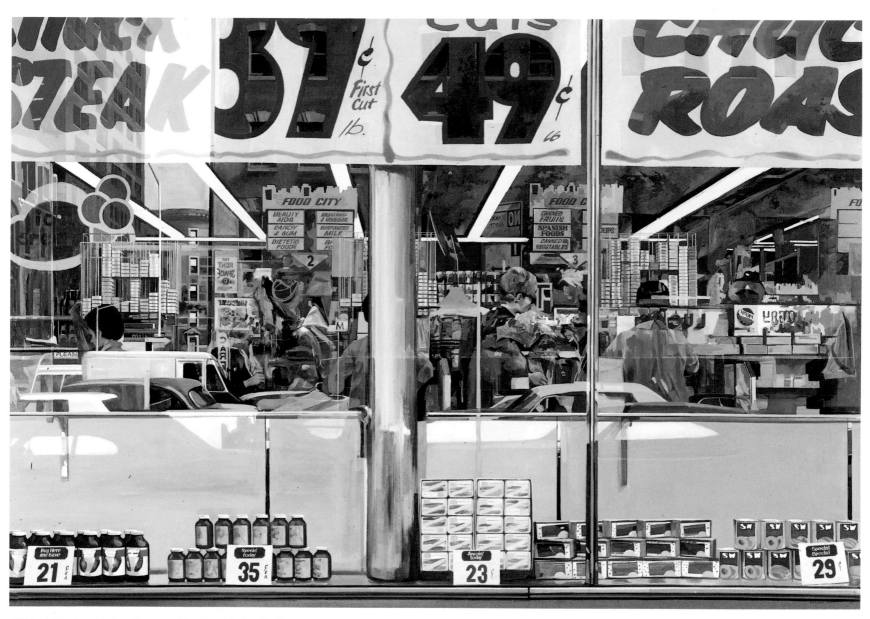

36. *Food City.* 1967. Oil on Masonite, 48 x 68″. Private collection

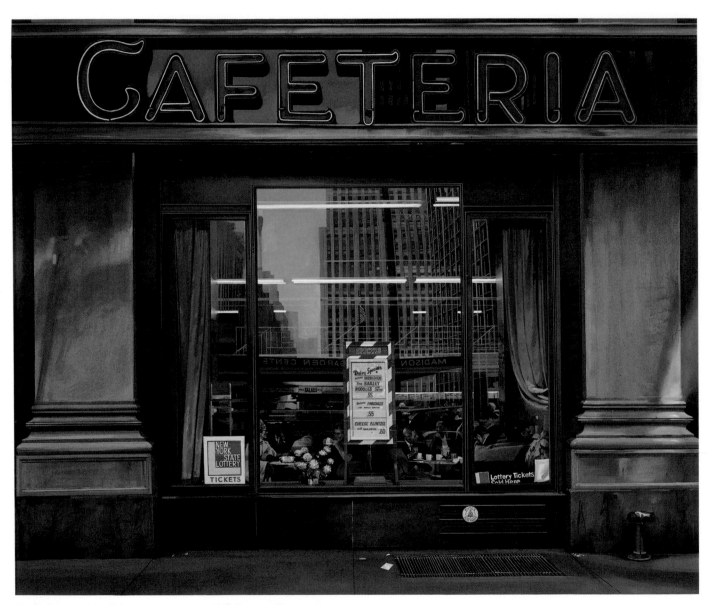

37. *Cafeteria*. 1970. Oil on canvas, 41½ x 48½″. Private collection, New York

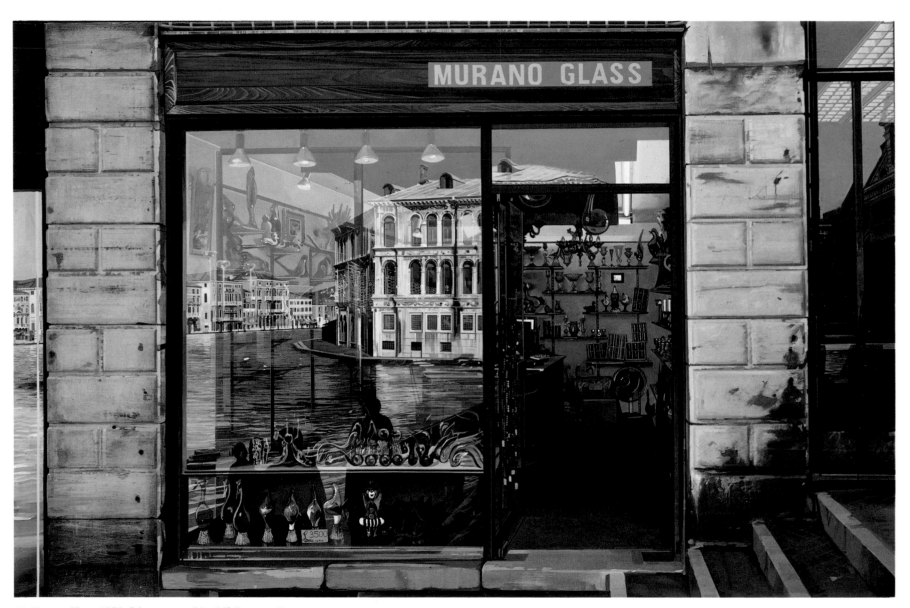

38. *Murano Glass*. 1976. Oil on canvas, 24 x 36". Private collection

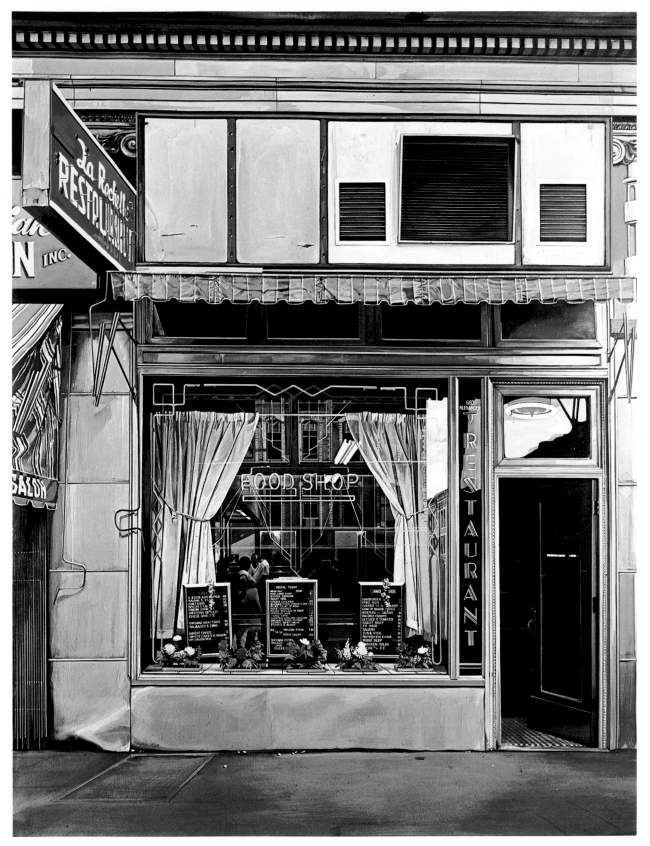

39. *Food Shop.* 1970. Oil on linen, 65⅝ x 48½″. Neue Galerie der Stadt Aachen, Aachen, West Germany. Ludwig Collection

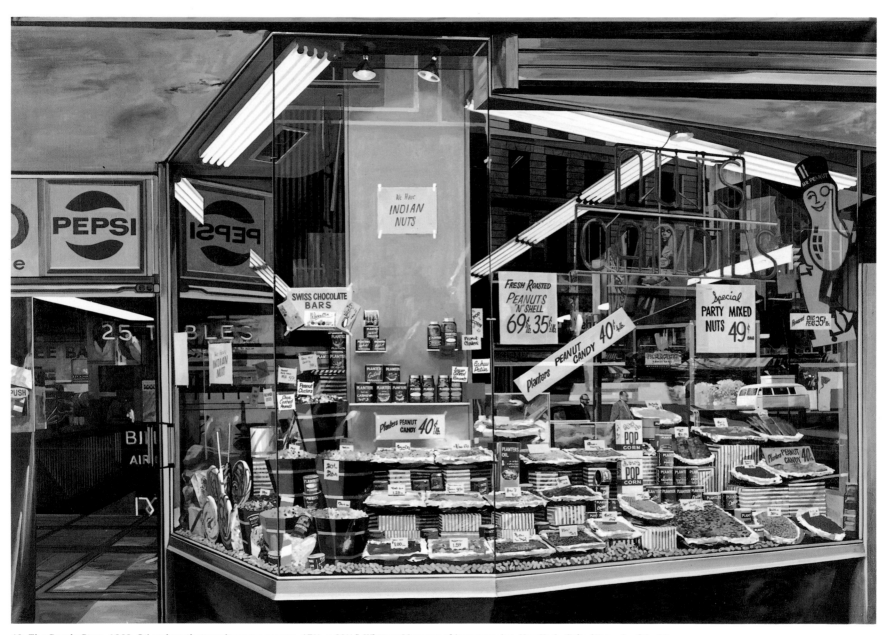

40. *The Candy Store.* 1969. Oil and synthetic polymer on canvas, 47¼ x 68¼". Whitney Museum of American Art, New York. Gift of Friends of the Museum

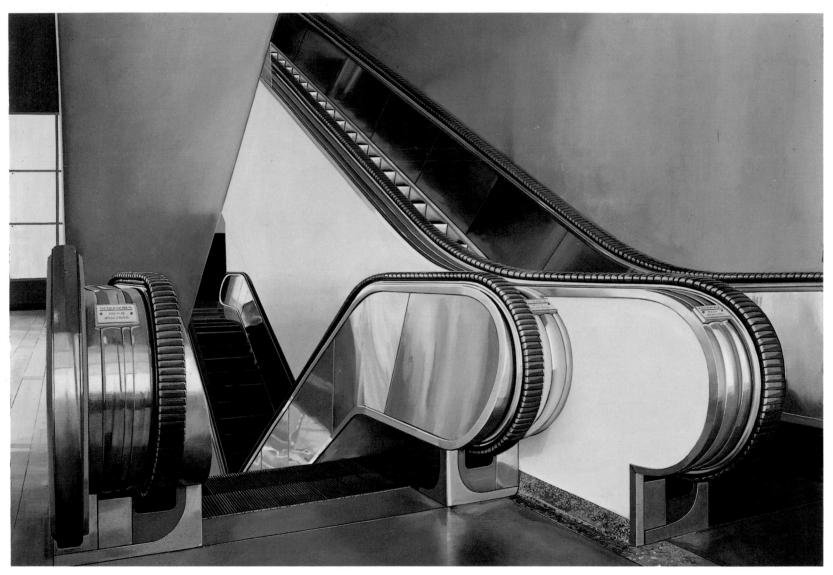

41. *Escalator.* c. 1971. Oil on canvas, c. 24 x 36″. Collection Mr. and Mrs. Morton G. Neumann, Ill.

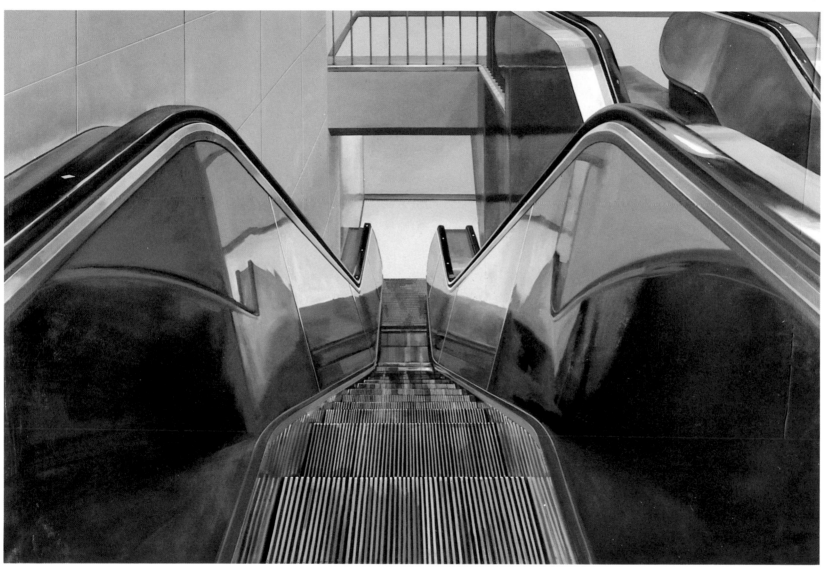

42. *Escalator.* 1970. Oil on canvas, 42½ x 62". Private collection

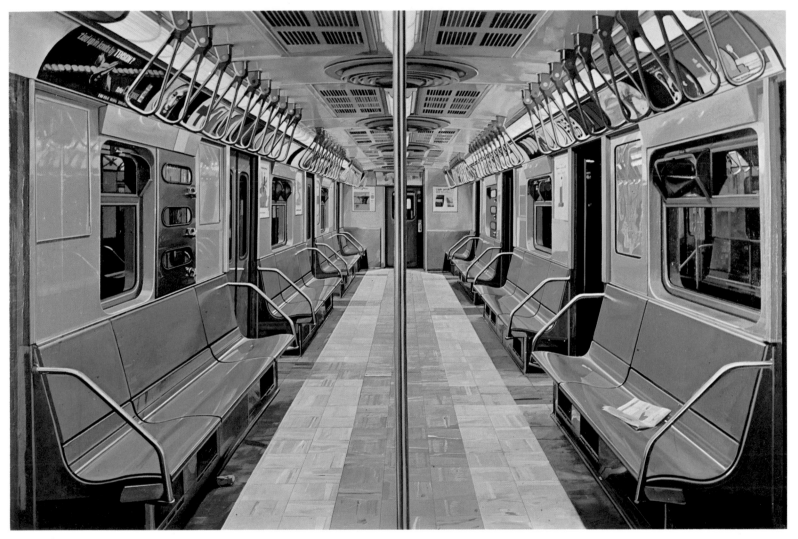

43. *Subway.* 1969. Oil on canvas, 42 x 60″. Private collection

Each of the four major paintings in this series is composed of narrow but powerful horizontal and vertical elements, with broader but still narrow bands of solid color on the horizontal axis; within these bands are rectangular areas of color. These works indicate an awareness of abstract painting and thinking, with a specific concession to Mondrian. A case might also be made that Estes has an understanding of spatial divisions and areas equal to that of artists like Barnett Newman and Brice Marden.

SLANT/REFLECTIONS

As Estes' earliest straight-ons evolved into his complex-storefront series, another branch of the same evolutionary process produced his largest body of work, the "slant/reflection" series. To compose the images in this series, the artist would stand between two and ten feet from a storefront, usually made of glass. He would then aim his camera straight up the street to create a single, centered vanishing point. Approximately half of the resultant photograph and the subsequent painting was a reflection of the other half. This exceedingly interesting way of seeing an urban landscape is almost unique to Richard Estes and will, as time passes, become totally identified with him.

One of the earliest and most famous of the slant/reflections is *Bus Reflections (Ansonia)* (fig. 114). The very earliest is *46th and Broadway* (fig. 108), and probably the clearest example of the approach is *Miami Rug Company* (fig. 49).

The illustrations in this volume indicate the myriad variations in angles, distances, and positions possible in the slant/reflection series. Such variations persist in Estes' later work right up to his most recent paintings, like *Times Square at 3:53 P.M. on a Winter Afternoon* (fig. 159) and *Broadway at 70th Street* (fig. 162).

Slant/reflections are even exploited in the Venice Canal paintings, *Accademia* (fig. 143) and *View toward La Salute, Venice* (fig. 144). Estes has made many trips to Europe in the past fifteen years, and European scenes, particularly of Paris (figs. 106, 118, and 138) and Venice (figs. 38, 51–55, 86, and 167), have occasionally served him as subjects. By far the most interesting, unique, and beautiful of his European paintings are his water scenes (figs. 139–41 from Paris, figs. 143 and 144 from Venice, and fig. 142 from Florence). Estes may never receive the same level of acclaim for these paintings as he has for his urban landscapes, but I think they demonstrate another aspect of his technical mastery. He handles these "waterscapes" as well

Continued on page 88

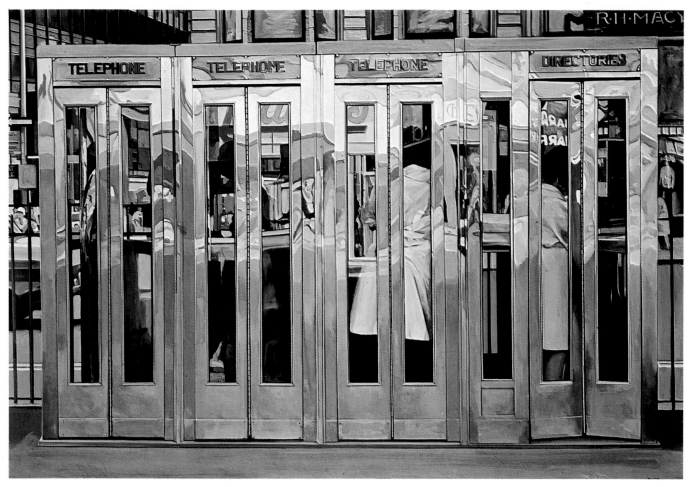

44. *Telephone Booths.* 1968. Oil on canvas, 48 x 69″. H. H. Thyssen-Bornemisza Collection

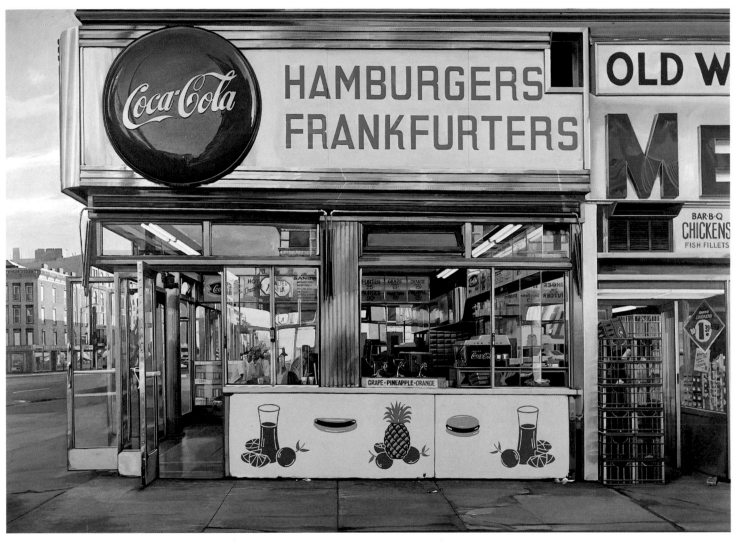

45. *Nedick's*. 1970. Oil on canvas, 48 x 66″. Private collection

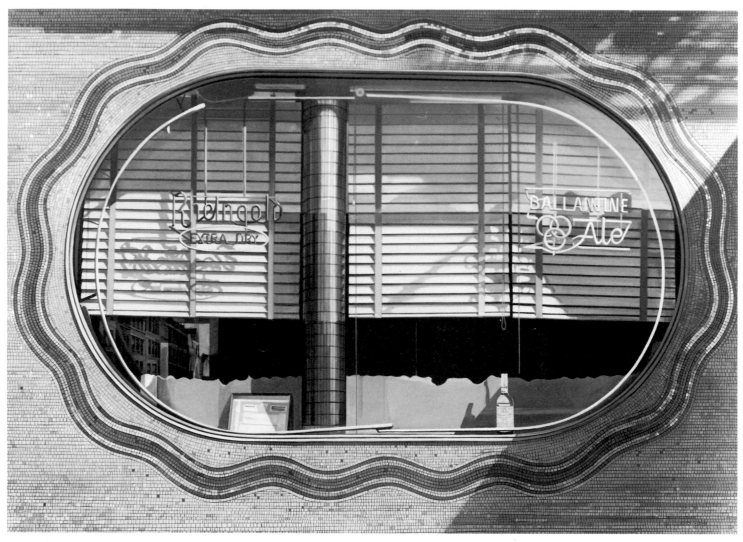

46. *Mosaic.* 1968. Oil on Masonite, 48½ x 66½". Collection Louis K. Miesel Gallery, New York

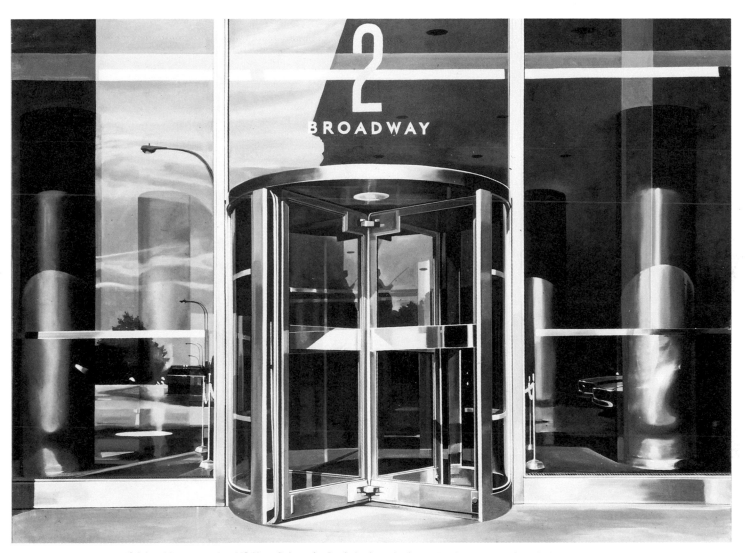

47. *2 Broadway.* 1968–69. Oil on Masonite, 48 x 66″. Neue Galerie der Stadt Aachen, Aachen, West Germany. Ludwig Collection

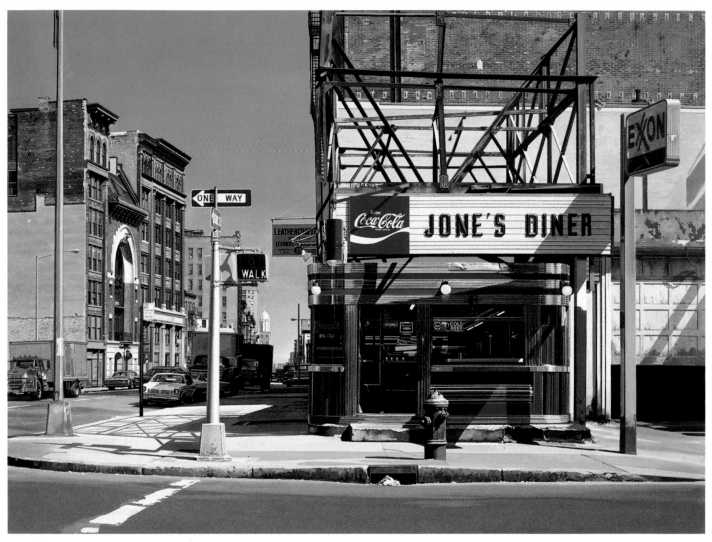

48. *Jone's Diner.* 1979. Oil on canvas, 36½ x 48″. Private collection

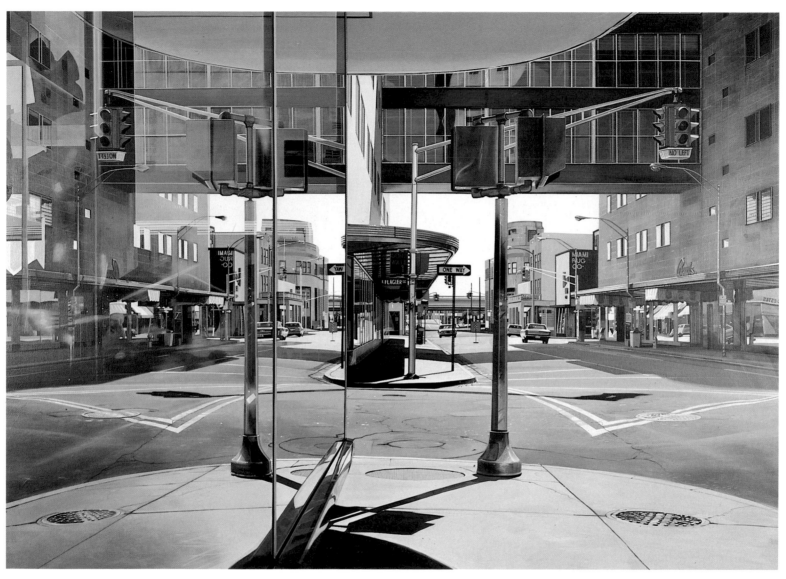

49. *Miami Rug Company.* 1974. Oil on canvas, 40 x 54″. Private collection

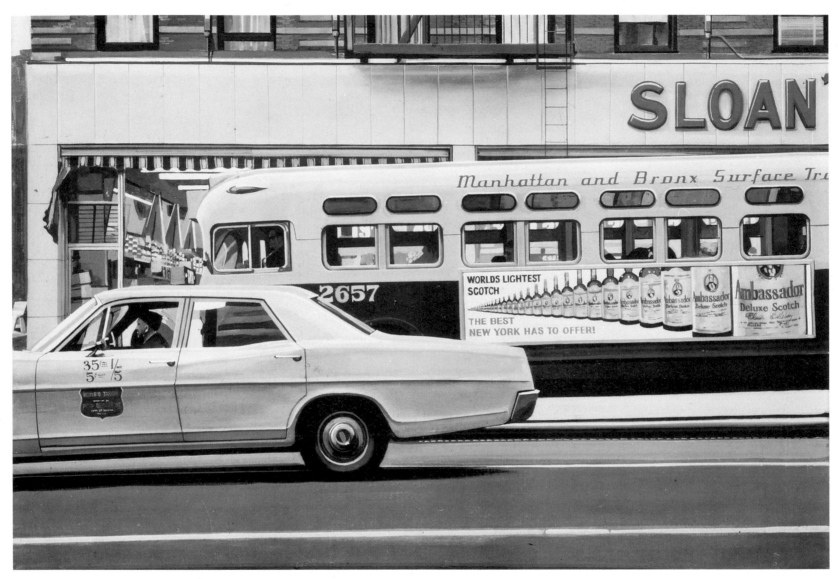

50. *Sloan's.* 1968. Oil on canvas, 24 x 33¾". Collection Citibank North America

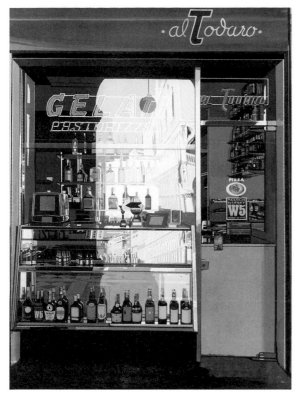

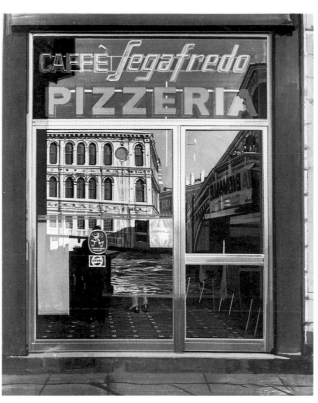

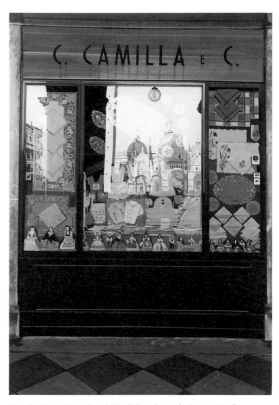

51. *Al Todaro.* 1979. Oil on board, 20 x 15¼″. Private collection

52. *Sega Fredo.* 1976. Gouache on board, 13½ x 11″. Private collection, Italy

53. *C. Camilla e C.* 1979. Oil on board, 21 x 14½″. Private collection

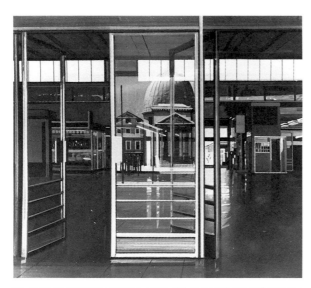

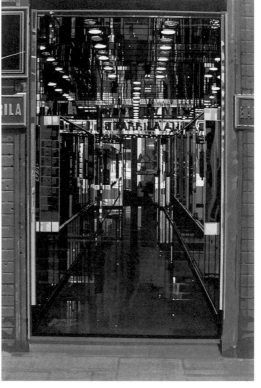

54. *Railway Station, Venice.* 1975. Oil on board, 9 x 10″. Private collection, Italy

55. *Bar in Italy.* 1978. Oil on board, 19 x 12″. Private collection

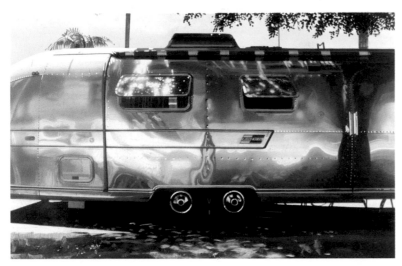

56. *Airstream*. 1974. Gouache on paper, 14 x 21″. Collection Louis and Susan Meisel, New York.

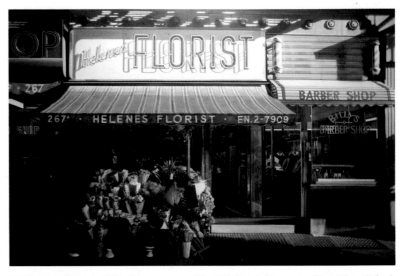

57. *Helene's Florist*. 1971. Oil on canvas, 48 x 72″. Toledo Museum of Art, Ohio. Gift of Edward Drummond Libbey

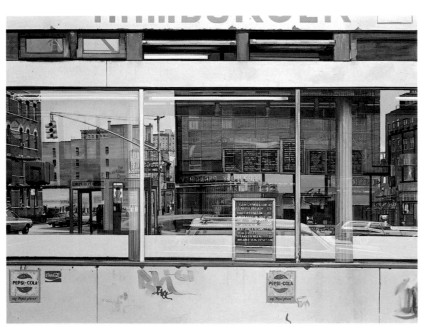

58. *A Hamburger Shop*. 1976. Oil on canvas, 40 x 50″. Neue Galerie der Stadt Aachen, Aachen, West Germany. Ludwig Collection

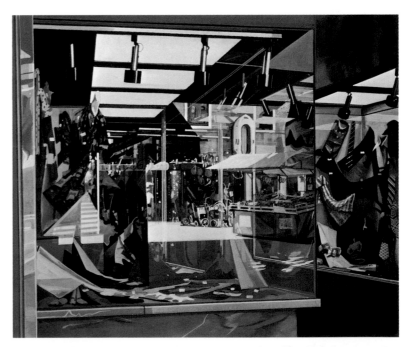

59. *Clothing Store*. 1976. Acrylic and oil on rag board, 13 x 15″. Collection Louis and Susan Meisel, New York

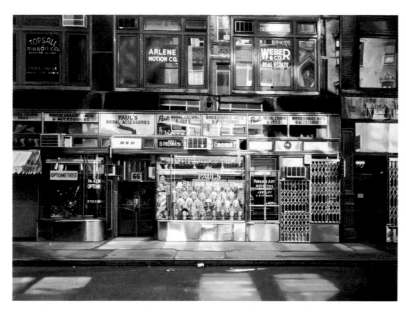

60. *Bridal Accessories.* 1975. Oil on canvas, 36 x 48″. Collection Graham Gund, Mass.

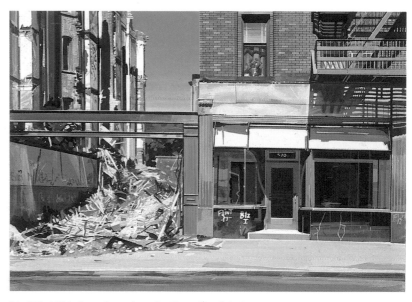

61. *570.* 1974. Gouache on board, 14½ x 20½″. Collection Morgan Gallery, Kansas City, Mo.

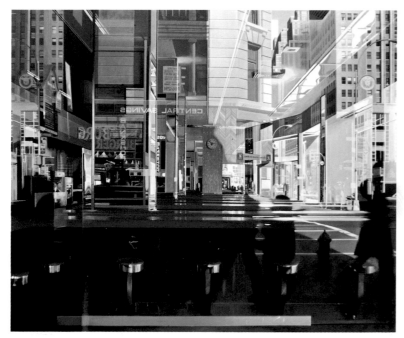

62. *Central Savings.* 1975. Oil on canvas, 36 x 48″. Nelson Gallery—Atkins Museum, Kansas City, Mo. Friends of Arts Collection

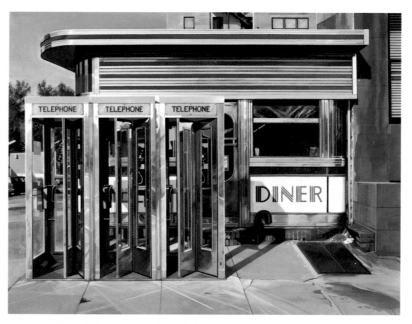

63. *Diner.* 1971. Oil on canvas, 40½ x 50″. Hirshhorn Museum and Sculpture Garden, Smithsonian Institution, Washington, D.C.

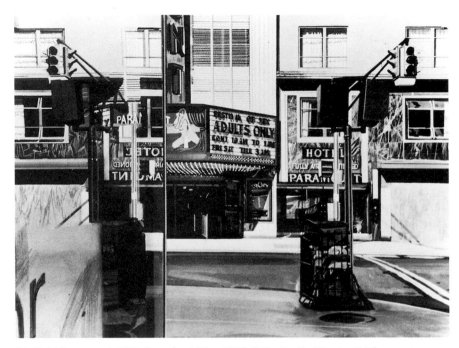

64. *Hotel Paramount.* 1974. Gouache, 14¼ x 19½". Collection Paul Kantor, Calif.

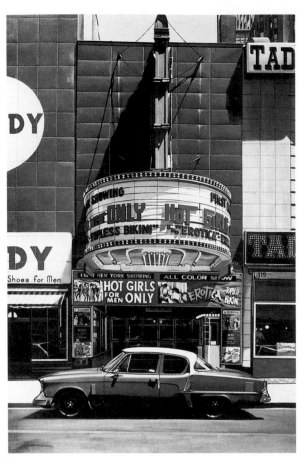

65. *Hot Girls.* 1968. Oil on canvas, 58¼ x 38⅝". Teheran Museum of Contemporary Art

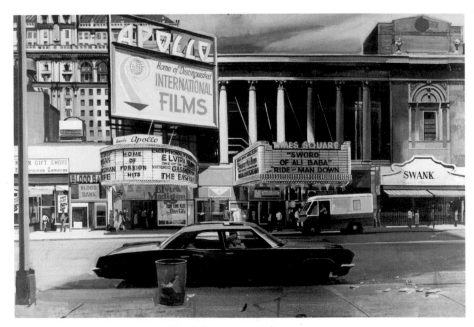

66. *Apollo.* 1968. Oil on Masonite, 24 x 36". Collection the artist

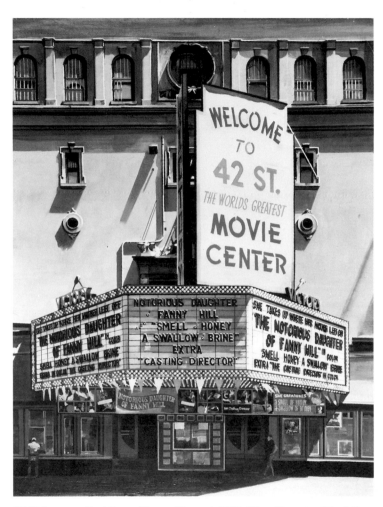

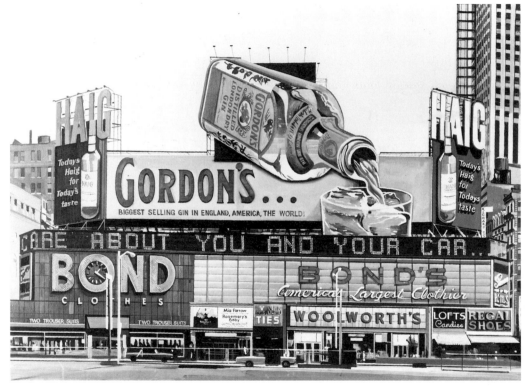

67. *Welcome to 42nd Street (Victory Theatre).* 1968. Oil on Masonite, 32 x 24".
Detroit Institute of Arts

68. *Gordon's Gin.* 1968. Oil on board, 24½ x 32". Private collection

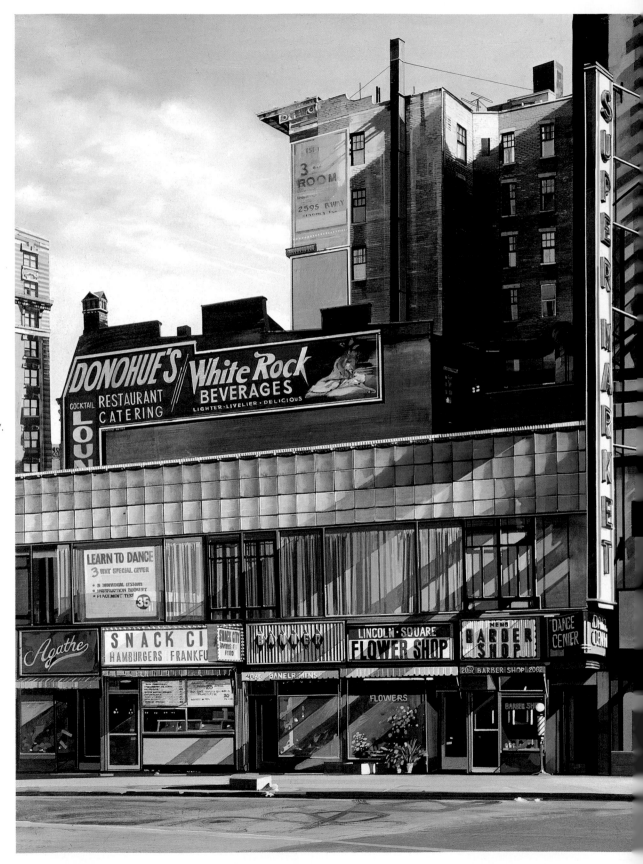

69. *Key Food.* 1970. Oil on canvas, 36 x 55″.
Collection Beatrice C. Mayer, Ill.

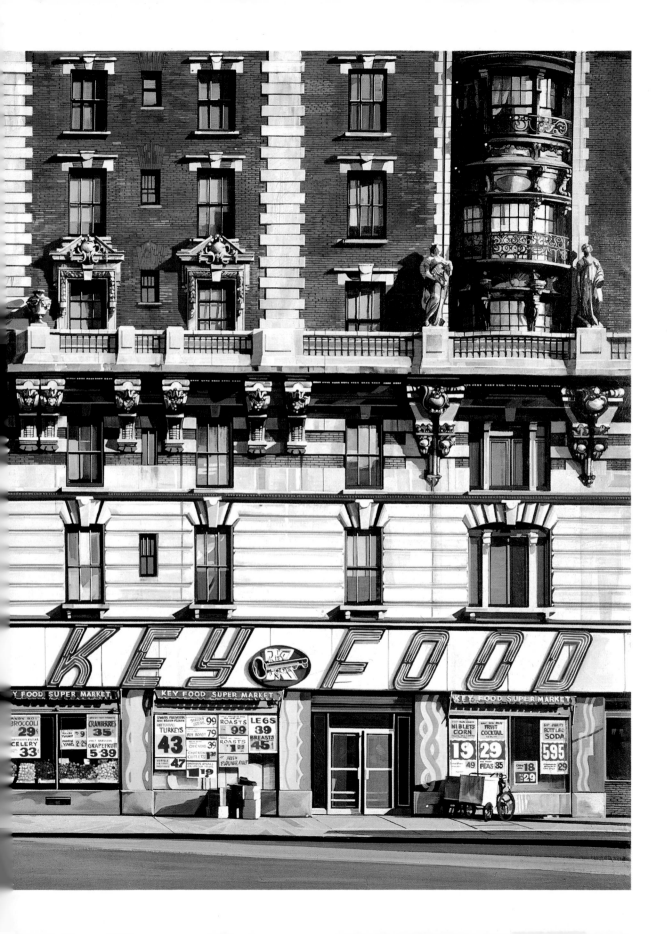

PORTFOLIO I
The paintings illustrated on these two pages were used by the artist as maquettes for
the screenprints in *Urban Landscape Portfolio I.*

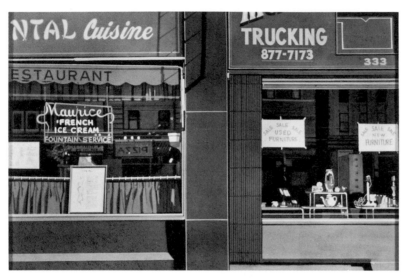

70. *Oriental Restaurant.* 1972. Gouache on board, 13½ x 20½″. Collection Mr. and
Mrs. Robert Saligman

71. *St. Louis Arch.* 1972. Oil on board, 14½ x 24″. Private collection

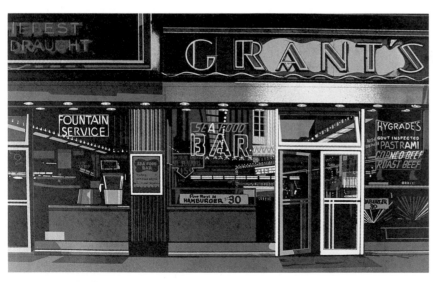

72. *Grant's.* 1972. Oil on board, 13½ x 20¼″. Private collection

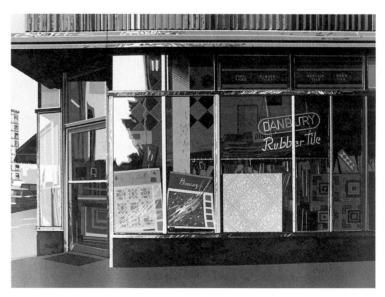

73. *Danbury Rubber Tile.* 1972. Oil on board, 14¾ x 19¾″. Private collection

72

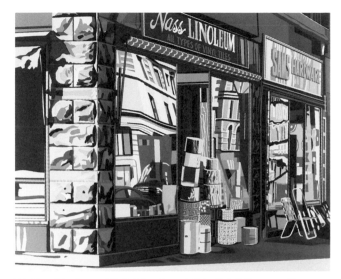

74. *Nass Linoleum*. 1972. Oil on board, 15 x 17¾". Private collection

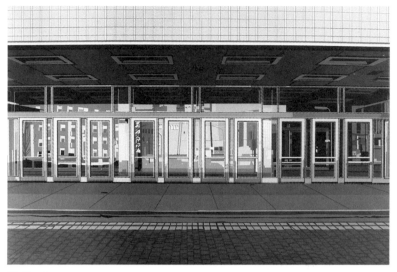

75. *Ten Doors*. 1972. Oil on board, 14½ x 21". Private collection

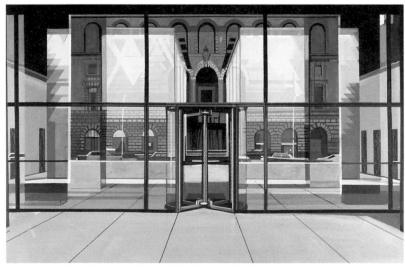

76. *Seagram's*. 1972. Oil on board, 14 x 22". Private collection

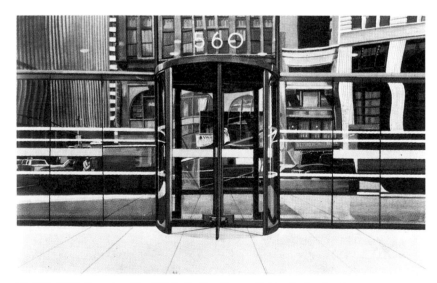

77. *560*. 1972. Gouache, 15 x 23". Collection Marcus Kutter, Switzerland

78. *Valet.* 1972. Oil on canvas, 44 x 68".
Collection Edmund P. Pillsbury, Tex.

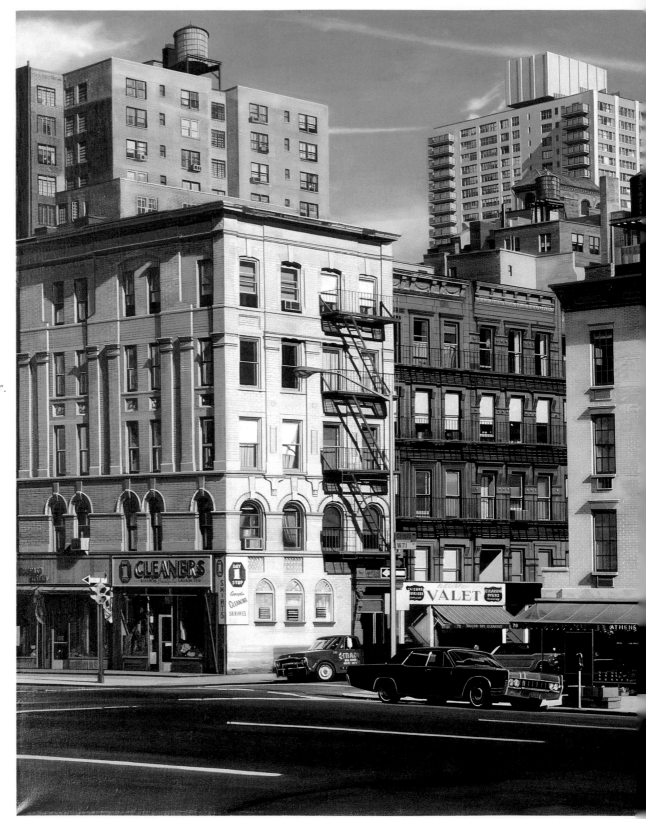

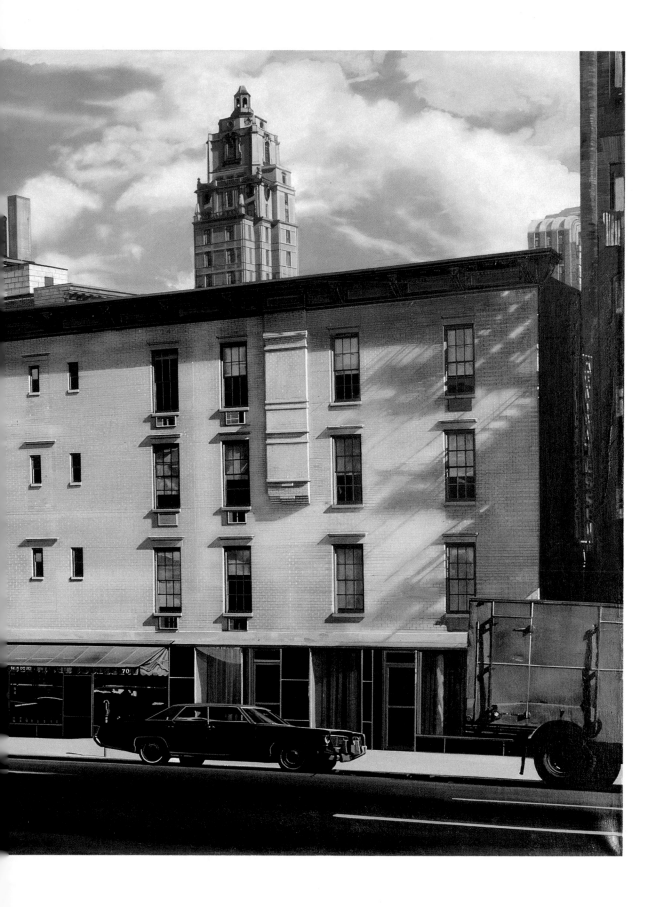

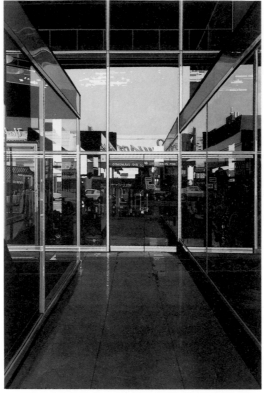

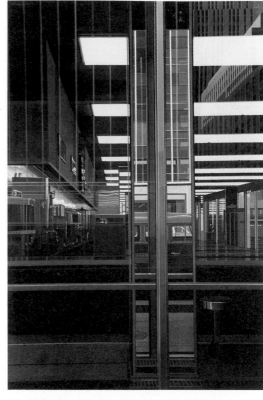

PORTFOLIO II
The paintings illustrated on these two pages were used by the artist as maquettes for the screenprints in *Urban Landscape Portfolio II*.

79. *Big Diamonds*. 1978. Oil on board, c. 19 x 13″. Private collection

80. *.40 Cash*. 1978. Oil on board, c. 20 x 13″. Private collection

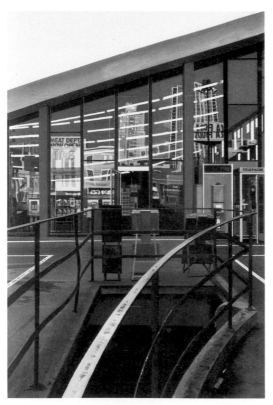

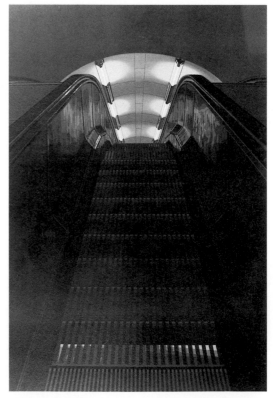

81. *Meat Dept*. 1978. Oil on board, 19 x 13″. Collection Glenn C. Janss

82. *Untitled (Escalator)*. 1978. Oil on board, 19½ x 13″. Private collection

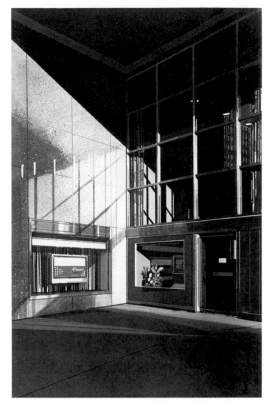

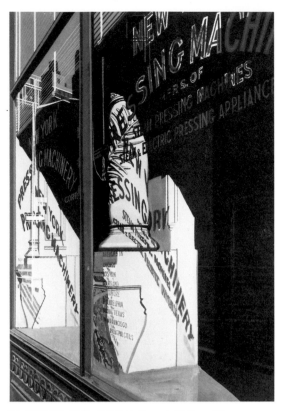

83. *4½% Interest.* 1978. Oil on board, 20 x 13".
Collection Louis K. Meisel Gallery, New York

84. *Pressing.* 1978. Acrylic on board, 19½ x 13".
Collection Pierre Mirabaud, Switzerland

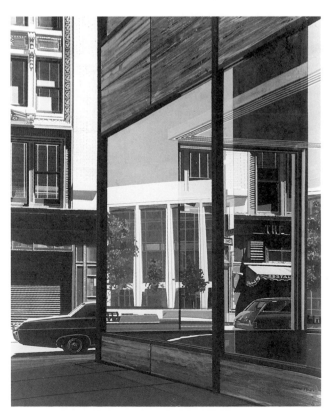

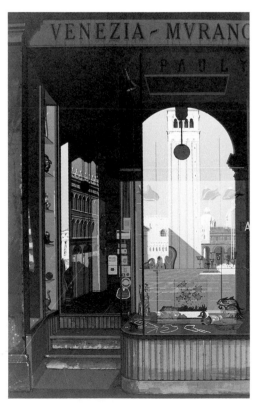

85. *Restaurant near Lincoln Center.* 1978. Acrylic on
board, 18 x 14". Collection Mr. and Mrs. Robert
Rosenberg

86. *Venezia-Murano.* 1978. Oil on board, 20 x 14½".
Private collection

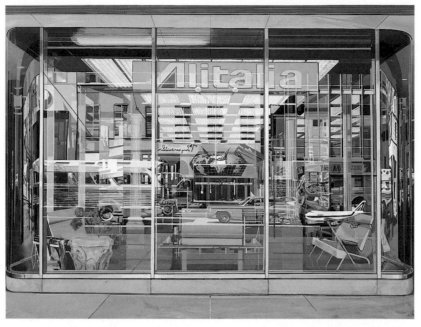

87. *Alitalia*. 1973. Oil on canvas, 30 x 40″. Smithsonian Institution, Washington, D.C. Stuart M. Speiser Collection

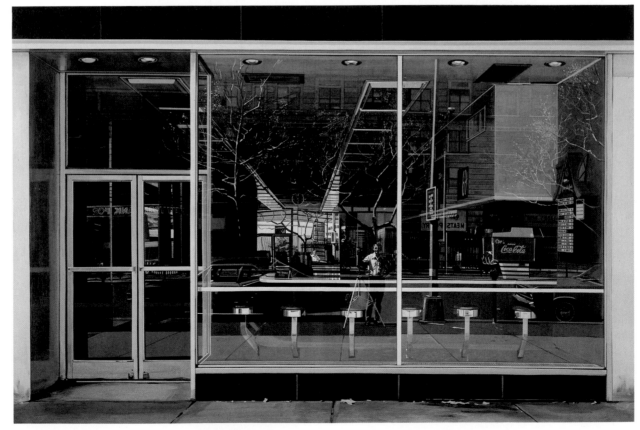

88. *Double Self-Portrait*. 1976. Oil on canvas, 24 x 36″. Museum of Modern Art, New York. Mr. and Mrs. Stuart M. Speiser Fund, 1976

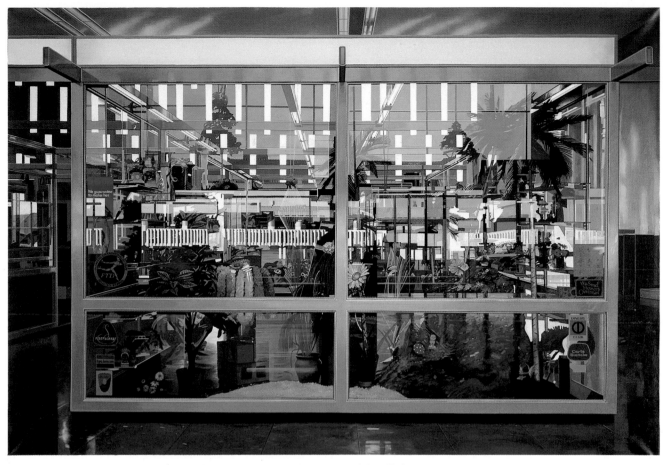

89. *Teleflorist*. 1974. Oil on canvas, 36 x 52″. Collection Louis and Susan Meisel, New York

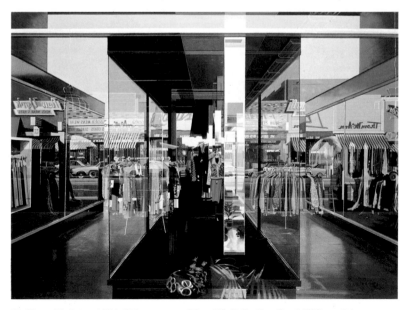

90. *Thom McAn*. c. 1974. Oil on canvas, 36 x 48″. Collection Daniel Filipacchi, New York

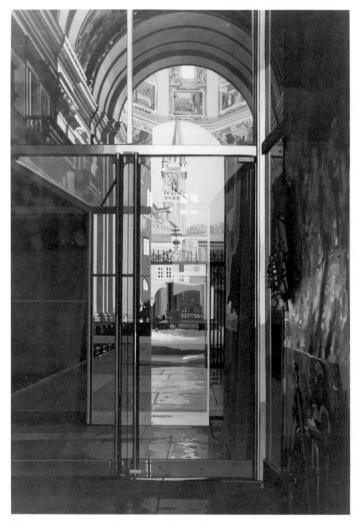

91. *Salisbury.* 1982. Oil on board, 20 x 14½". Private collection

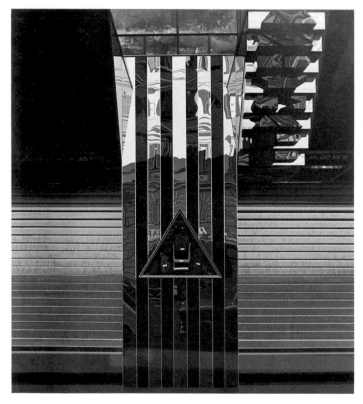

92. *Andy Capp.* 1982. Oil on board, 19½ x 17½". Collection Mr. and Mrs. Charles Herman, Kansas City, Mo.

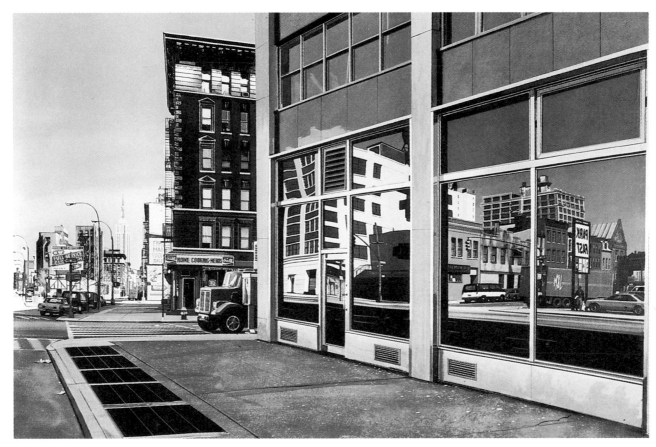

93. *Home Cooking—Heros*. 1983. Oil on canvas, 24 x 36″. Private collection

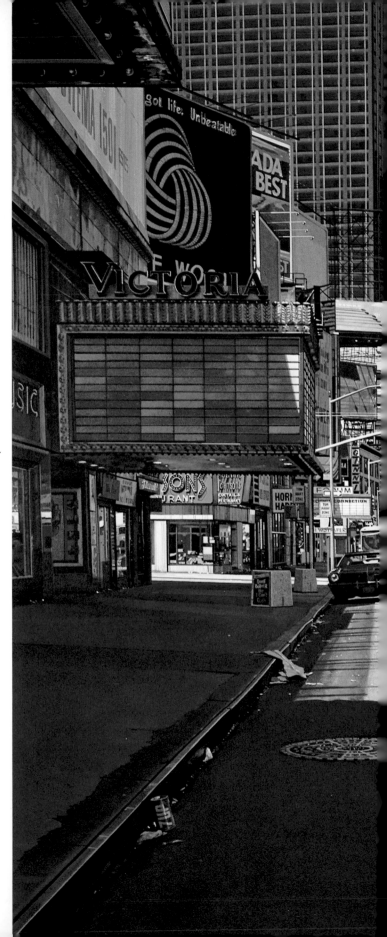

94. *Canadian Club.* 1974. Oil on Masonite, 48 x 60″.
Collection Neumann Family, Ill.

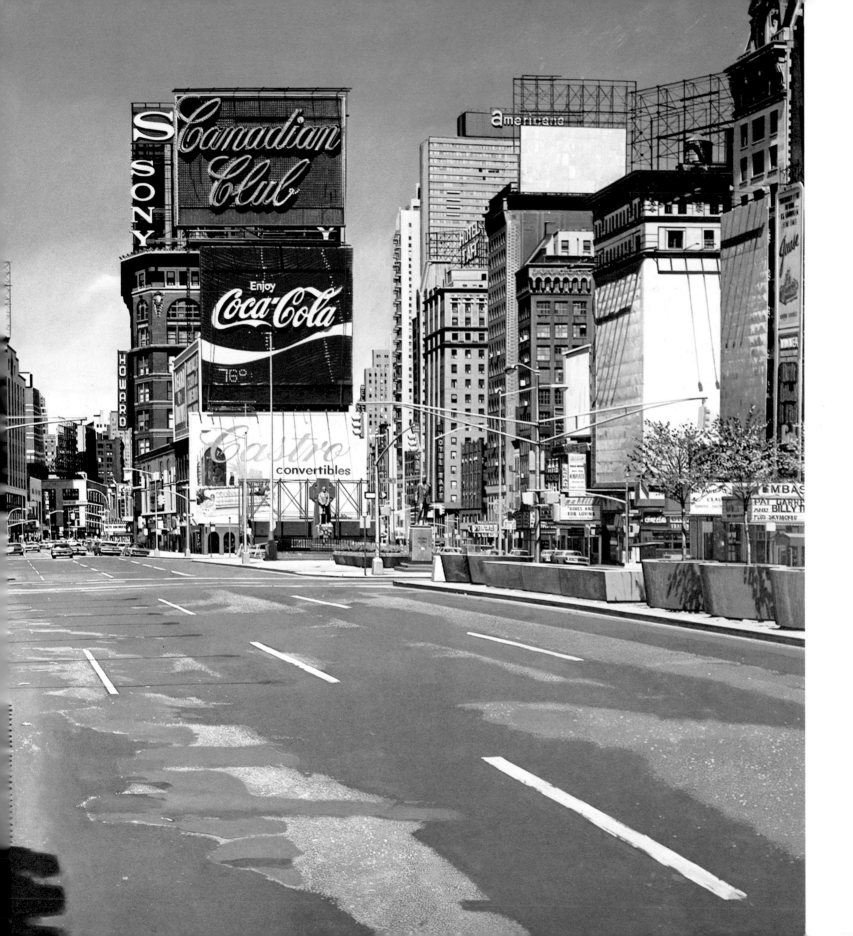

83

95. *General Machinist.* c. 1969. Oil on Masonite, c. 48 x 60″. Private collection

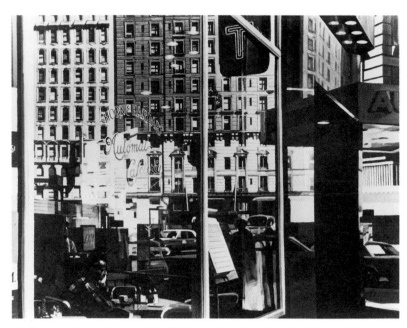

96. *Horn and Hardart Automat.* 1967. Oil on Masonite, 48 x 60″. Collection Mr. and Mrs. Stephen Paine, Mass.

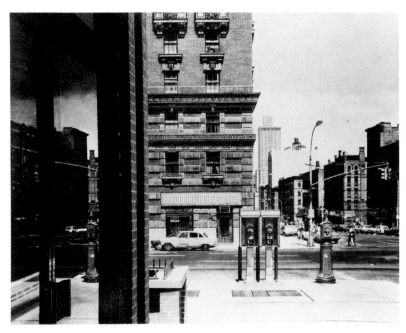

97. *Hotel Lucerne.* **1976.** Oil on canvas, 48 x 60″. H. H. Thyssen-Bornemisza Collection

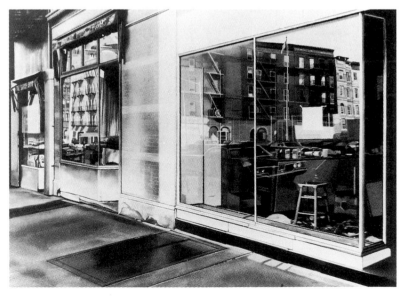

98. *Storefront.* 1971. Oil on canvas, 32⅛ x 44¼″. Sydney and Frances Lewis Foundation, Va.

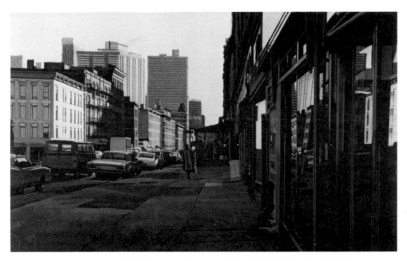

99. *Columbus Avenue.* 1975. Acrylic on board, 12½ x 12½″. Private collection

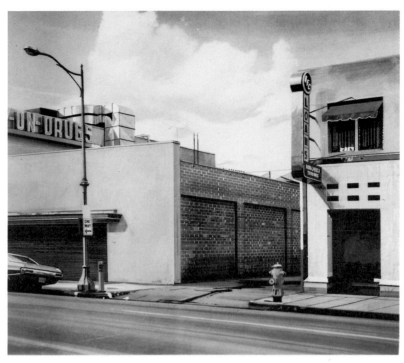

100. *Sav-On-Drugs.* 1973—74. Gouache on board, 16½ x 18¾″. Private collection

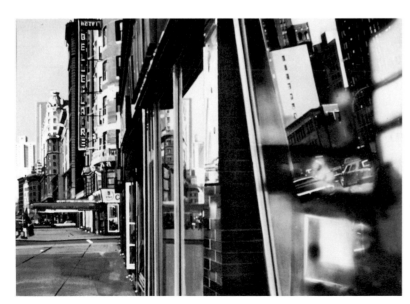

101. *Hotel Belleclaire.* 1974. Oil on board, c. 14 x 20″. Private collection, Paris

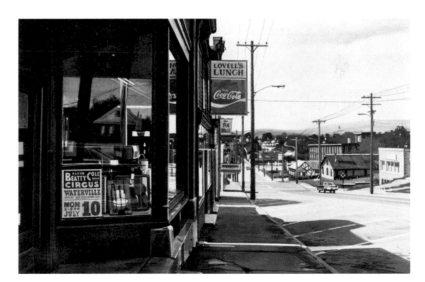

102. *Lovell's Lunch.* 1978. Watercolor, 8¾ x 12¾″. Collection Jose Saenz

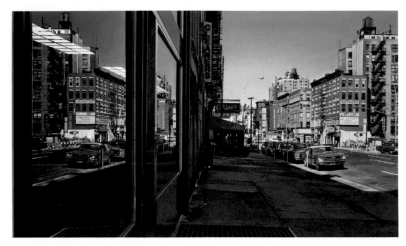

103. *Chipp's.* 1976. Oil on canvas, 27 x 44½". Private collection

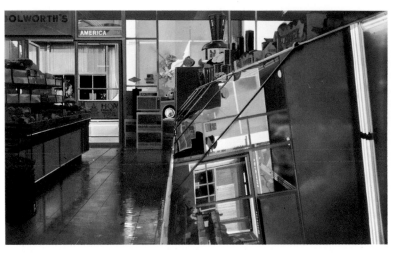

104. *Woolworth's.* 1973. Gouache, 14½ x 23¼". Collection Edmund P. Pillsbury, Tex.

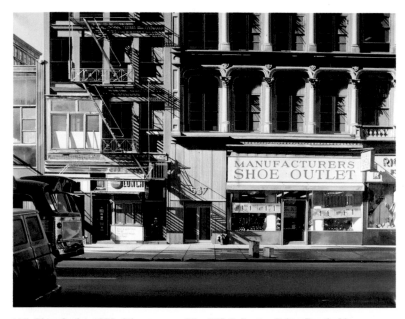

105. *Shoe Outlet.* 1973. Oil on canvas, 28 x 38". Collection Belger Family, Mo.

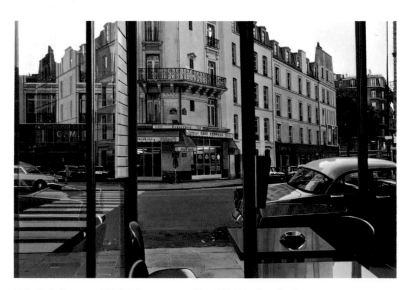

106. *Cafe Express.* 1975. Oil on canvas, 24 x 36". Private collection

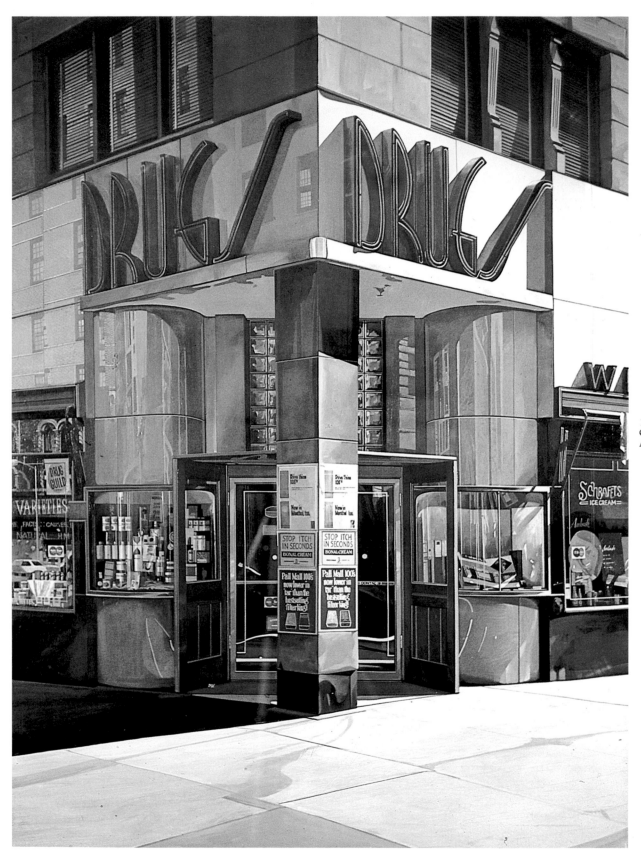

107. *Drugs.* c. 1970.
Oil on canvas, 60 x 44³/₈".
Art Institute of Chicago

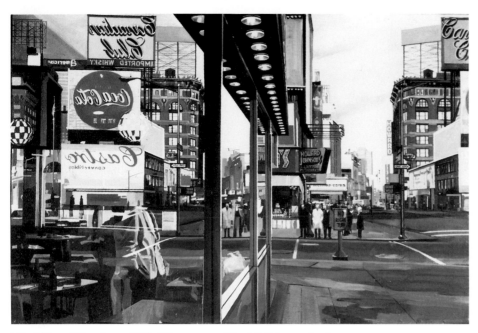

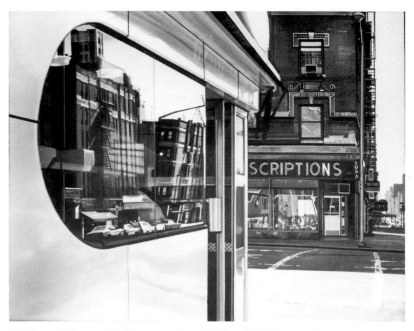

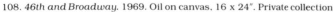

108. *46th and Broadway.* 1969. Oil on canvas, 16 x 24″. Private collection

109. *Prescriptions.* 1974. Gouache on board, 15¼ x 20½″. Private collection

as or better than any artist we've ever seen. He knows and understands all that the old masters knew, but he has today's tools.

Another painting in Estes' personal collection, and one that has never been seen outside his home in Maine, is *View of 34th Street from Eighth Avenue* (fig. 1). The largest work he has ever painted, it was done just prior to the beginning of his "panorama" series.

PANORAMAS

The earliest forerunner to what I call the "panoramas" is *Canadian Club* (fig. 94), painted in 1974. It is not quite as wide angled as the mature images in the panorama series, but the concept was definitely born with this painting.

Five years later, *The Solomon R. Guggenheim Museum* (fig. 145) became the first real panorama and led to the beautiful and exhilarating work of the eighties. The idea for this painting was born in the spring of 1979, when

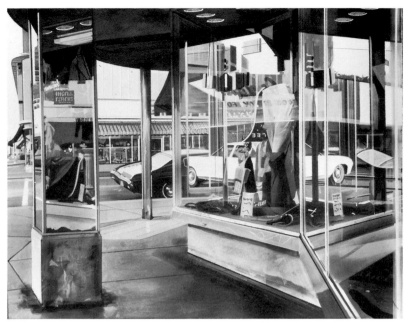

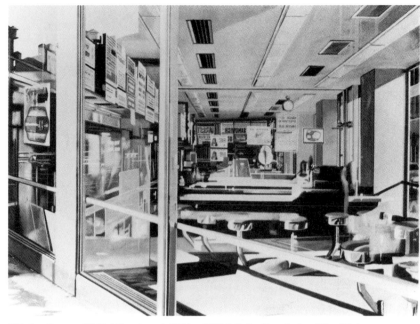

110. *Lee.* 1974. Oil on board, 16 x 19½". Collection Louis K. Miesel Gallery, New York

111. *Ice Cream.* 1976. Oil on board, 13½ x 17⅜". Collection Joel and Zoe Dictrow

Thomas Messer, director of the Guggenheim, and I were sitting with Estes in his studio. Looking out the tenth-floor window across Central Park at the museum, we discussed ways in which the Guggenheim might acquire an Estes painting, and somehow the idea evolved of there being a painting of the museum.

When it was completed later that year, the painting was atypical of Estes' work at the time, but it was also magnificently beautiful. To create it, the artist had to stretch for ideas and to push his photographic skills and equipment beyond anything he had done before. It meant using new lenses, solving new problems of perspective and distortion. The proportions of the painting, with the width being roughly twice the height, created totally new compositional challenges. The proportions are even more extreme in later paintings: in *Teddy's* (fig. 152), done in 1982, and *Union Square* (fig. 160), painted three years later, the width-to-height ratio is even greater than two to one.

Union Square, in particular, is closest to the true panoramic images taken by photographers using circuit cameras in the teens, twenties, and

Continued on page 98

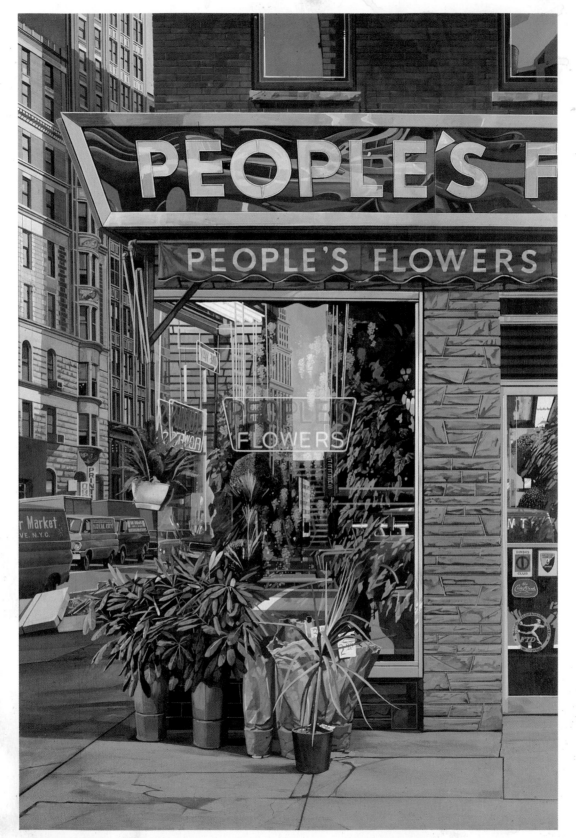

112. *People's Flowers*. 1971. Oil on canvas, 60 x 40". H. H. Thyssen-Bornemisza Collection

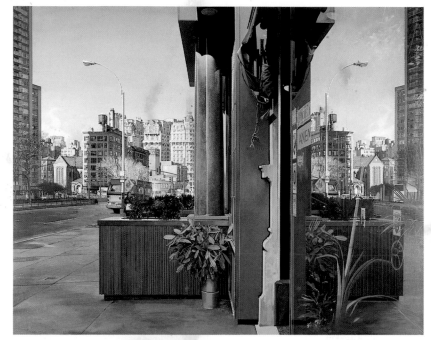

113. *Ansonia.* 1977. Oil on canvas, 48 x 60".
Whitney Museum of American Art, New York.
Gift of Sydney and Frances Lewis Foundation

114. *Bus Reflections
(Ansonia).* 1972.
Oil on canvas, 40 x 52".
Private collection

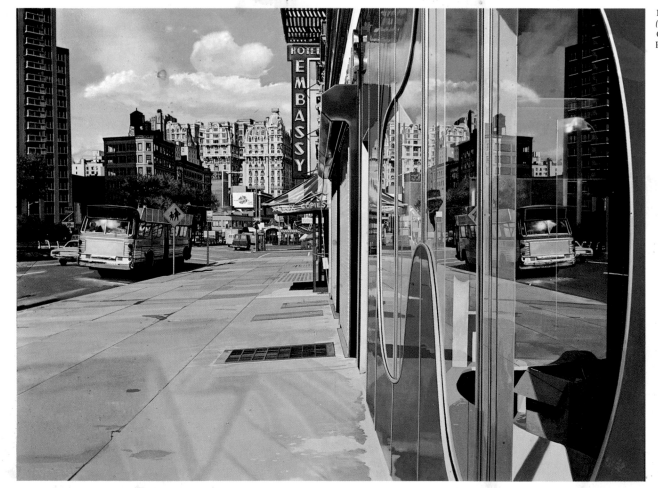

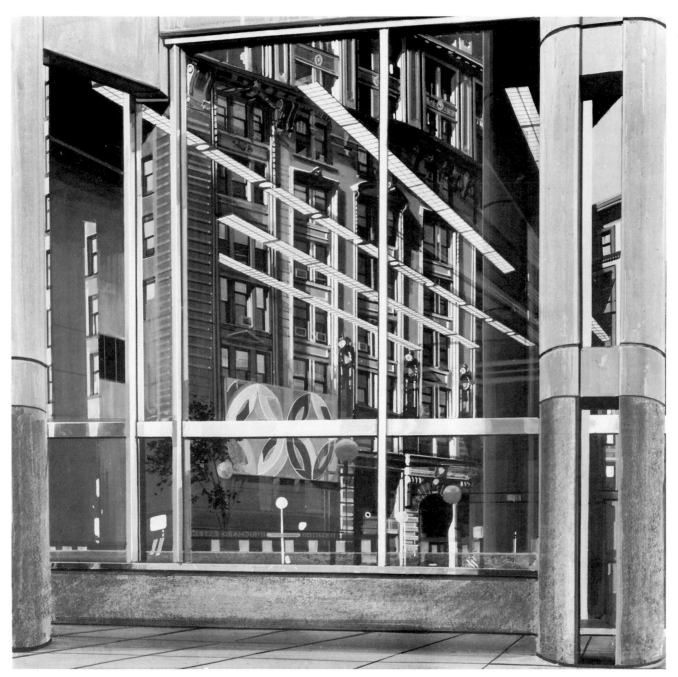

115. *Boston Bank Building*, 1974. Gouache, 16½ x 16½". Collection Mr. and Mrs. Barry Hirschfeld. Colo.

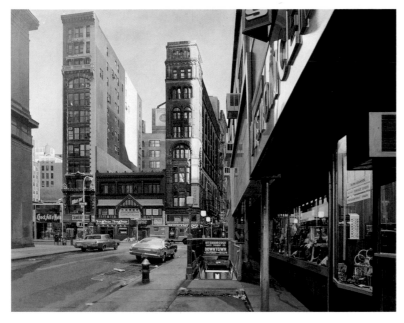

116. *Downtown.* 1978. Oil on canvas, 48 x 60". Neue Galerie der Stadt Aachen, Aachen, West Germany. Ludwig Collection

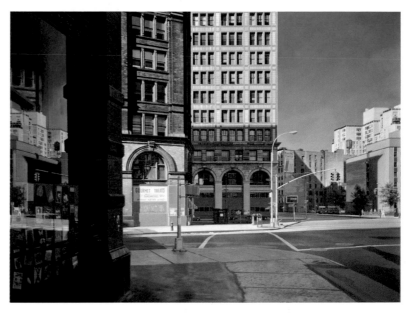

117. *Gourmet Treats.* 1977. Oil on canvas, 36 x 48". Sydney and Frances Lewis Foundation, Va.

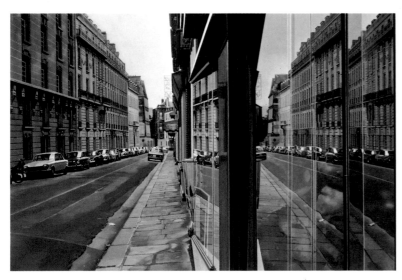

118. *Paris Street Scene.* 1972. Oil on canvas, 40 x 60". Sydney and Frances Lewis Foundation, Va.

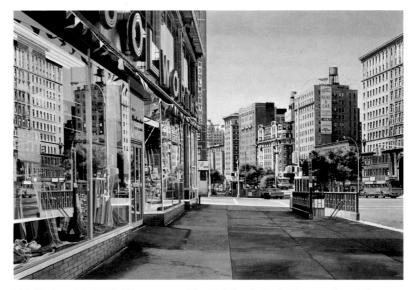

119. *Woolworth's.* 1974. Oil on canvas, 38 x 55". San Antonio Museum Association

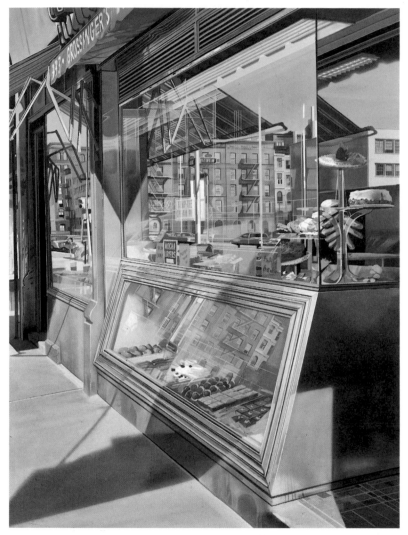

120. *Grossinger's.* c. 1970. Oil on canvas, 36 x 24″. Private collection

121. *American Express Downtown.* 1979. Oil on canvas, 24 x 36″. Private collection

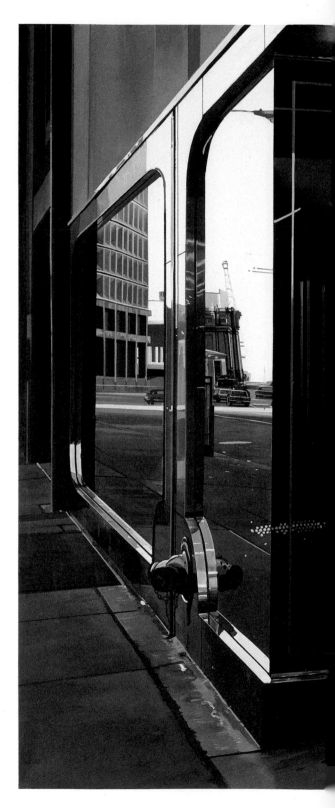

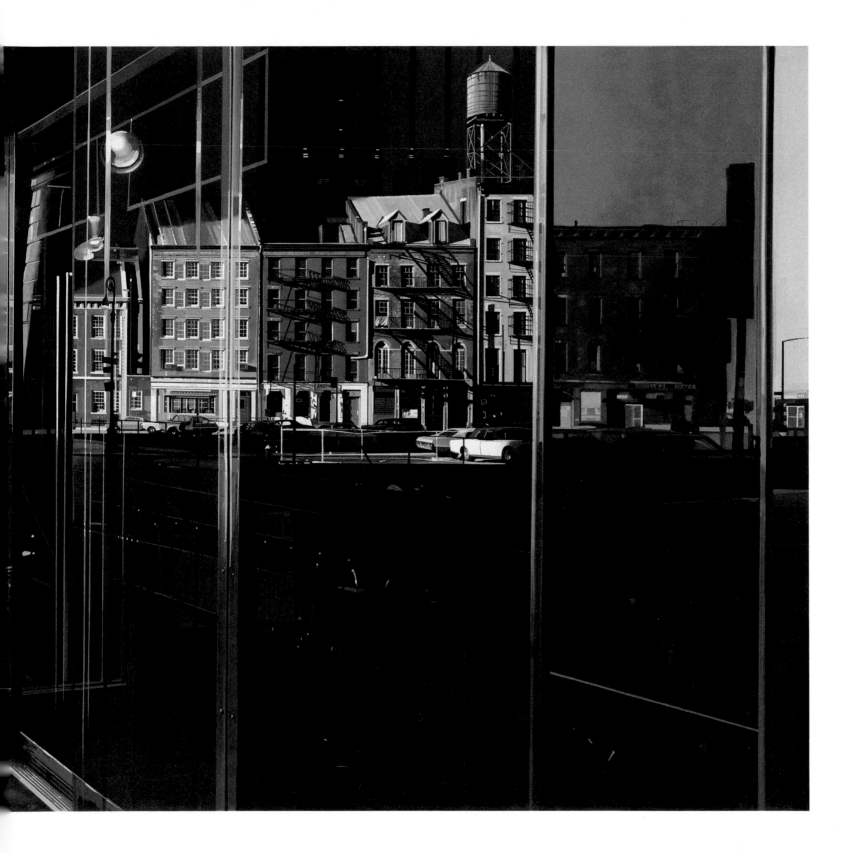

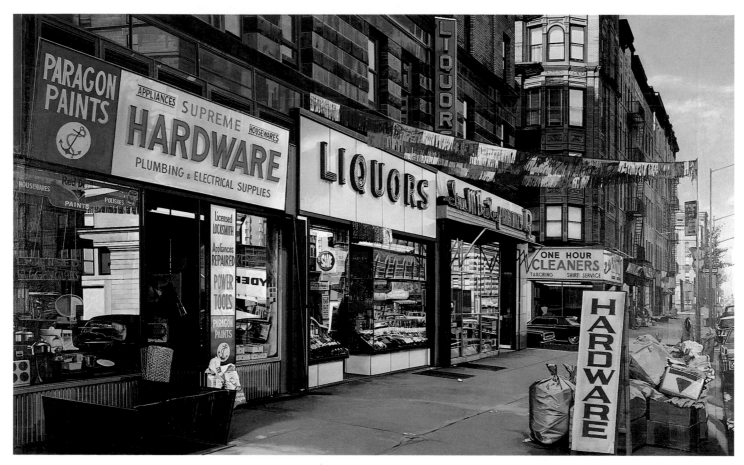

122. *Supreme Hardware*. 1974. Oil on canvas, 39 x 66″. High Museum of Art, Atlanta

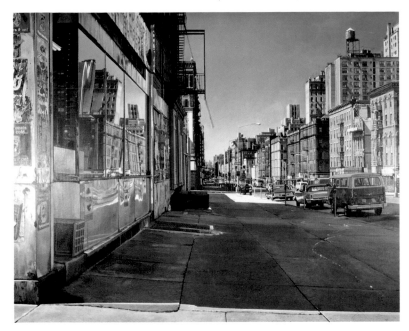

123. *Columbus Avenue at 90th Street.* 1974. Oil on canvas, 48 x 60″. Private collection

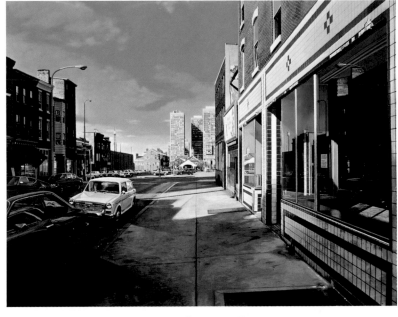

124. *B & O.* 1975. Oil on canvas, 48 x 60″. Private collection

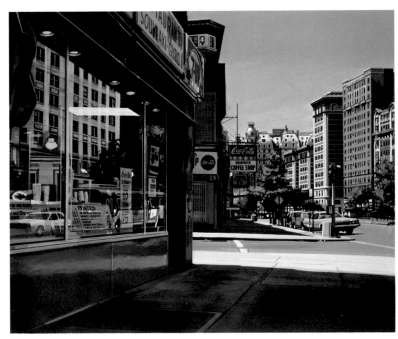

125. *Harvey's Coffee Shop.* 1976. Oil on board, 19½ x 25½″. Collection Michael Haber, New York

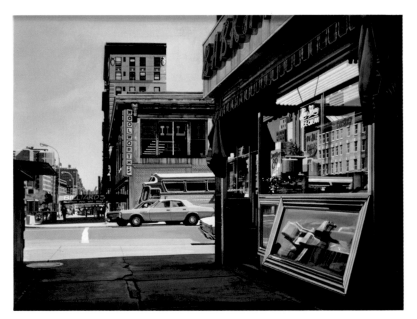

126. *Billiards.* 1976. Gouache on board, 19⅝ x 25⅜″. Private collection

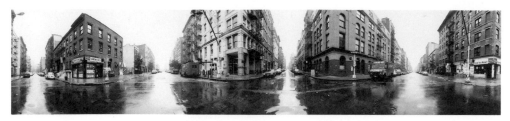

127. Kenneth Snelson. *Prince and West Broadway.* 1980. Panoramic photograph

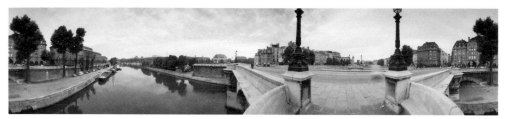

128. Kenneth Snelson. *Paris; Pont Neuf with Ile de la Cité.* 1985. Panoramic photograph

thirties; it is from these photographs that I have taken the name for this series. A contemporary artist, Ken Snelson, collects such early cameras and is producing panoramic photographs today (compare fig. 127 with figs. 129, 152, 157, 158, and 160; and fig. 128 with figs. 139–41). *Union Square* is probably a harbinger of things to come, but as this book goes to press, it and *View of Paris* (fig. 141) are the only examples of such close correspondence to the classic panoramic photograph.

While Snelson has the cameras to take a single panoramic photo, Estes must shoot a series of wide-angle shots and then, through drawing and optical adjustments, make a believable painting. No artist is better at this than Estes, and few are even willing to attempt it. It seems likely that Estes will spend the next years focusing on the challenge of this series and that his best work is yet to come.

Since Estes is only fifty-four, the rich period of his artistic life covered in this volume may represent only his formative years. In the visual arts, it seems the rule that an artist's best and most mature work is generally created between the ages of forty-five and sixty-five—despite some delusions to the contrary in the fad- and fashion-ridden art world of the eighties.

One of the best and most significant artists working today, Richard Estes has never wasted a moment being a "famous artist," celebrity, superstar, or publicity seeker. Nor does he paint for financial reasons; he paints because he must. Painting is when he is happiest. All the rest will come.

98

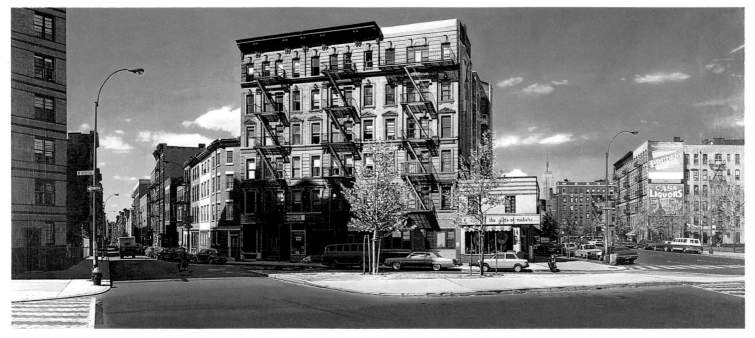

129. *Gifts of Nature*. 1978. Oil on canvas, 36 x 80¾″. Private collection

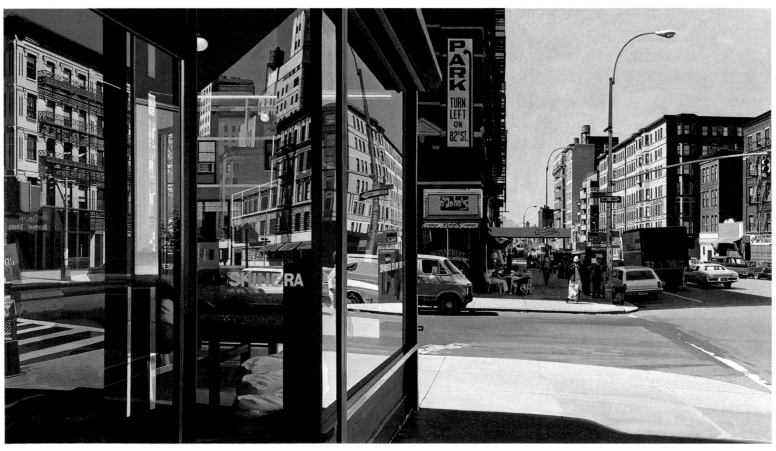

130. *Oenophilia*. 1983. Oil on canvas, 24 x 42″. Private collection

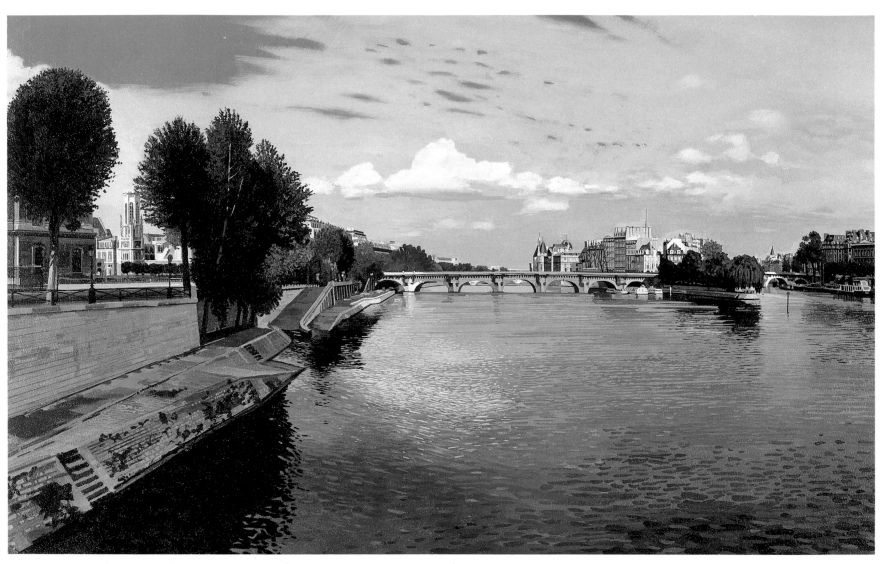

139. *View of the Pont Neuf, Paris.* 1985. Oil on canvas, 17 x 27½". Collection the artist

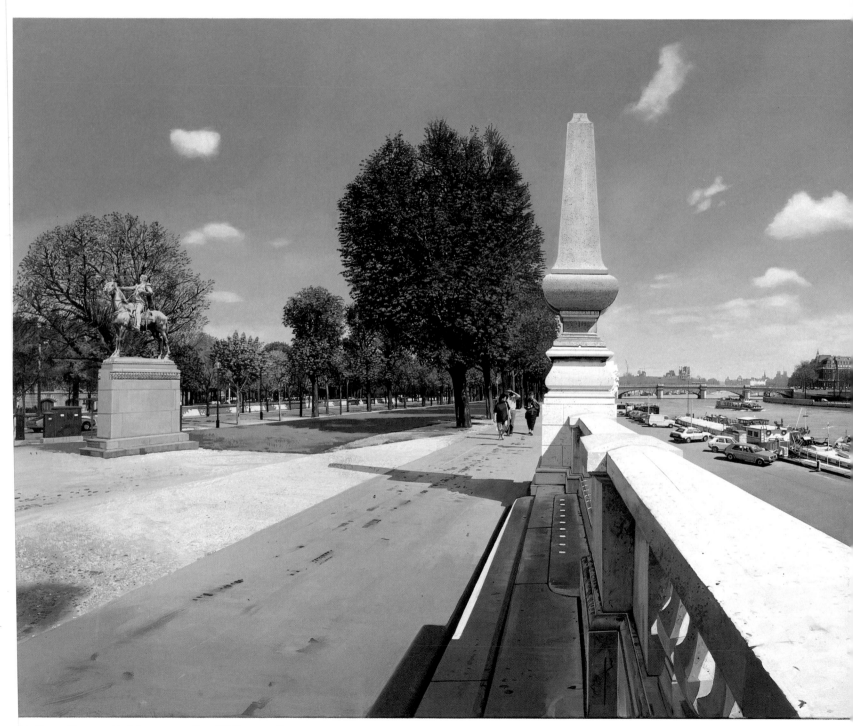

41. *View of Paris.* 1986. Oil on canvas, 36 x 89″. Private collection

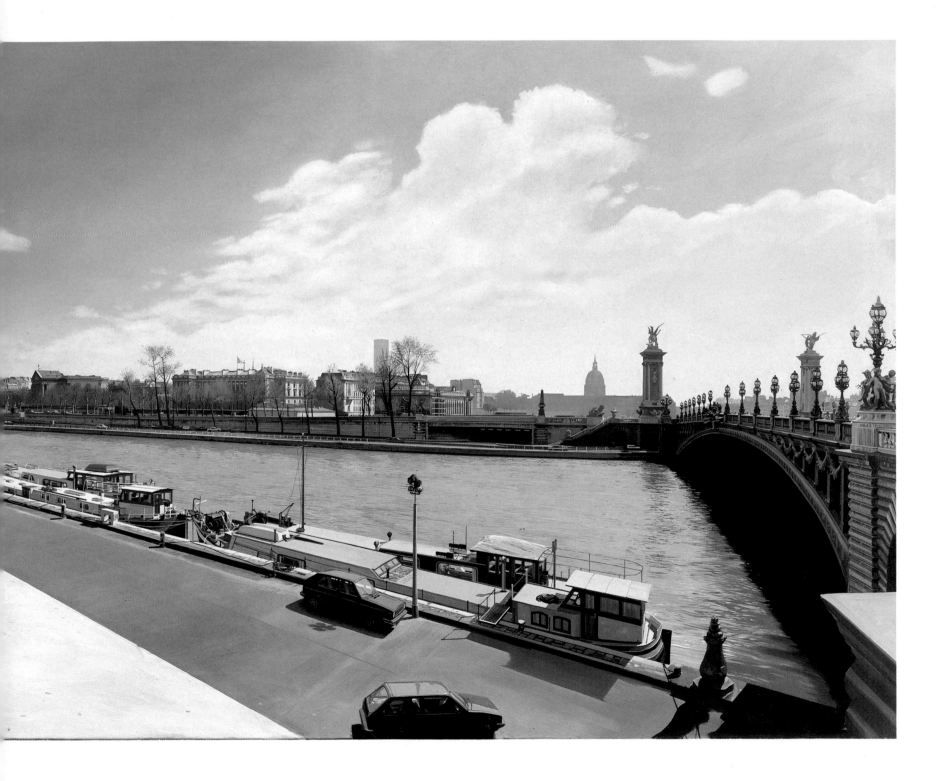

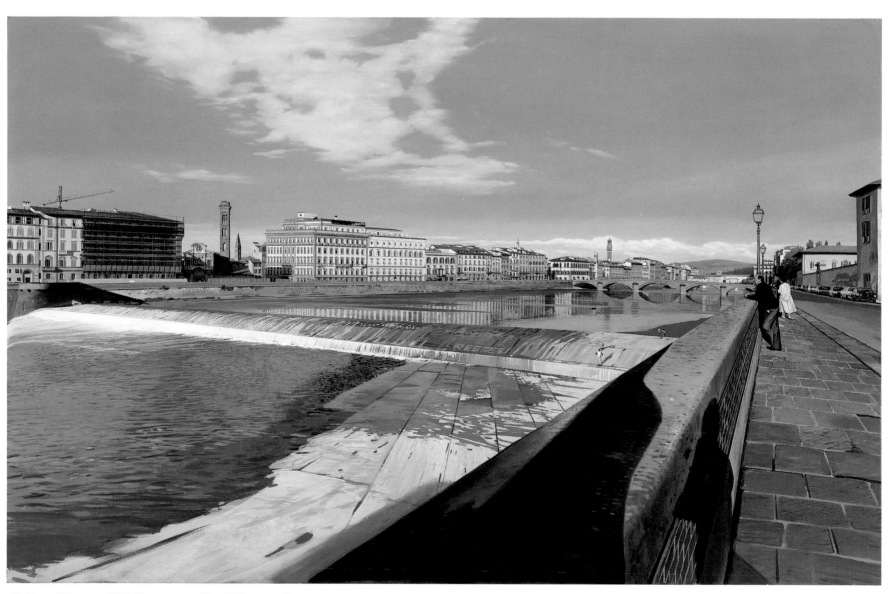

142. *View of Florence*. 1985. Oil on canvas, 30 x 46″. Private collection

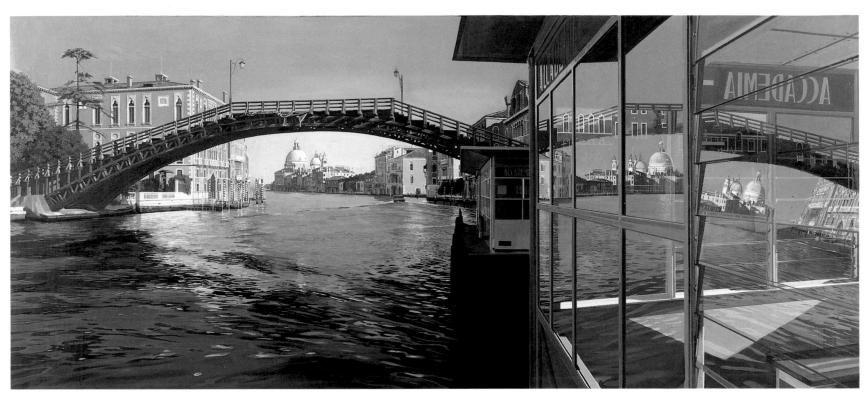

143. *Accademia*. c. 1980. Oil on canvas, 24 x 49½″. Collection the artist

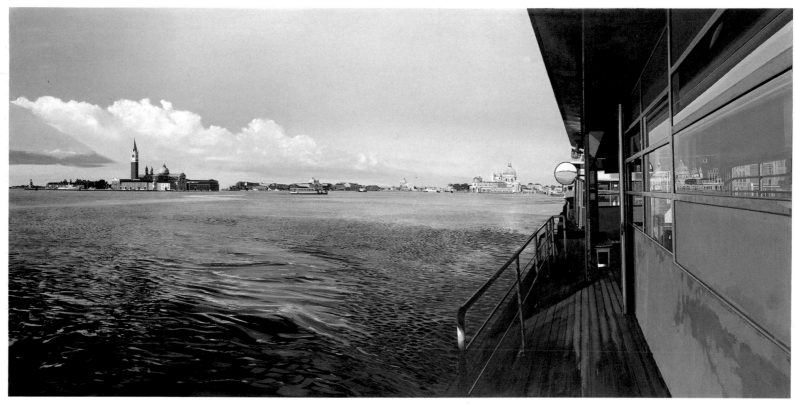

144. *View toward La Salute, Venice.* 1980. Oil on canvas, 36 x 72". Collection the artist

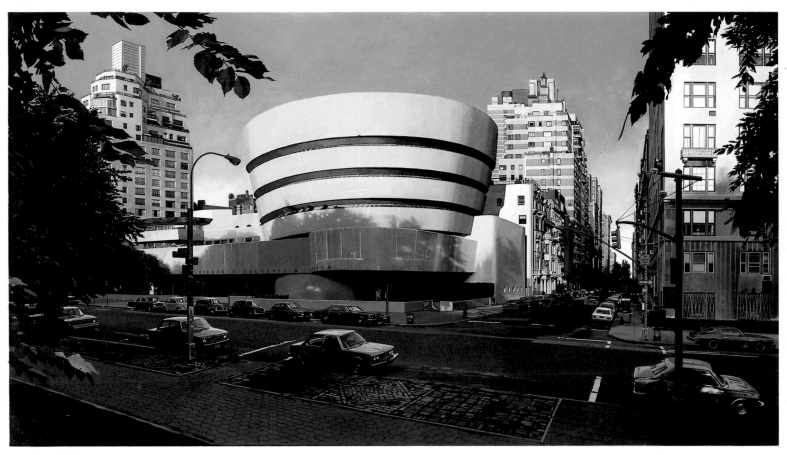

145. *The Solomon R. Guggenheim Museum.* 1979. Oil on canvas, 31 1/8 x 55 1/8". Solomon R. Guggenheim Museum, New York

146. *Baby Doll Lounge*. 1978. Oil on canvas, 36 x 60". Collection Mr. H. Christopher J. Brumder

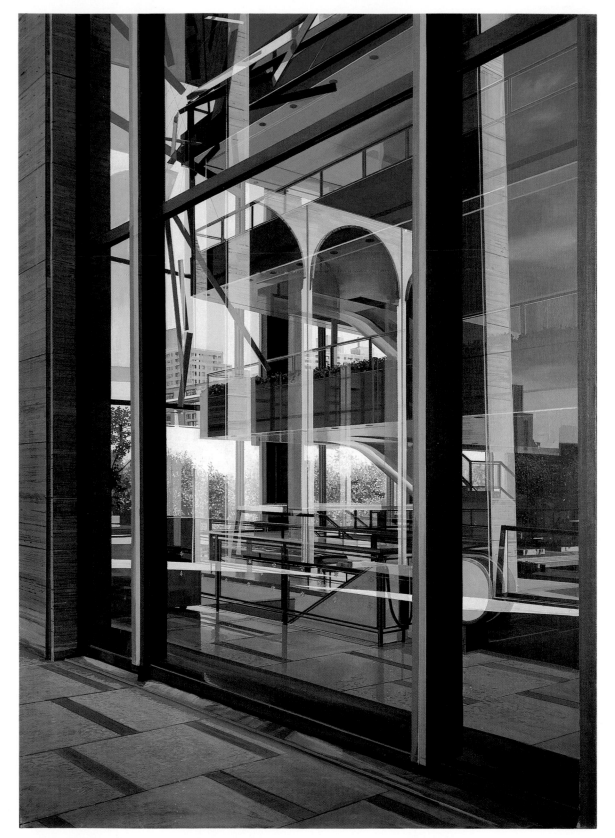

147. *Opera*. 1983. Oil on canvas, 48 x 34″. Private collection

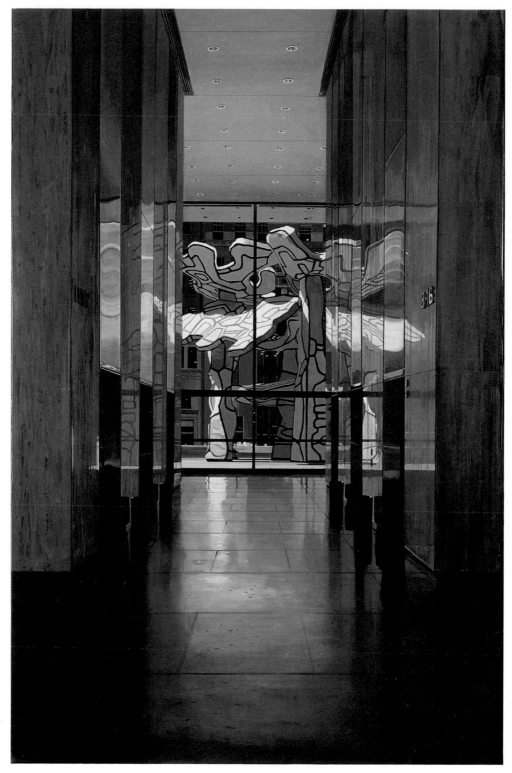

148. *Chase Manhattan.* 1981. Oil on canvas, 28 x 18″. Private collection

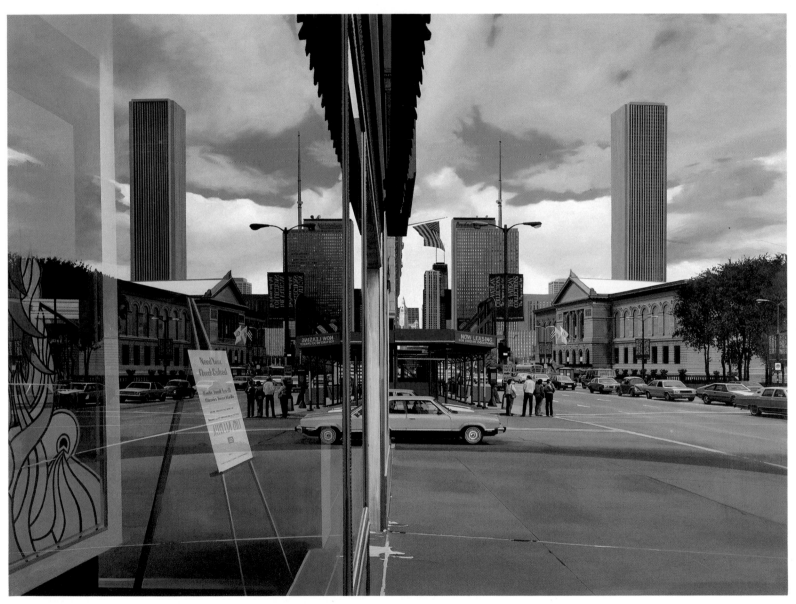

149. *Art Institute of Chicago.* 1984. Oil on canvas, 36 x 48". Art Institute of Chicago

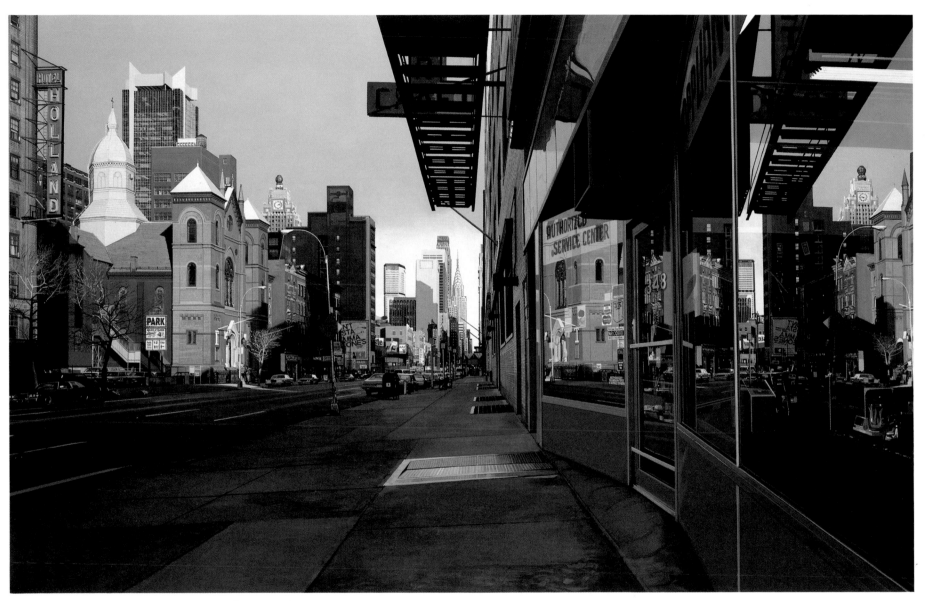

150. *Holland Hotel.* 1984. Oil on canvas, 45 x 72½". Private collection

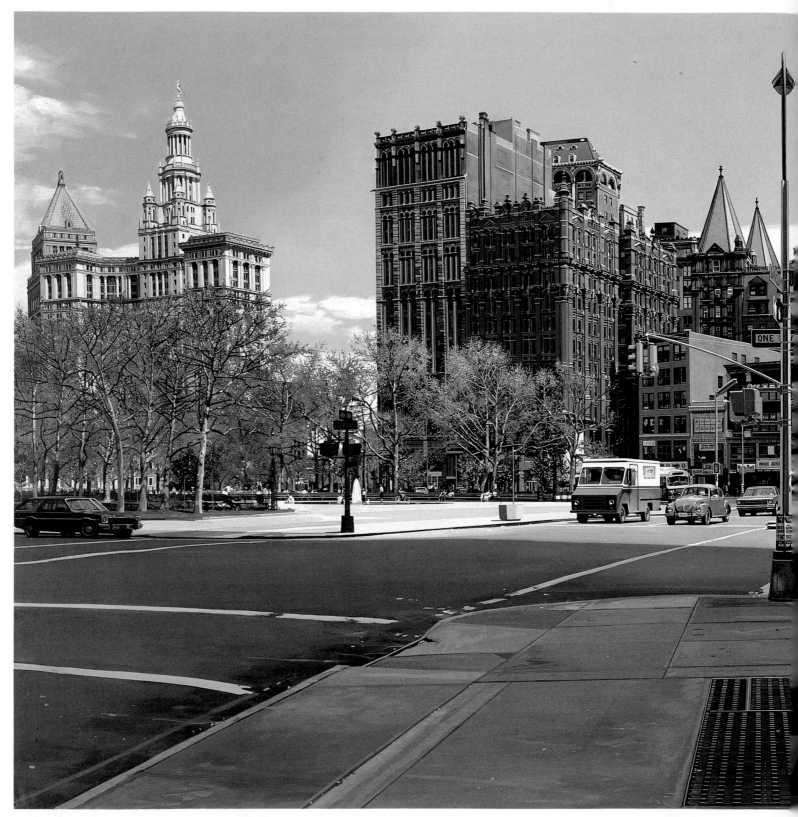

151. *Prescriptions Filled (Municipal Building).* 1983. Oil on canvas, 36 x 72". Private collection

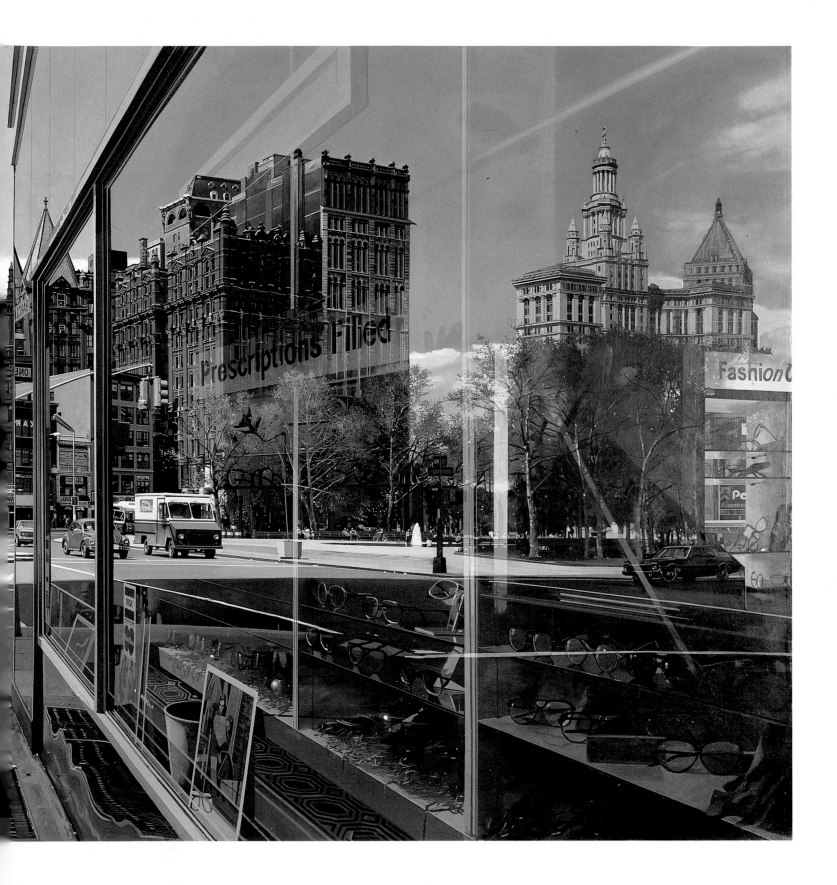

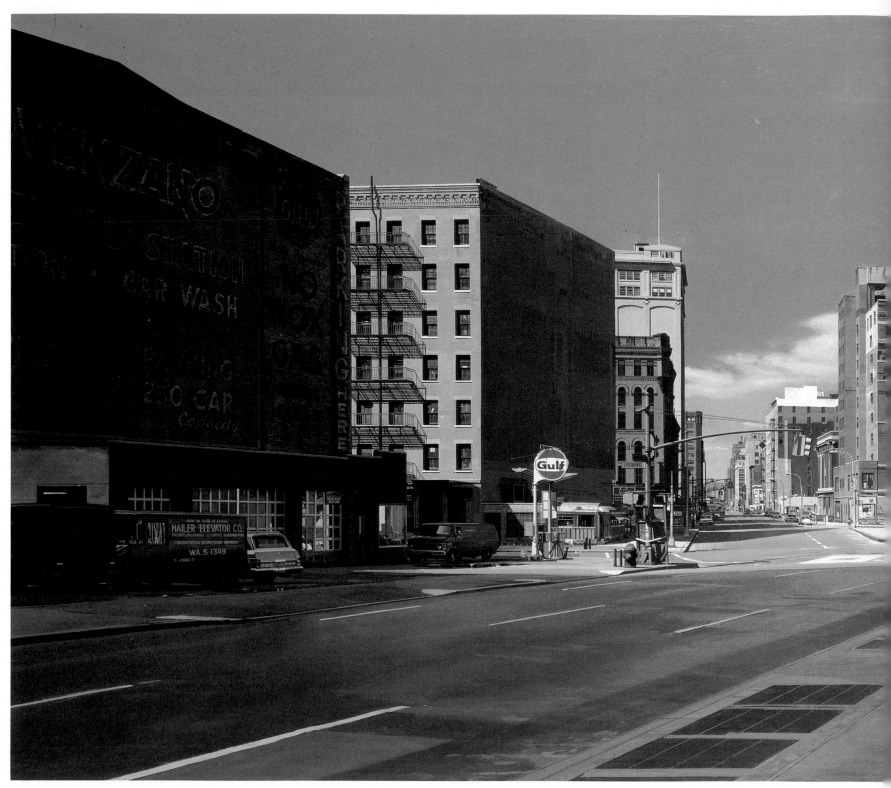

152. *Teddy's.* 1982. Oil on canvas, 38 x 88". Private collection

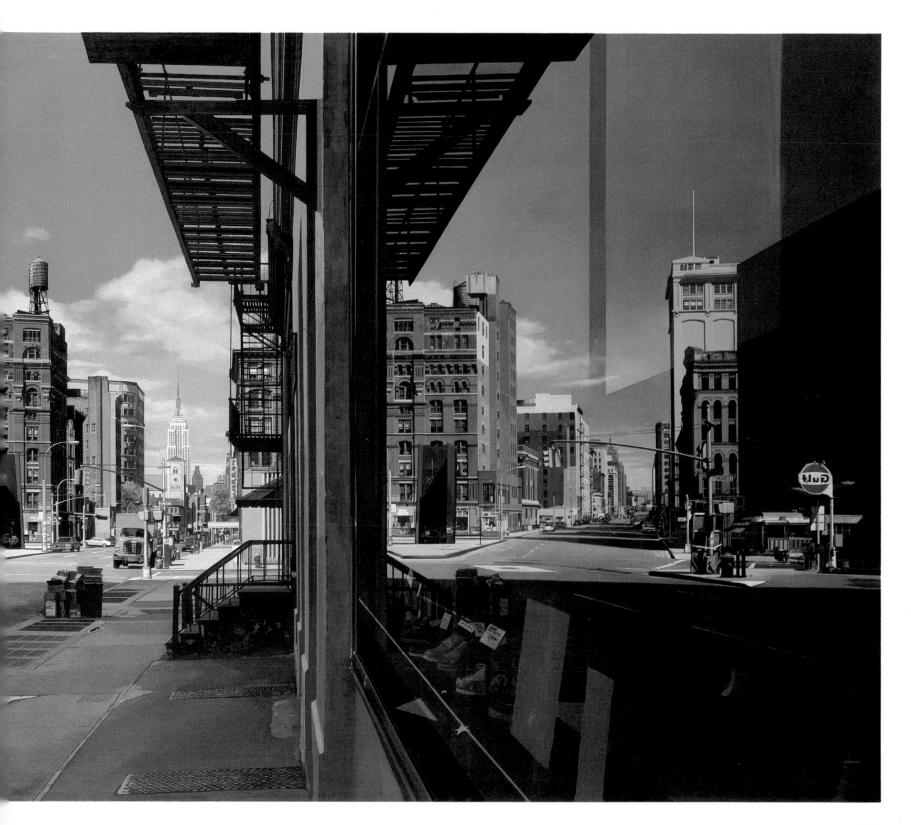

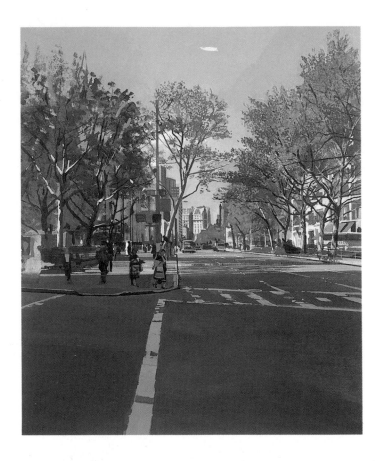

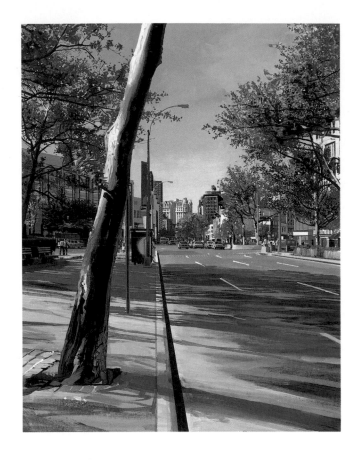

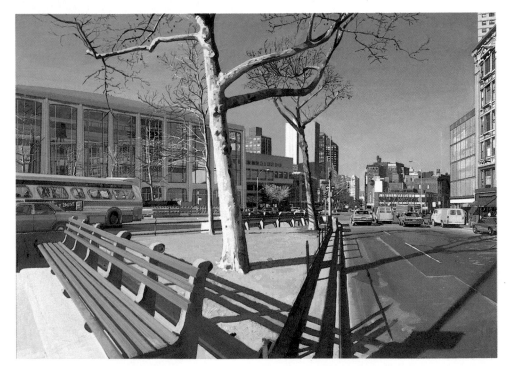

above left: 153. *Study for Broadway at Lincoln Center*. 1983. Gouache on board, 19½ x 16″. Collection Pieper Powers Company

above right: 154. *Broadway at Lincoln Center No. 1*. 1983–85. Acrylic on board, 23 x 18″. Collection Louis and Susan Meisel, New York

left: 155. *Broadway at Lincoln Center No. 2*. 1983. Acrylic on board, 17 x 22″. Collection Louis and Susan Meisel, New York

opposite: 156. *Broadway and 64th, Spring '84*. 1984. Oil on canvas, 40 x 72″. Collection Martin Z. Margulies, Miami

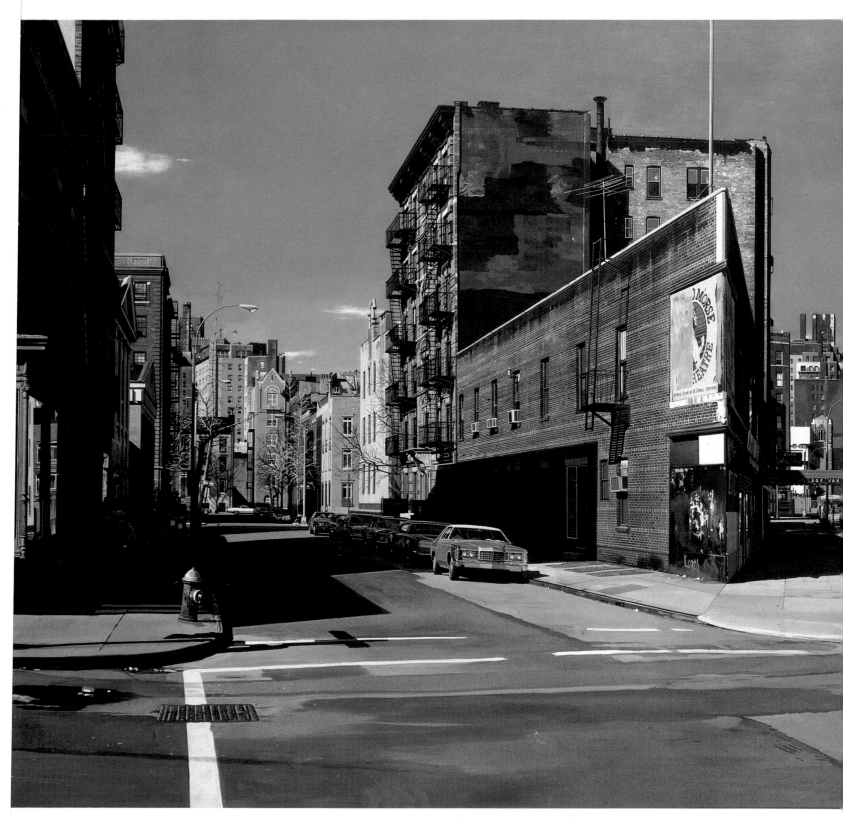

Waverly Place. 1980. Oil on canvas, 48 x 84″. Hirshhorn Museum and Sculpture Garden, Smithsonian Institution, Washington, D.C.

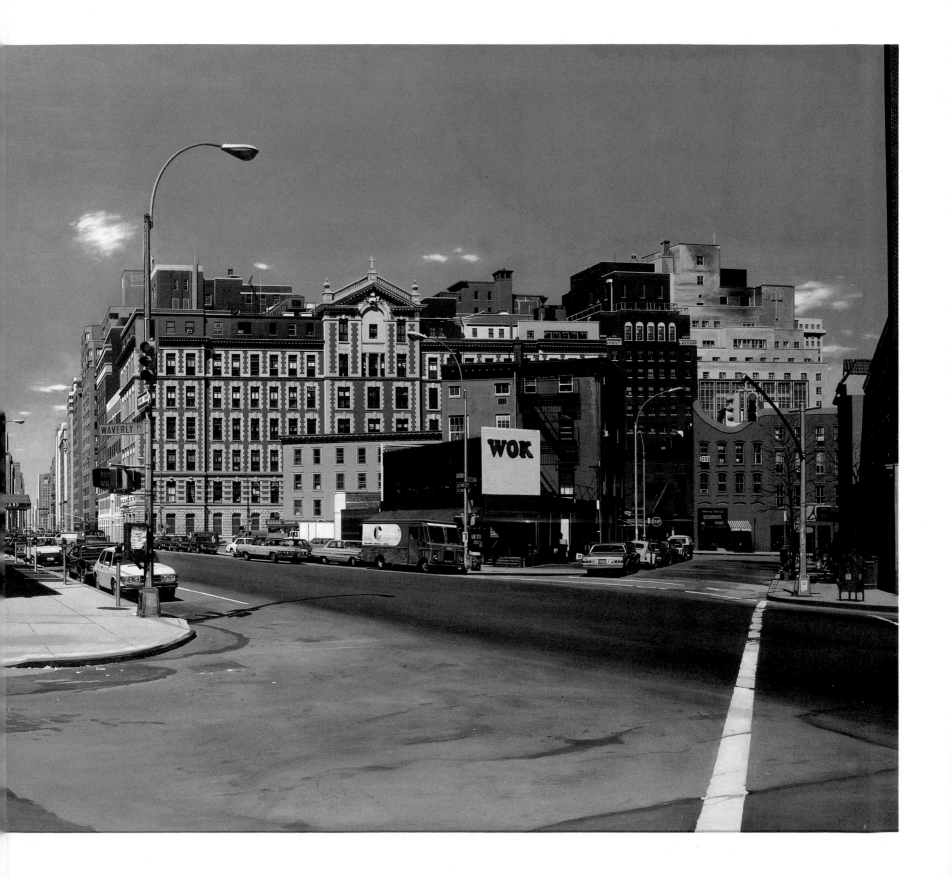

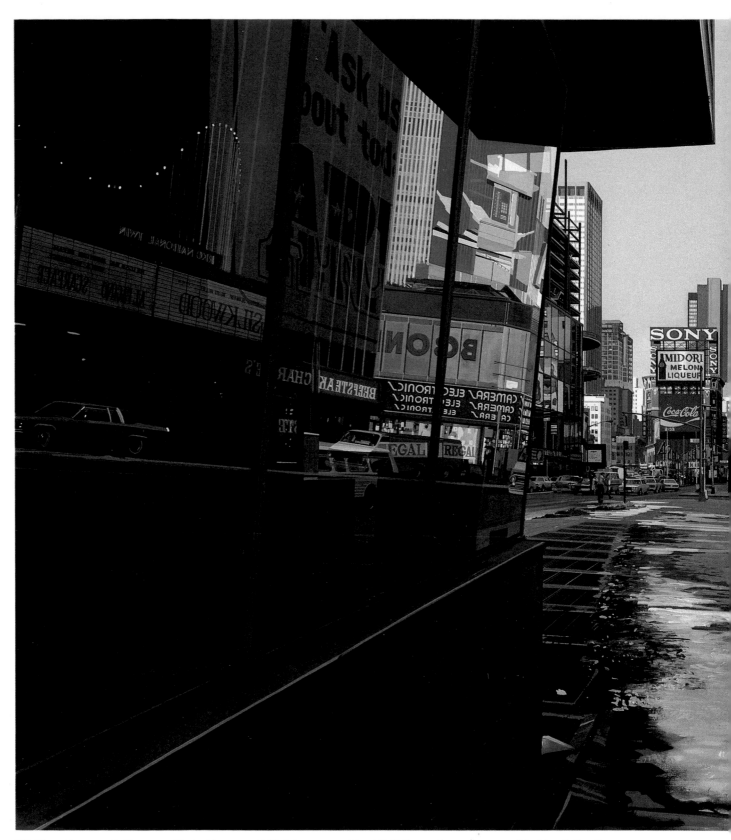

159. *Times Square at 3:53 P.M. on a Winter Afternoon*. 1985. Oil on canvas, 27 x 49". Collection Louis, Susan, and Ari Meisel, New York

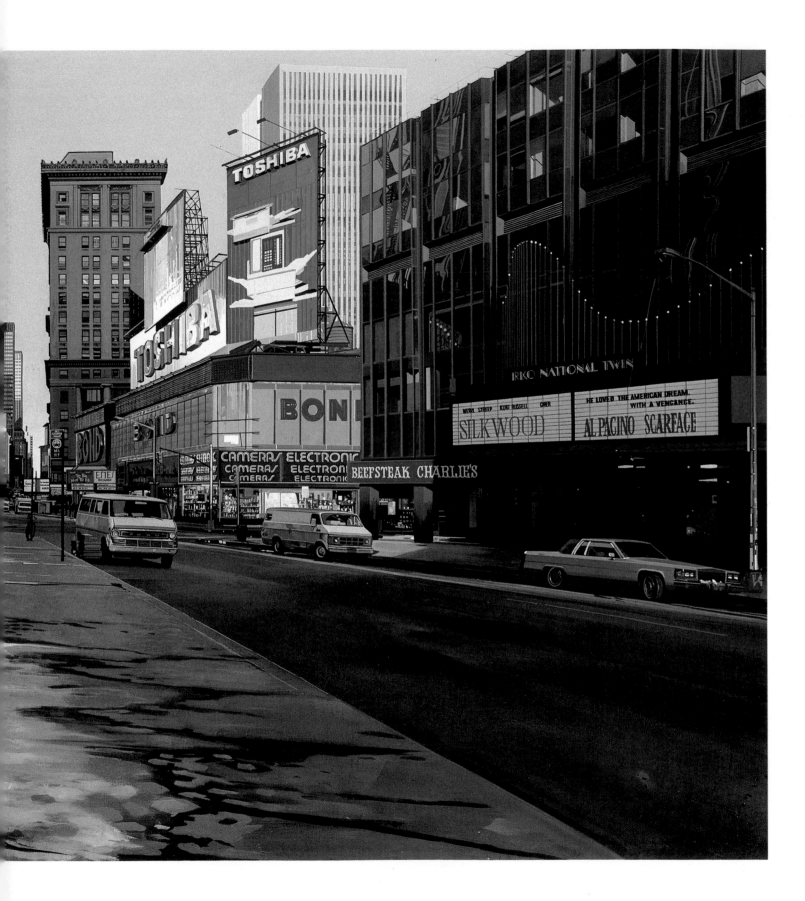

161. *McDonald's.* 1981. Oil on canvas, 34 x 55″. Private collection

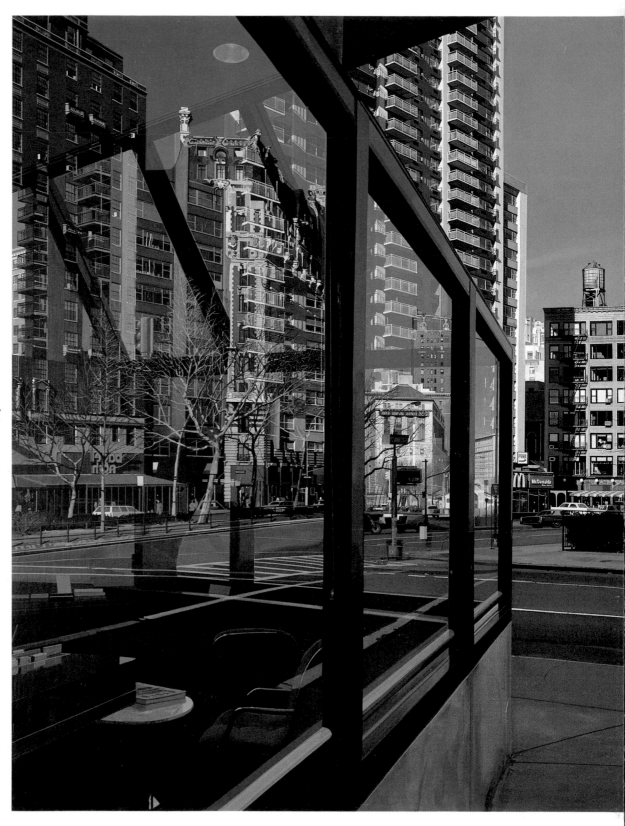

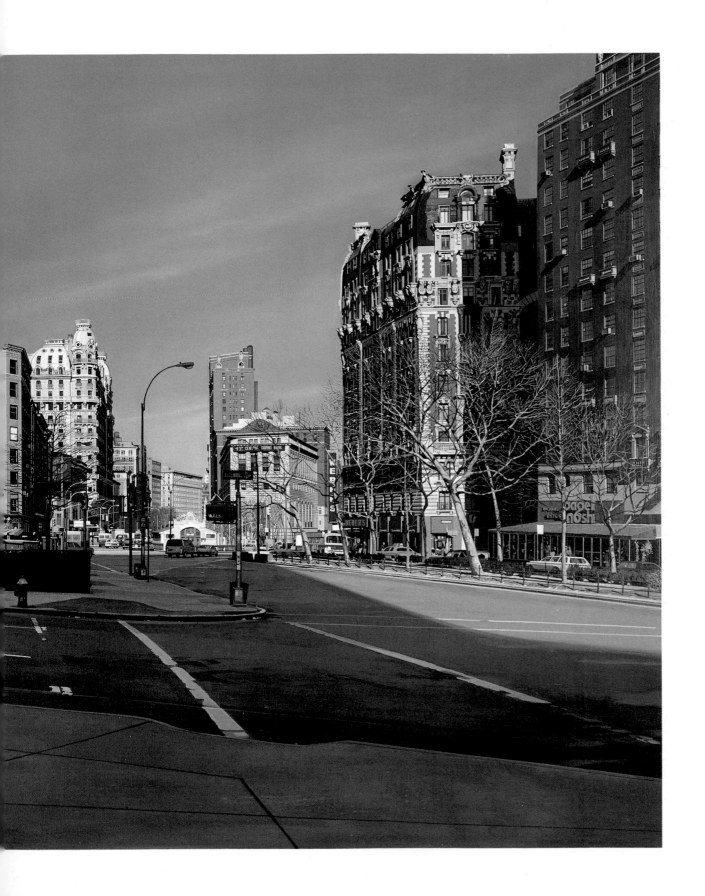

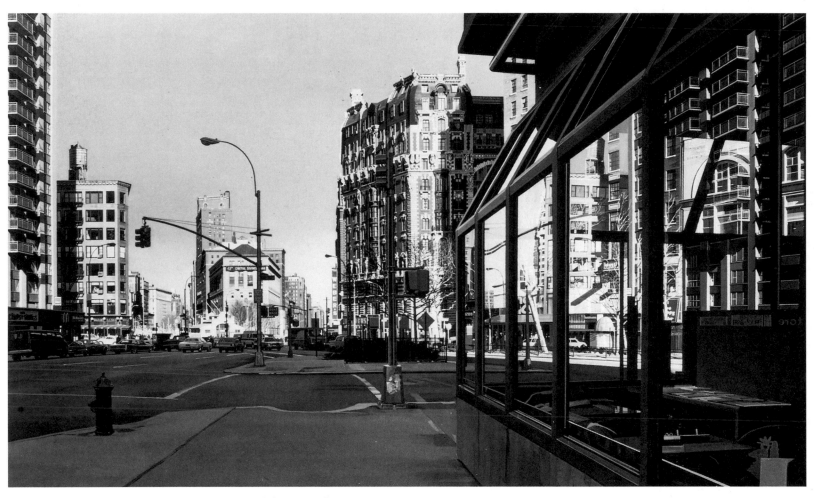

162. *Broadway at 70th Street.* 1985. Oil on canvas, 30 x 50″. Private collection

163. *Gingko Tree.* c. 1970. Oil on panel, 15 x 22".
Collection James Goodman Gallery, New York

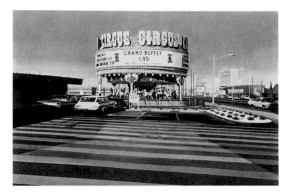

164. *Circus, Circus.* c. 1971. Oil on canvas, c. 18 x 30".
Private collection

165. *NYC Parking Lot.* 1969. Oil on Masonite,
24 x 36". Collection the artist

166. *D 106.* 1968. Oil on canvas, 22¼ x 30¼".
Collection Beatrice C. Mayer, Ill.

167. *Bridge.* 1974. Gouache, 16 x 17". Private
collection

168. Unfinished, untitled work

169. *Home of Chicago Blackhawks.*
1969. Oil on canvas, 30⅛ x 22¼".
Private collection

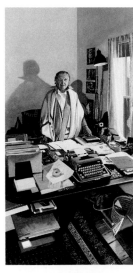

170. *Portrait of Marguerite
Yourcenar.* 1985. Oil on
canvas, 18 x 36". French
Academy, Paris

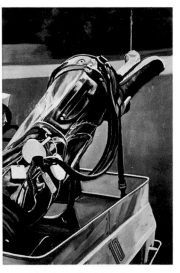

171. *Golf Bag.* c. 1969. Oil on
board, 23 x 16". Private collection

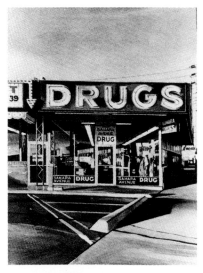

172. *Drugs.* 1970. Acrylic on board,
19¾ x 14¼". Private collection

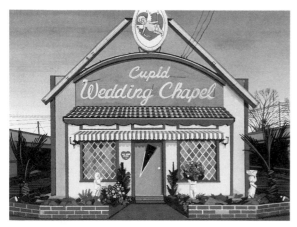

173. *Cupid Wedding Chapel.* 1972. Gouache on paper, 13½ x 18″. Collection the artist

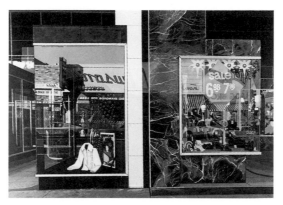

174. *Qualicraft Shoes.* 1975. Gouache on board, 33 x 47″. Collection the artist

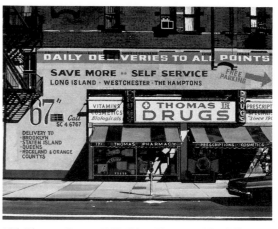

175. *Thomas Drugs.* 1969. Oil on Masonite, 18 x 24″. Private collection

176. *Central Park.* 1965. Oil on board, 36 x 52″. Private collection

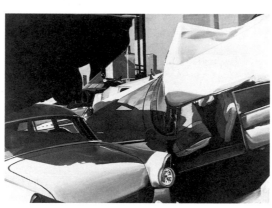

177. *Car Dump under the Brooklyn Bridge.* 1969. Oil on wood, 14 x 20″. Collection the artist

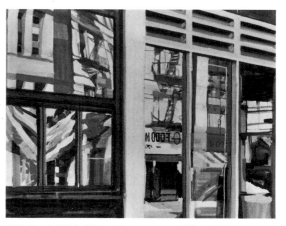

178. *Food.* 1968. Watercolor on paper, 11⅝ x 14¼″. Collection Dr. Jack Reddin, Kans.

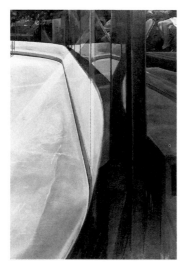

179. *Hockey Rink.* 1969. Oil on canvas, 30½ x 20″. Collection the artist

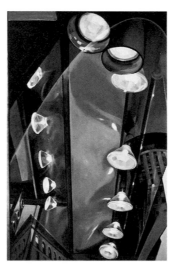

180. *Lights.* 1968. Oil on Masonite, 54 x 36″. Private collection

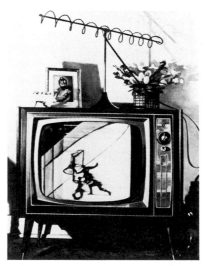

181. *T.V.* 1969. Oil on Masonite, 36 x 24″. Private collection

135

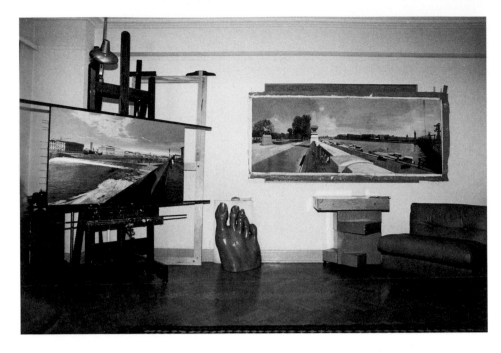

Richard Estes' New York studio,
with *View of Florence* (fig. 142)
on easel and *View of Paris* (fig. 141)
unstretched and underpainted,
November 1985

Catalogue of Paintings

Listed here, by date, are all the Richard Estes paintings
from the years 1965 to 1986 that are illustrated in this
volume. Unless otherwise noted, all works are in oil
paint on canvas, board, or Masonite.

1965
Central Park, fig. 176

1966
*Flatiron Building Reflected in Car with Figure in
 Bus*, fig. 2
Subway Passengers (unfinished), fig. 16

c. 1966
Other information, including whereabouts,
 unknown, fig. 24

1967
Astrojet, fig. 29
Automat, fig. 15
Bus Front, fig. 17
Bus Window (repainted in 1973), fig. 27
Cadillac, fig. 26
Car Front, fig. 7
Coconut Custard, fig. 32
Donohue's, fig. 33
Fastback, fig. 11
Food City, fig. 36
Honda, fig. 5
Horn and Hardart Automat, fig. 96
Hot Foods, fig. 31
Untitled, fig. 21
Untitled (Car Reflection), fig. 20

1968
Apollo, fig. 66
Auto Graveyard, fig. 13
D 106, fig. 166
Food (watercolor on paper), fig. 178
Gordon's Gin, fig. 68
Hot Girls, figs. 3, 65
Lights, fig. 180
Mosaic, fig. 46
Revolving Doors, fig. 30
Sloan's, fig. 50
Telephone Booths, fig. 44
Welcome to 42nd Street (Victory Theatre), fig. 67

1968–69
Nedick's, fig. 34
2 Broadway, fig. 47

1969
Automobile Reflections, fig. 22
The Candy Store (oil and synthetic polymer on
 canvas), fig. 40
Car Dump under the Brooklyn Bridge, fig. 177
Car Reflections, fig. 19
46th and Broadway, fig. 108
Grand Luncheonette, fig. 35
Hockey Rink, fig. 179
Home of the Chicago Blackhawks, fig. 169
NYC Parking Lot, fig. 165
Subway, fig. 43
Thomas Drugs, fig. 175
T.V., fig. 181

c. 1969
Flatiron Building, fig. 28
General Machinist, fig. 95
Golf Bag, fig. 171
Robert Hall Reflections, fig. 25

1970
Cafeteria, fig. 37
Car Reflections (acrylic on Masonite), fig. 18

Drugs (acrylic on board), fig. 172
Escalator, fig. 42
Food Shop, fig. 39
Key Food, fig. 69
Nedick's, fig. 45

c. 1970
Drugs, fig. 107
Gingko Tree, fig. 163
Grossinger's, fig. 120

1971
Diner, figs. 9, 63
Helene's Florist, fig. 57
People's Flowers, fig. 112
Storefront, fig. 98

c. 1971
Circus, Circus, fig. 164
Escalator, fig. 41

1972
Bus Reflections (Ansonia), fig. 114
Cupid Wedding Chapel (gouache on paper), fig. 173
Danbury Rubber Tile, fig. 73
560 (gouache), fig. 77
Grant's, fig. 72
Nass Linoleum, fig. 74
Oriental Restaurant (gouache on board), fig. 70
Paris Street Scene, fig. 118
St. Louis Arch, fig. 71
Seagram's, fig. 76
Ten Doors, fig. 75
Valet, fig. 78

1973
Alitalia, fig. 87
Bus Window (1967; repainted in 1973), fig. 27
Shoe Outlet, fig. 105
Woolworth's (gouache), fig. 104

1973–74
Sav-On-Drugs (gouache on board), fig. 100

Richard Estes' house, Maine

Biography

May 14, 1932 Born: Kewanee, Ill.

Education
1952–56 Chicago Art Institute

Solo Exhibitions
1968 Allan Stone Gallery, New York
 Hudson River Museum, Yonkers, N.Y.
1969 Allan Stone Gallery, New York
1970 Allan Stone Gallery, New York
1972 Allan Stone Gallery, New York
1974 Allan Stone Gallery, New York
 Museum of Contemporary Art, Chicago
1977 Allan Stone Gallery, New York
1978–79 "Richard Estes: The Urban Landscape,"
 Museum of Fine Arts, Boston; Toledo
 Museum of Art, Ohio; Nelson Gallery–
 Atkins Museum, Kansas City, Mo.;
 Hirshhorn Museum and Sculpture
 Garden, Smithsonian Institution,
 Washington, D.C.
1983 Allan Stone Gallery, New York
1985 Louis K. Meisel Gallery, New York

Public Collections
Whitney Museum of American Art, New York
Neue Galerie der Stadt Aachen, Ludwig Collection,
 Aachen, West Germany
Solomon R. Guggenheim Museum, New York
Art Institute of Chicago
Museum of Contemporary Art, Chicago
Smithsonian Institution, Washington, D.C., Stuart
 M. Speiser Collection
Teheran Museum of Contemporary Art
Toledo Museum of Art, Ohio
Nelson Gallery–Atkins Museum, Kansas City, Mo.
Hirshhorn Museum and Sculpture Garden,
 Smithsonian Institution, Washington, D.C.
Museum of Modern Art, New York
Detroit Institute of Arts
High Museum of Art, Atlanta
San Antonio Museum of Art
Des Moines Art Center
Currier Gallery of Art, Manchester, N.H.

Selected Group Exhibitions

1966
"Ninety-ninth Exhibition," American Watercolor
 Society, National Academy Galleries, New York

1967
"Biennial Exhibition of American Art," Krannert Art
 Museum, University of Illinois, Champaign-Urbana

1968
"Realism Now," Vassar College Art Gallery,
 Poughkeepsie

"The Wellington-Ivest Collection," Museum of Fine
 Arts, Boston

1969
"American Report on the '60s," Denver Art Museum
"Contemporary American Painting and Sculpture,"
 Krannert Art Museum, University of Illinois,
 Champaign-Urbana
"Directions 2: Aspects of a New Realism," Akron Art
 Institute; Milwaukee Art Center; Contemporary
 Arts Museum, Houston
"Painting and Sculpture Today, 1969," Indianapolis
 Museum of Art
"Painting from the Photo," Riverside Museum,
 New York
"Thirty-fourth Annual Mid-Year Show," Butler
 Institute of American Art, Youngstown

1970
"American Painting 1970," Virginia Museum of Fine
 Arts, Richmond
"Centennial Exhibit," Indiana State University,
 Indianapolis
"Cool Realism," Albright-Knox Art Gallery, Buffalo
"Cool Realism," Everson Museum of Art, Syracuse
"The Cool Realists," Jack Glenn Gallery, Corona del
 Mar, Calif.
"Directly Seen—New Realism in California," Newport
 Harbor Art Museum, Balboa, Calif.
"The Highway," Institute of Contemporary Art,
 University of Pennsylvania, Philadelphia;
 Institute for the Arts, Rice University, Houston;
 Akron Art Institute
"New Realism 1970," Headley Hall Gallery, St. Cloud
 State College, Minn.
"Painting and Sculpture Today, 1970," Indianapolis
 Museum of Art
"22 Realists," Whitney Museum of American Art,
 New York

1971
"Art Around the Automobile," Emily Lowe Gallery,
 Hofstra University, Hempstead, N.Y.
"Art of the 1960s," Sammlung Ludwig, Wallraf-
 Richartz Museum, Cologne
"Contemporary Selections 1971," Birmingham
 Museum of Art, Ala.
National Academy of Design, New York
"Neue amerikanische Realisten," Galerie de
 Gestlo, Hamburg
"New Realism," State University College,
 Potsdam, N.Y.
"New Realism, Old Realism," Bernard Danenberg
 Gallery, New York
"Radical Realism," Museum of Contemporary
 Art, Chicago
"Thirty-second Biennial Exhibition of Contemporary
 American Painting," Corcoran Gallery of Art,
 Washington, D.C.
"Selected Painters," Mulvane Art Center of Topeka
"Whitney Annual," Whitney Museum of American Art,
 New York

1972
"Colossal Scale," Sidney Janis Gallery, New York
"Documenta and No-Documenta Realists," Galerie de
 Gestlo, Hamburg
"Documenta 5," Kassel, West Germany
"L'Hyperréalistes américains," Galerie des Quatre
 Mouvements, Paris

"Phases of the New Realism," Lowe Art Museum,
 University of Miami, Coral Gables
"The Realist Revival," New York Cultural Center,
 New York
"Seventieth American Exhibition," Art Institute
 of Chicago
"Sharp-Focus Realism," Sidney Janis Gallery,
 New York
"Thirty-sixth International Biennial Exhibition,"
 Venice
"Whitney Annual," Whitney Museum of American Art,
 New York

1972–73
"Amerikanischer Fotorealismus," Württembergischer
 Kunstverein, Stuttgart; Frankfurter Kunstverein,
 Frankfurt; Kunst und Museumsverein, Wuppertal,
 West Germany

1973
"American Art—Third Quarter Century," Seattle
 Art Museum
"Amerikansk Realism," Galleri Ostergren, Malmö,
 Sweden
"Art in Evolution," Xerox Square Exhibit Center,
 Xerox Corporation, Rochester, N.Y.
"East Coast/West Coast/New Realism," University Art
 Gallery, San Jose State University
"The Emerging Real," Storm King Art Center,
 Mountainville, N.Y.
Galleria Civica d'Arte Moderna, Turin
"Grands maîtres hyperréalistes américains," Galerie
 des Quatre Mouvements, Paris
"Hyperréalistes américains," Galerie Arditti, Paris
"Iperrealisti americani," Galleria La Medusa, Rome
"Mit Kamera, Pinsel und Spritzpistole,"
 Ruhrfestspiele Recklinghausen, Städtische
 Kunsthalle, Recklinghausen, West Germany
"Options 73/30," Contemporary Arts Center,
 Cincinnati
"Photo-Realism," Serpentine Gallery, London
"The Super-Realist Vision," DeCordova and Dana
 Museum, Lincoln, Mass.
"Twenty-five Years of American Painting," Des Moines
 Art Center

1973–74
"Hyperréalisme," Galerie Isy Brachot, Brussels

1973–78
"Photo-Realism 1973: The Stuart M. Speiser
 Collection," traveling exhibition: Louis K. Meisel
 Gallery, New York; Herbert F. Johnson Museum of
 Art, Ithaca, N.Y.; Memorial Art Gallery of the
 University of Rochester, N.Y.; Addison Gallery of
 American Art, Andover, Mass.; Allentown Art
 Museum, Pa.; University of Colorado Museum,
 Boulder; University Art Museum, University of
 Texas, Austin; Witte Memorial Museum, San
 Antonio; Gibbes Art Gallery, Charleston, S.C.;
 Brooks Memorial Art Gallery, Memphis; Krannert
 Art Museum, University of Illinois, Champaign-
 Urbana; Helen Foresman Spencer Museum of Art,
 University of Kansas, Lawrence; Paine Art Center
 and Arboretum, Oshkosh, Wis.; Edwin A. Ulrich
 Museum, Wichita State University, Kans.; Tampa
 Bay Art Center, Tampa; Rice University, Sewall Art
 Gallery, Houston; Tulane University Art Gallery,
 New Orleans; Smithsonian Institution,
 Washington, D.C.

1974
"Amerikaans fotorealisme grafiek," Hedendaagse
 Kunst, Utrecht; Palais des Beaux-Arts, Brussels
"Ars '74 Ateneum," Fine Arts Academy of Finland,
 Helsinki
"Art 5 '74," Basel
"Contemporary American Paintings from the Lewis
 Collection," Delaware Art Museum, Wilmington
"Hyperréalistes américains—réalistes européens,"
 Centre National d'Art Contemporain, Paris
"Kijken naar de werkelijkheid," Museum Boymans—
 van Beuningen, Rotterdam
"New Images: Figuration in American Painting,"
 Queens Museum, Flushing, N.Y.
"New Photo-Realism," Wadsworth Atheneum,
 Hartford
"Seventy-first American Exhibition," Art Institute
 of Chicago
"Three Realists: Close, Estes, Raffael," Worcester Art
 Museum, Mass.
"Tokyo Biennale, '74," Tokyo Metropolitan Museum of
 Art; Kyoto Municipal Museum; Aichi Prefectural Art
 Museum, Nagoya
"Twelve American Painters," Virginia Museum of Fine
 Arts, Richmond
"Twenty-five Years of Janis: Part II," Sidney Janis
 Gallery, New York

1975
"Photo-Realists," Louis K. Meisel Gallery, New York
"Realismus und Realität," Kunsthalle, Darmstadt,
 West Germany
"Trends in Contemporary American Realist Painting,"
 Museum of Fine Arts, Boston
"Watercolors and Drawings—American Realists,"
 Louis K. Meisel Gallery, New York

1976
"Alumni Exhibition," School of the Art Institute,
 Chicago
"America as Art," National Collection of Fine Arts,
 Smithsonian Institution, Washington, D.C.
"American Master Drawings and Watercolors (Works
 on Paper from Colonial Times to the Present),"
 Whitney Museum of American Art, New York
"Art 7 '76," Basel
"A Selection of American Art, The Skowhegan School
 1946–1976," Institute of Contemporary Art,
 Boston; Colby Museum of Art, Waterville, Maine
"Seventy-second American Exhibition," Art Institute
 of Chicago
"Super Realism," Baltimore Museum of Art
"Three Decades of American Art," Seibu Museum of
 Art, Tokyo
"Urban Aesthetics," Queens Museum, Flushing, N.Y.

1976–77
"Photo-Realism in Painting," Art and Culture
 Center, Hollywood, Fla.; Museum of Fine Arts,
 St. Petersburg

1976–78
"America 1976," Corcoran Gallery of Art, Washington,
 D.C.; Wadsworth Atheneum, Hartford; Fogg Art
 Museum, Cambridge, and Institute of
 Contemporary Art, Boston; Minneapolis Institute of
 Arts; Milwaukee Art Center; Fort Worth Art
 Museum; San Francisco Museum of Modern Art;

High Museum of Art, Atlanta; Brooklyn Museum,
 New York
"Aspects of Realism," traveling exhibition sponsored
 by Rothman's of Pall Mall Canada, Ltd.: Stratford,
 Ont.; Centennial Museum, Vancouver; Glenbow-
 Alberta Institute, Calgary; Mendel Art Gallery,
 Saskatoon; Winnipeg Art Gallery; Edmonton Art
 Gallery; Art Gallery, Memorial University of
 Newfoundland, St. John's; Confederation Art
 Gallery and Museum, Charlottetown, P.E.I.; Musée
 d'Art Contemporain, Montreal; Dalhousie
 University Museum and Gallery, Halifax; Windsor
 Art Gallery, Ont.; London Public Library and Art
 Museum and McIntosh Memorial Art Gallery,
 University of Western Ontario; Art Gallery of
 Hamilton, Ont.

1977
"New Acquisitions Exhibition," Museum of Modern
 Art, New York
"New Realism," Jacksonville Art Museum, Fla.
"New Realism: Modern Art Form," Boise Gallery of Art
"Photo-Realists," Shore Gallery, Boston
"A View of a Decade," Museum of Contemporary Art,
 Chicago
"Washington International Art Fair," Washington, D.C.
"Whitney Biennial Exhibition," Whitney Museum of
 American Art, New York
"Works on Paper II," Louis K. Meisel Gallery, New York

1977–78
"Illusion and Reality," Australian touring exhibition:
 Australian National Gallery, Canberra; Western
 Australian Art Gallery, Perth; Queensland Art
 Gallery, Brisbane; Art Gallery of New South Wales,
 Sydney; Art Gallery of South Australia, Adelaide;
 National Gallery of Victoria, Melbourne; Tasmanian
 Museum and Art Gallery, Hobart

1978
"Art About Art," Whitney Museum of American
 Art, New York; North Carolina Museum of Art,
 Raleigh; Frederick S. Wight Art Gallery, University
 of California, Los Angeles; Portland Art
 Museum, Oreg.
"Art and the Automobile," Flint Institute of Arts, Mich.
Monmouth Museum, Lincroft, N.J.
"Photo-Realism and Abstract Illusionism," Arts and
 Crafts Center, Pittsburgh
"Photo-Realist Printmaking," Louis K. Meisel Gallery,
 New York
Tolarno Galleries, Melbourne, Australia
"Works by Living Artists from the Collection of
 Mr. and Mrs. Leigh Block," Santa Barbara Museum
 of Art

1979
"America in the 70s As Depicted by Artists in the
 Richard Brown Baker Collection," Meadowbrook Art
 Gallery, Oakland University, Rochester, Mich.
"The Opposite Sex: A Realistic Viewpoint," University
 of Missouri Art Gallery, Kansas City
"Selections of Photo-Realist Paintings from N.Y.C.
 Galleries," Southern Alleghenies Museum of Art, St.
 Francis College, Loretto, Pa.
Washington International Art Fair, Washington, D.C.

1980
"Directions in Realism," Danforth Museum,
 Framingham, Mass.

"The Morton G. Neumann Family Collection," National
 Gallery of Art, Washington, D.C.
"Realism/Photorealism," Philbrook Art Center, Tulsa

1981
"Real, Really Real, Super Real," traveling exhibition:
 San Antonio Museum of Art; Indianapolis Museum
 of Art; Tucson Museum of Art; Museum of Art,
 Carnegie Institute, Pittsburgh
"Seven Photorealists from New York Collections,"
 Solomon R. Guggenheim Museum, New York
"Toyama Now '81," Museum of Modern Art,
 Toyama, Japan

1981–82
"Contemporary American Realism Since 1960,"
 traveling exhibition: Pennsylvania Academy of Fine
 Arts, Philadelphia; Virginia Museum of Fine Arts,
 Richmond; Oakland Museum, Calif. USICA-
 sponsored tour: Gulbenkian Museum, Lisbon;
 Germanisches Nationalmuseum, Nuremberg
"Super Realism From The Morton G. Neumann Family
 Collection," Kalamazoo Institute of Arts, Mich.; The
 Art Center, Inc., South Bend; Springfield Art
 Museum, Springfield, Mo.; Dartmouth College
 Museum and Galleries, Hanover, N.H.; DeCordova
 and Dana Museum, Lincoln, Mass.; Des Moines
 Art Center

1982
"An Appreciation of Realism," Munson-Williams-
 Proctor Institute Museum of Art, Utica
"Assignment: Aviation," traveling exhibition
 sponsored by Smithsonian Institution Traveling
 Exhibition Service: The Columbus Museum of Art,
 Ga.; Springfield Art Museum, Springfield, Mo.
"Photographs by the Photorealists," Fort Wayne
 Museum of Art; Cleveland Museum of Art; Ball State
 Museum, Muncie
"Photo-Réalisme—Dix Ans Après," Galerie Isy
 Brachot, Paris

1983
"American Super Realism from the Morton G.
 Neumann Family Collection," Terra Museum of
 American Art, Evanston, Ill.
"Modern Art in the West," Tokyo Metropolitan
 Museum of Art
"Realism Now," Museum of Modern Art, Saitama,
 Japan

1984
"America Seen," Adams-Middleton Gallery, Dallas
"Andrew Wyeth: A Trojan Horse Modernist," Greenville
 County Museum of Art, Greenville, S.C.
"Art of 42nd Street," Whitney Museum of American
 Art at Philip Morris Agency, New York
"Photorealists Group Show," Martha White Gallery,
 Louisville
"Through the Looking Glass: Reflected Images in
 Contemporary Art," The Heckscher Museum,
 Huntington, N.Y.
Walter Moos Gallery, Toronto
"What's New? Important Recent Acquisitions & New
 Directions," Byer Museum of the Arts, Evanston, Ill.

1985
"American Realism: The Precise Image," Isetan
 Museum, Tokyo; Daimaru Museum, Osaka

Bibliography

Catalogues

American Watercolor Society Ninety-ninth Annual Exhibition. National Academy Galleries, New York, Apr. 7–24, 1966.

Biennial Exhibition of American Art. Krannert Art Museum, University of Illinois, Champaign-Urbana, 1967.

Nochlin, Linda. "The New Realists," *Realism Now.* Vassar College Art Gallery, Poughkeepsie, May 8–June 21, 1968.

Taylor, John Lloyd, and Atkinson, Tracy. Introduction to *Directions 2: Aspects of a New Realism.* Milwaukee Art Center, June 28–Aug. 10, 1969; Contemporary Arts Center, Houston, Sept. 17–Oct. 19, 1969; Akron Art Institute, Nov. 9–Dec. 14, 1969.

Thirty-fourth Annual Mid-Year Show. Butler Institute of American Art, Youngstown, June 29–Sept. 1, 1969.

Warrum, Richard L. Introduction to *Painting and Sculpture Today, 1969.* Indianapolis Museum of Art, May, 1969.

Farb, Oriole. Introduction to *Painting from the Photo.* Riverside Museum, New York, Dec. 9, 1969–Feb. 15, 1970.

Brown, Denise Scott, and Venturi, Robert. Introduction to *The Highway.* Institute of Contemporary Art, University of Pennsylvania, Philadelphia, Jan. 14–Feb. 25, 1970; Institute for the Arts, Rice University, Houston, Mar. 12–May 18, 1970; Akron Art Institute, June 5–July 16, 1970.

Directly Seen—New Realism in California. Newport Harbor Art Museum, Balboa, Calif., 1970.

Monte, James. Introduction to *22 Realists.* Whitney Museum of American Art, New York, Feb., 1970.

Selz, Peter. Introduction to *American Painting 1970.* Foreword by James M. Brown. Virginia Museum of Fine Arts, Richmond, May 4–June 7, 1970.

Wallin, Lee. Introduction to *New Realism, 1970.* St. Cloud State College, Minn., Feb. 13–Mar. 11, 1970.

Warrum, Richard L. Introduction to *Painting and Sculpture Today, 1970.* Foreword by Robert J. Rohn. Indianapolis Museum of Art, May, 1970.

Art Around the Automobile. Emily Lowe Gallery, Hofstra University, Hempstead, N.Y., June–Aug., 1971.

Baur, I. H. Foreword to *1971 Annual Exhibition.* Whitney Museum of American Art, New York, Feb., 1971.

Goldsmith, Benedict. *New Realism.* Brainerd Hall Art Gallery, State University College, Potsdam, N.Y., Nov. 5–Dec. 12, 1971.

Hopps, Walter. Introduction to *Thirty-second Biennial Exhibition of Contemporary American Painting.* Corcoran Gallery of Art, Washington, D.C., Feb. 28–Apr. 4, 1971.

Karp, Ivan C. Introduction to *Radical Realism.* Museum of Contemporary Art, Chicago, May 22–June 4, 1971.

Weiss, Evelyn. Introduction to *Art of the 1960s, Sammlung Ludwig.* Foreword by Peter Ludwig and Horst Keller. Wallraf-Richartz Museum, Cologne, 1971.

Abadie, Daniel. Introduction to *Hyperréalistes américains.* Galerie des Quatre Mouvements, Paris, Oct. 25–Nov. 25, 1972.

Amman, Jean Christophe. Introduction to *Documenta 5.* Neue Galerie and Museum Fridericianum, Kassel, West Germany, June 30–Oct. 8, 1972.

Baratte, John J., and Thompson, Paul E. *Phases of the New Realism.* Lowe Art Museum, University of Miami, Coral Gables, Jan. 20–Feb. 20, 1972.

Baur, I. H. Foreword to *1972 Annual Exhibition.* Whitney Museum of American Art, New York, Jan. 25–Mar. 19, 1972.

Colossal Scale. Sidney Janis Gallery, New York, Mar., 1972.

Janis, Sidney. Introduction to *Sharp Focus Realism.* Sidney Janis Gallery, New York, Jan. 6–Feb. 4, 1972.

Speyer, James A. Introduction to *Seventieth American Exhibition.* Art Institute of Chicago, June 24–Aug. 20, 1972.

Burton, Scott. *The Realist Revival.* New York Cultural Center, New York, Dec. 6, 1972–Jan. 7, 1973.

Schneede, Uwe, and Hoffman, Heinz. Introduction to *Amerikanischer Fotorealismus.* Württembergischer Kunstverein, Stuttgart, Nov. 16–Dec. 26, 1972; Frankfurter Kunstverein, Frankfurt, Jan. 6–Feb. 18, 1973; Kunst und Museumsverein, Wuppertal, West Germany, Feb. 25–Apr. 8, 1973.

Alloway, Lawrence. Introduction to *Amerikansk Realism.* Galleri Ostergren, Malmö, Sweden, Sept. 8–Oct. 14, 1973.

———. Introduction to *Photo-Realism.* Serpentine Gallery, London, Apr. 4–May 6, 1973.

Becker, Wolfgang. Introduction to *Mit Kamera, Pinsel und Spritzpistole.* Ruhrfestspiele Recklinghausen, Städtische Kunsthalle, Recklinghausen, West Germany, May 4–June 17, 1973.

Boulton, Jack. Introduction to *Options 73/30.* Contemporary Arts Center, Cincinnati, Sept. 25–Nov. 11, 1973.

C. A. B. S. Introduction to *Realisti iperrealisti.* Galleria La Medusa, Rome, Nov. 12, 1973.

Combattimento per un'immagine. Galleria Civica d'Arte Moderna, Turin, Mar. 4, 1973.

Dali, Salvador. Introduction to *Grands maîtres hyperréalistes américains.* Galerie des Quatre Mouvements, Paris, May 23–June 25, 1973.

Hogan, Carroll Edwards. Introduction to *Hyperréalistes américains.* Galerie Arditti, Paris, Oct. 16–Nov. 30, 1973.

Iperrealisti americani. Galleria La Medusa, Rome, Jan. 2, 1973.

Kozloff, Max. *Twenty-five Years of American Painting.* Des Moines Art Center, Mar. 6–Apr. 22, 1973.

Lamagna, Carlo. Foreword to *The Super Realist Vision.* DeCordova and Dana Museum, Lincoln, Mass., Oct. 7–Dec. 9, 1973.

Meisel, Louis K. *Photo-Realism 1973: The Stuart M. Speiser Collection.* New York, 1973.

Radde, Bruce. Introduction to *East Coast/West Coast/New Realism.* University Art Gallery, San Jose State University, Apr. 24–May 18, 1973.

Sims, Patterson. Introduction to *Realism Now.* Katonah Gallery, Katonah, N.Y., May 20–June 24, 1973.

Sorce, Anthony John. Introduction to *Art in Evolution.* Xerox Corporation, Rochester, N.Y., May, 1973.

Van der Marck, Jan. *American Art: Third Quarter Century.* Foreword by Thomas N. Maytham and Robert B. Dootson. Seattle Art Museum, Aug. 22–Oct. 14, 1973.

Becker, Wolfgang. Introduction to *Kunst nach Wirklichkeit.* Kunstverein Hannover, West Germany, Dec. 9, 1973–Jan. 27, 1974.

Hyperréalisme. Galerie Isy Brachot, Brussels, Dec. 14, 1973–Feb. 9, 1974.

Amerikaans fotorealisme grafiek. Hedendaagse Kunst, Utrecht, Aug., 1974; Palais des Beaux-Arts, Brussels, Sept.–Oct., 1974.

Chase, Linda. "Photo-Realism." In *Tokyo Biennale 1974.* Tokyo Metropolitan Museum of Art; Kyoto Municipal Museum; Aichi Prefectural Art Museum, Nagoya, 1974.

Clair, Jean; Abadie, Daniel; Becker, Wolfgang; and Restany, Pierre. Introductions to *Hyperréalistes américains—réalistes européens.* Centre National d'Art Contemporain, Paris, Archives 11/12, Feb. 15–Mar. 31, 1974.

Cowart, Jack. *New Photo-Realism.* Wadsworth Atheneum, Hartford, Apr. 10–May 19, 1974.

Gaines, William. Introduction to *Twelve American Painters.* Foreword by James M. Brown. Virginia Museum of Fine Arts, Richmond, Sept. 30–Oct. 27, 1974.

Kijken naar de Werkelijkheid. Museum Boymans–van Beuningen, Rotterdam, June 1–Aug. 18, 1974.

Sarajas-Korte, Salme. Introduction to *Ars '74 Ateneum.* Fine Arts Academy of Finland, Helsinki, Feb. 15–Mar. 31, 1974.

Shulman, Leon. *Three Realists: Close, Estes, Raffael.* Worcester Art Museum, Mass., Feb. 27–Apr. 7, 1974.

Speyer, James A. Introduction to *Seventy-first American Exhibition.* Art Institute of Chicago, June 15–Aug. 11, 1974.

Tatistcheff, Peter, and Schneider, Janet. Introduction to *New Images: Figuration in American Painting.* Queens Museum, Flushing, N.Y., Nov. 16–Dec. 29, 1974.

Twenty-five Years of Janis: Part II from Pollack to Pop, Op and Sharp Focus Realism. Sidney Janis Gallery, New York, Mar. 13–April 13, 1974.

Walthard, Dr. Frederic P. Foreword to *Art 5 '74.* Basel, June 19–24, 1974.

Wyrick, Charles, Jr. Introduction to *Contemporary American Paintings from the Lewis Collection.* Delaware Art Museum, Wilmington, Sept. 13–Oct. 17, 1974.

Krimmel, Bernd. Introduction to *Realismus und Realität.* Foreword by H.W. Sabais. Kunsthalle, Darmstadt, West Germany, May 24–July 6, 1975.

Meisel, Susan Pear. *Watercolors and Drawings—American Realists.* Louis K. Meisel Gallery, New York, Jan., 1975.

Richardson, Brenda. Introduction to *Super Realism.* Baltimore Museum of Art, Nov. 18, 1975–Jan. 11, 1976.

Armstrong, Thomas N., III. *Three Decades of American Art.* Seibu Museum of Art, Tokyo, June 18–July 20, 1976.

Schneider, Janet. *Urban Aesthetics.* Queens Museum, Flushing, N.Y., Jan. 17–Feb. 29, 1976.

Speyer, James A., and Rorimer, Ann. *Seventy-second American Exhibition.* Art Institute of Chicago, Mar. 13–May 9, 1976.

Taylor, Joshua C. Introduction to *America as Art.* National Collection of Fine Arts, Smithsonian Institution, Washington, D.C., 1976.

Walthard, Dr. Frederic P. Introduction to *Art 7 '76.* Basel, June 16–21, 1976.

Hicken, Russell Bradford. Introduction to *Photo-Realism in Painting.* Art and Culture Center, Hollywood, Fla., Dec. 3, 1976–Jan. 10, 1977; Museum of Fine Arts, St. Petersburg, Jan. 21–Feb. 25, 1977.

Chase, Linda. "U.S.A." In *Aspects of Realism.* Rothman's of Pall Mall Canada, Ltd., June, 1976–

Jan., 1978.

Kleppe, Thomas S.; Rosenblum, Robert; and Welliver, Neil. *America 1976.* Corcoran Gallery of Art, Washington, D.C., Apr. 27–June 6, 1976; Wadsworth Atheneum, Hartford, July 4–Sept. 12, 1976; Fogg Art Museum, Cambridge, and Institute of Contemporary Art, Boston, Oct. 19–Dec. 7, 1976; Minneapolis Institute of Arts, Jan. 16–Feb. 27, 1977; Milwaukee Art Center, Mar. 19–May 15, 1977; Fort Worth Art Museum, June 18–Aug. 14, 1977; San Francisco Museum of Modern Art, Sept. 10–Nov. 13, 1977; High Museum of Art, Atlanta, Dec. 10, 1977–Feb. 5, 1978; Brooklyn Museum, N.Y., Mar. 11–May 21, 1978.

Dempsey, Bruce. *New Realism.* Jacksonville Art Museum, Fla., 1977.

Felluss, Elias A. Foreword to *Washington International Art Fair.* Washington, D.C., 1977.

Friedman, Martin; Pincus Witten, Robert; and Gay, Peter. *A View of a Decade.* Museum of Contemporary Art, Chicago, 1977.

Haskell, Barbara, and Tucker, Marcia. Introduction to *1977 Biennial Exhibition.* Whitney Museum of American Art, New York, Feb. 19–Apr. 3, 1977.

Karp, Ivan. Introduction to *New Realism: Modern Art Form.* Boise Gallery of Art, Apr. 14–May 29, 1977.

Stringer, John. Introduction to *Illusion and Reality.* Australian Gallery Directors' Council, North Sydney, 1977–78.

Hodge, G. Stuart. Foreword to *Art and the Automobile.* Flint Institute of Arts, Mich., Jan. 12–Mar. 12, 1978.

Mead, Katherine Harper. Introduction to *Works by Living Artists from the Collection of Mr. and Mrs. Leigh Block.* Santa Barbara Museum of Art, Feb. 11–Apr. 9, 1978.

Meisel, Susan Pear. Introduction to *The Complete Guide to Photo-Realist Printmaking.* Louis K. Meisel Gallery, New York, Dec., 1978.

Canaday, John. Introduction to *Richard Estes: The Urban Landscape.* Interview by John Arthur. Museum of Fine Arts, Boston, May 31–Aug. 6, 1978; Toledo Museum of Art, Ohio, Sept. 10–Oct. 22, 1978; Nelson Gallery–Atkins Museum, Kansas City, Mo., Nov. 9–Dec. 31, 1978; Hirshhorn Museum and Sculpture Garden, Smithsonian Institution, Washington, D.C., Jan. 25–Apr. 1, 1979.

Felluss, Elias A. Introduction to *Washington International Art Fair '79.* Washington, D.C., May, 1979.

Stokes, Charlotte. "As Artists See It: America in the 70s." In *America in the 70s As Depicted by Artists in the Richard Brown Baker Collection.* Meadowbrook Art Gallery, Oakland University, Rochester, Mich., Nov. 18–Dec. 16, 1979.

Streuber, Michael. Introduction to *Selections of Photo-Realist Paintings from N.Y.C. Galleries.* Southern Alleghenies Museum of Art, St. Francis College, Loretto, Pa., May 12–July 8, 1979.

Brown, J. Carter. *The Morton G. Neumann Family Collection.* National Gallery of Art, Washington, D.C., Aug. 31–Dec. 31, 1980.

Perreault, John. *Aspects of the 70's: Directions in Realism.* Danforth Museum, Framingham, Mass., May 17–Aug. 24, 1980.

Realism/Photorealism. Philbrook Art Center, Tulsa, Oct. 5–Nov. 23, 1980.

Toyama Now '81. Museum of Modern Art, Toyama, Japan, July 5–Sept. 23, 1981.

Goodyear, Frank H., Jr. *Contemporary American Realism Since 1960.* New York Graphic Society, Boston, with the Pennsylvania Academy of Fine Arts, 1981.

Real, Really Real, Super Real: Directions in Contemporary American Realism. San Antonio Museum Association, 1981.

Chase, Linda. *Super Realism from the Morton G. Neumann Family Collection.* Kalamazoo Institute of Arts, Mich., Sept. 1–Nov. 1, 1981; The Art Center, Inc., South Bend, Nov. 22, 1981–Jan. 3, 1982; Springfield Art Museum, Springfield, Mo., Jan. 16–Feb. 28, 1982; Dartmouth College Museum and Galleries, Hanover, N.H., Mar. 19–May 2, 1982; DeCordova and Dana Museum, Lincoln, Mass., May 9–June 20, 1982; Des Moines Art Center, July 6–Aug. 15, 1982.

Manning, John. *An Appreciation of Realism.* Munson-Williams-Proctor Institute Museum of Art, Utica, Feb. 13–Apr. 11, 1982.

Photo-Réalisme: Dix Ans Après. Galerie Isy Brachot, Paris, Jan. 13–Mar. 6, 1982.

American Super Realism from the Morton G. Neumann Family Collection. Terra Museum of American Art, Evanston, Ill., Nov. 4–Dec. 7, 1983.

Realism Now. Museum of Modern Art, Saitama, Japan, Oct. 4–Dec. 4, 1983.

Richard Estes: A Decade. Allan Stone Gallery, New York, 1983.

Art of 42nd Street. Whitney Museum of American Art, New York, 1984.

Martin, Alvin. *America Seen: Contemporary American Artists View America.* Adams-Middleton Gallery, Dallas, June–Sept. 1984.

Articles

Constable, Rosalind. "Style of the Year: The Inhumanists," *New York,* vol. 1, no. 37 (Dec. 16, 1968), pp. 44–50, cover illustration.

Levin, Kim. "Reviews and Previews," *ARTnews,* vol. 67, no. 1 (Apr., 1968), p. 12.

Alloway, Lawrence. "Art," *The Nation,* Dec. 29, 1969, pp. 741–42.

Baumgold, Julie, ed. "Best Bets," *New York,* Dec. 8, 1969.

Benedict, Michael. "Reviews and Previews," *ARTnews,* vol. 68, no. 1 (Mar., 1969), p. 17.

Brumer, Miriam. "In the Galleries," *Arts,* vol. 43, no. 4 (Feb., 1969), p. 58.

Burton, Scott. "Generation of Light, 1945–1969," *ARTnews Annual 35* (Newsweek, Inc.), 1969, pp. 20–23.

Canaday, John. "Realism: Waxing or Waning?," *New York Times,* July 13, 1969, sec. 2, p. 27.

Gaynor, Frank. "Photographic Exhibit Depicts Today's U.S.," *Newark Sunday News,* Dec. 14, 1969, sec. 6, p. E18.

Perreault, John. "Get the Picture?" *Village Voice,* Dec. 18, 1969, p. 47.

Schjeldahl, Peter. "The Flowering of the Super-Real," *New York Times,* Mar. 2, 1969, sec. 2, pp. D31, D33.

Shirey, David L. "The Gallery: It's Happening Out There," *Wall Street Journal,* Apr. 13, 1969, p. 14.

"Super Realism," *Life,* vol. 66, no. 25 (June 27, 1969), pp. 44–50A.

Tillim, Sidney. "A Variety of Realisms," *Artforum,* vol. 7, no. 10 (Summer, 1969), pp. 42–47.

Alloway, Lawrence. "In the Museums: Paintings from the Photo," *Arts,* Dec. 1, 1970.

Davis, Douglas. "Return of the Real: Twenty-two Realists on View at New York's Whitney," *Newsweek,* Feb. 23, 1970, p. 105.

Deschin, Jacob. "Photo into Painting," *New York Times,* Jan. 4, 1970.

Genauer, Emily. "On the Arts," *Newsday* (Long Island, N.Y.), Feb. 21, 1970.

Gruen, John. "The Extended Vision," *New York,* Jan. 12, 1970.

———. "The Imported Dream, Richard Estes," *New York,* Apr. 20, 1970, p. 54.

Lichtblau, Charlotte. "Painters Use of Photographs Explored," *Philadelphia Enquirer,* Feb. 1, 1970.

Nemser, Cindy. "Presenting Charles Close," *Art in America,* Jan., 1970, pp. 98–101.

Nordstrom, Sherry C. "Reviews and Previews," *ARTnews,* vol. 69, no. 3 (May, 1970), p. 28.

Ratcliff, Carter. "Twenty-two Realists Exhibit at the Whitney," *Art International,* Apr., 1970, p. 105.

Stevens, Carol. "Message into Medium: Photography as an Artist's Tool," *Print,* vol. XXIV, no. III (May 6, 1970), pp. 54–59.

Stevens, Elizabeth. "The Camera's Eye on Canvas," *Wall Street Journal,* Jan. 6, 1970.

"Visual Arts," *Annual Report,* National Endowment for the Arts/National Council on the Arts, 1970.

Genauer, Emily. "Art '72: The Picture Is Brighter," *New York Post,* Dec. 31, 1971.

Marandel, J. Patrice. "The Deductive Image: Notes on Some Figurative Painters," *Art International,* Sept., 1971, pp. 58–61.

Sager, Peter. "Neue Formen des Realismus," *Magazin Kunst,* 4th Quarter, 1971, pp. 2512–16.

Amman, Jean Christophe. "Realismus," *Flash Art,* May–July, 1972, pp. 50–52.

Borden, Lizzie. "Cosmologies," *Artforum,* Oct., 1972, pp. 45–50.

Borsick, Helen. "Realism to the Fore," *Cleveland Plain Dealer,* Oct. 8, 1972.

Canaday, John. "A Critic's Valedictory: The Americanization of Modern Art and Other Upheavals," *New York Times,* Aug. 8, 1972, sec. 2, pp. 1, 23.

Chase, Linda; Foote, Nancy; and McBurnett, Ted. "The Photo-Realists: 12 Interviews," *Art in America,* vol. 60, no. 6 (Nov.–Dec., 1972), pp. 73–89.

"Cityscape," *Arts,* Mar., 1972, p. 57.

Davis, Douglas. "Art Is Unnecessary. Or Is It?," *Newsweek,* July 17, 1972, pp. 68–69.

———. "Nosing Out Reality," *Newsweek,* Aug. 14, 1972, p. 58.

"Documenta 5," *Frankfurter Allgemeine Zeitung,* no. 155 (July 8, 1972).

"Documenta Issue," *Zeit Magazin,* no. 31/4 (Aug., 1972), pp. 4–15.

Henry, Gerrit. "The Real Thing," *Art International,* vol. XVI, no. 6 (Summer, 1972), pp. 87–91, 194.

Hickey, David. "New York Reviews," *Art in America,* vol. 60, no. 2 (Mar.–Apr., 1972), pp. 116–18.

———. "Previews," *Art in America,* Jan.–Feb., 1972, pp. 37–38.

"Les hommes et les oeuvres," *La Galerie,* no. 120 (Oct., 1972), pp. 16–17.

Hughes, Robert. "The Realist as Corn God," *Time,* Jan. 31, 1972, pp. 50–55.

"Hyperréalisme arrive à Paris," *Argus de la Presse,* Nov., 1972.

"L'hyperréalisme ou le retour aux origines," *Argus de la Presse,* Oct. 16, 1972.

Karp, Ivan. "Rent Is the Only Reality, or the Hotel Instead of the Hymn," *Arts,* Dec., 1972, pp. 47–51.

Kramer, Hilton. "And Now, Pop Art: Phase II," *New York Times,* Jan. 16, 1972.

Kurtz, Bruce. "Documenta 5: A Critical Preview," *Arts,* Summer, 1972, pp. 34–41.

Lerman, Leo. "Sharp Focus Realism," *Mademoiselle,* Mar., 1972, pp. 170–73.

Levequi, J. J. "Les hommes et les oeuvres," *Argus de la Presse,* Oct., 1972.

Lista, Giovanni. "Iperrealisti americani," *NAC* (Milan), no. 12 (Dec., 1972), pp. 24–25.

Lubell, Ellen. "In the Galleries," *Arts Magazine,* vol. 46, no. 7 (May, 1972), pp. 67–68.

"Les malheurs de l'Amérique," *Le Nouvel Observateur*, Nov. 6, 1972.

Marvel, Bill. "Saggy Nudes? Giant Heads? Make Way for 'Superrealism,'" *National Observer*, Jan. 29, 1972, p. 22.

Naimer, Lucille. "The Whitney Annual," *Arts*, Mar., 1972, p. 54.

Nemser, Cindy. "New Realism," *Arts*, Nov., 1972, p. 85.

"La nouvelle coqueluche: l'hyperréalisme," *L'Express*, Oct. 30, 1972.

"Novedades desde París," *El Dia*, Dec. 17, 1972.

Perreault, John. "Reports, Forecasts, Surprises and Prizes," *Village Voice*, Jan. 6, 1972, pp. 21–24.

———. "The Hand Was Colossal But Small," *Village Voice*, Mar. 23, 1972, p. 72.

Pozzi, Lucio. "Super realisti U.S.A.," *Bolaffiarte*, no. 18 (Mar., 1972), pp. 54–63.

Rose, Barbara. "Real, Realer, Realist," *New York*, vol. 5, no. 5 (Jan. 31, 1972), p. 50.

Rosenberg, Harold. "The Art World," *The New Yorker*, Feb. 5, 1972, pp. 88–93.

Seitz, William C. "The Real and the Artificial: Painting of the New Environment," *Art in America*, Nov.–Dec., 1972, pp. 58–72.

Seldis, Henry J. "Documenta: Art Is Whatever Goes On in Artist's Head," *Los Angeles Times Calendar*, July 9, 1972.

Skowhegan (Maine) *School of Painting and Sculpture Bulletin*, 1972.

Thornton, Gene. "These Must Have Been a Labor of Love," *New York Times*, Jan. 23, 1972.

Wasmuth, E. "La révolte des réalistes," *Connaissance des Arts*, June, 1972, pp. 118–23.

Wolmer, Denise. "In the Galleries," *Arts*, Mar., 1972, p. 57.

Allen, Barbara. "In and Around," *Interview*, Nov., 1973, p. 36.

Apuleo, Vito. "Tra manifesto e illustrazione sino al rifiuto della scelta," *La voce repubblicana*, Feb. 24, 1973, p. 5.

Art Now Gallery Guide, Sept., 1973, pp. 1–3.

Beardsall, Judy. "Stuart M. Speiser Photorealist Collection," *Art Gallery*, vol. XVII, no. 1 (Oct., 1973), pp. 5, 29–34.

Becker, Wolfgang. "NY? Realisme?," *Louisiana Revy*, vol. 13, no. 3 (Feb., 1973).

Bell, Jane. "Stuart M. Speiser Collection," *Arts*, Dec., 1973, p. 57.

Bovi, Arturo di. "Arte/Piú brutto del brutto," *Il Messaggiero*, Feb. 13, 1973, p. 3.

Chase, Linda, and McBurnett, Ted. "Interviews with Robert Bechtle, Tom Blackwell, Chuck Close, Richard Estes and John Salt," *Opus International*, no. 44–45 (June, 1973), pp. 38–50.

Chase, Linda. "Recycling Reality," *Art Gallery*, Oct., 1973, pp. 75–82.

"Don Eddy," *Art International*, Dec. 20, 1973.

E. D. G. "Arrivano gli iperrealisti," *Tribuna Letteraria*, Feb., 1973.

"European Galleries," *International Herald Tribune*, Feb. 17–18, 1973, p. 6.

"Gallerie," *L'Espresso* (Rome), no. 9 (Mar. 4, 1973).

Giannattasio, Sandra. "Riproduce la vita di ogni giorno la nuova pittura americano," *Avanti*, Feb. 8, 1973, p. 1.

Gilmour, Pat. "Photo-Realism," *Arts Review*, vol. 25 (Apr. 21, 1973), p. 249.

"Goings On About Town," *The New Yorker*, Oct. 1, 1973.

Gosling, Nigel. "The Photo Finish," *Observer Review* (London), Apr. 8, 1973.

Guercio, Antonio del. "Iperrealismo tra 'pop' e informale," *Rinascita*, no. 8 (Feb. 23, 1973), p. 34.

Hart, John. "A 'hyperrealist' U.S. tour at La Medusa," *Daily American* (Rome), Feb. 8, 1973.

Henry, Gerrit. "A Realist Twin Bill," *ARTnews*, Jan., 1973, pp. 26–28.

Hjort, Oysten. "Kunstmiljoeti Rhinlandet," *Louisiana Revy*, vol. 13, no. 3 (Feb., 1973).

"L'hyperréalisme américain," *Le Monde des Grandes Musiques*, no. 2 (Mar.–Apr., 1973), pp. 4, 56–57.

"Hyperréalistes américains," *Art Press*, Dec. 1, 1973, p. 2.

La Mesa, Rina G. "Nel vuoto di emozioni," *Sette Giorni*, Feb. 18, 1973, p. 31.

Levin, Kim. "The New Realism: A Synthetic Slice of Life," *Opus International*, no. 44–45 (June, 1973), pp. 28–37.

Lucie-Smith, Edward. "Super Realism from America," *Illustrated London News*, Mar., 1973.

Maraini, Letizia. "Non fatevi sfuggire," *Il Globo*, Feb. 6, 1973, p. 8.

Marziano, Luciano. "Iperrealismo: la coagulazione dell'effimero," *Il Margutta* (Rome), no. 3–4 (Mar.–Apr., 1973).

Melville, Robert. "The Photograph as Subject," *Architectural Review*, vol. CLIII, no. 915 (May, 1973), pp. 329–33.

Micacchi, Dario. "La ricerca degli iperrealisti," *Unità*, Feb. 12, 1973.

Michael, Jacques. "Le super-réalisme," *Le Monde*, Feb. 6, 1973, p. 23.

Moulin, Raoul-Jean. "Hyperréalistes américains," *L'Humanité*, Jan. 16, 1973.

Palazzoli, Daniel, and Mazzoletti, Raffaello. "Da Daguerre a Warhol," *Arte* (Milan), Mar., 1973, pp. 25–35, 93–94.

Perreault, John. "Airplane Art in a Head Wind," *Village Voice*, Oct. 4, 1973, p. 24.

Piradel, Jean-Louis. "Paris I: hyperréalistes américains," *Opus International*, no. 39 (1973), pp. 51–52.

"Realism Now," *Patent Trader*, May 26, 1973, p. 7A.

Restany, Pierre. "Sharp Focus: La continuité réaliste d'une vision américaine," *Domus*, Aug., 1973.

Rubiu, Vittorio. "Il gusto controverso degli iperrealisti," *Corriere della Sera*, Feb. 25, 1973.

Seldis, Henry J. "New Realism: Crisp Focus on the American Scene," *Los Angeles Times*, Jan. 21, 1973, p. 54.

Sherman, Jack. "Art Review: Photo-Realism, Johnson Museum," *Ithaca Journal*, Nov. 13, 1973.

"Specialize and Buy the Best," *Business Week*, Oct. 27, 1973, p. 107.

Trucchi, Lorenza di. "Iperrealisti americani alla Medusa," *Momento-sera*, Feb. 9–10, 1973, p. 8.

Alliata, Vicky. "American Essays on Super-Realism," *Domus*, no. 536 (July, 1974), pp. 52–54.

"ARS '74/Helsinki," *Art International*, May, 1974, pp. 38–39.

Berkman, Florence. "Three Realists: A Cold, Plastic World," *Hartford Times*, Mar. 10, 1974.

Butler, Joseph T. "America (Three Realists: Close, Estes, and Raffael)," *The Connoisseur*, vol. 186, no. 748 (June, 1974), pp. 142–43.

Campbell, Lawrence. "Reviews," *ARTnews*, vol. 73, no. 7 (Sept., 1974), p. 114.

Chase, Linda. "The Connotation of Denotation," *Arts*, Feb., 1974, pp. 38–41.

Clair, Jean. "Situation des réalismes," *Argus de la Presse*, Apr., 1974.

Coleman, A. D. "From Today Painting Is Dead," *Camera 35*, July, 1974, pp. 34, 36–37, 78.

"Collection of Aviation Paintings at Gallery," *Andover* (Mass.) *Townsman*, Feb. 28, 1974.

Cossitt, F. D. "Current Virginia Museum Show Is One of Best in Years," *Richmond Times Dispatch*, Oct. 6, 1974, sec. H.

Davis, Douglas. "Is Photography Really Art?," *Newsweek*, Oct. 21, 1974, p. 69.

———. "Summing Up the Season," *Newsweek*, July 1, 1974, p. 73.

Deroudille, René. "Réalistes et hyperréalistes," *Derrière Heure Lyonnaise*, Mar. 31, 1974.

"Expositions," *Argus de la Presse*, Mar., 1974.

"Flowers, Planes and Landscapes in New Art Exhibits," *Saturday Times-Union* (Rochester, N.Y.), Jan. 5, 1974.

Frank, Peter. "On Art," *Soho Weekly News*, Apr. 18, 1974, p. 14.

———. "On Art," *Soho Weekly News*, May 16, 1974, pp. 19, 22.

"Gallery Notes," *Memorial Art Gallery of the University of Rochester Bulletin*, vol. 39, no. 5 (Jan., 1974).

Gassiot-Talabor, Gerald. "Le choc des réalismes," *XXe Siècle*, no. 42 (June, 1974), pp. 25–32.

Gibson, Michael. "Paris Show Asks a Question: What Is Reality?," *International Herald Tribune*, Feb. 23–24, 1974, p. 7.

Hartman, Rose. "In and Around," *Soho Weekly News*, Apr. 18, 1974, p. 4.

Hemphill, Chris. "Estes," *Andy Warhol's Interview*, vol. IV, no. 11 (Oct., 1974), pp. 42–43.

Hughes, Robert. "An Omnivorous and Literal Dependence," *Arts*, June, 1974, pp. 25–29.

Kelley, Mary Lou. "Pop-Art Inspired Objective Realism," *Christian Science Monitor*, Mar. 1, 1974.

Lascault, Gilbert. "Autour de ce qui se nomme hyperréalisme," *Paris-Normandie*, Mar. 31, 1974.

Levin, Kim. "Audrey Flack at Meisel," *Art in America*, May–June, 1974, p. 106.

Loring, John. "Photographic Illusionist Prints," *Arts*, Feb., 1974, pp. 42–43.

Lubell, Ellen. "Noel Mahaffey," *Arts*, June, 1974, p. 62.

Michael, Jacques. "La 'mondialisation' de l'hyperréalisme," *Le Monde*, Feb. 24, 1974.

Moulin, Raoul-Jean. "Les hyperréalistes américains et la neutralisation du réel," *L'Humanité*, Mar. 21, 1974.

Nemser, Cindy. "The Close Up Vision," *Arts*, vol. 48, no. 5 (Feb., 1974).

Norman, Geraldine. "£21,000 Bright Spot in Sale," *The Times* (London), Dec. 5, 1974.

"The Objects of the Exercise," *Arts Guardian*, Apr. 29, 1974.

Olson, Robert J. M. "Arts Reviews," *Arts*, vol. 49, no. 1 (Sept., 1974), p. 62.

Perreault, John. "Critics Bogged and Mired," *Village Voice*, May 30, 1974, pp. 33–34.

Picard, Lil. "In…Out…und in Again," *Kunstforum International*, Jan. 2, 1974.

Progresso fotografico, Dec., 1974, pp. 61–62.

Raymond, Herbert. "The Real Estes," *Art and Artists*, vol. 9 (Aug., 1974), pp. 24–29.

Rose, Barbara. "Keeping Up with American Art," *Vogue*, June, 1974.

———. "Treacle and Trash," *New York*, vol. 7, no. 21 (May 27, 1974), pp. 80–81.

Russell, John. "An Unnatural Silence Pervades Estes Paintings," *New York Times*, May 25, 1974.

Shirey, David. "A New Realism Is on Display at Queens Museum," *New York Times*, Dec. 15, 1974, sec. BQLI, p. 18.

Spear, Marilyn W. "An Art Show That Is for Real," *Worcester* (Mass.) *Telegram*, Feb. 24, 1974, sec. E.

———. "Three Realists Showing at Museum," *Worcester* (Mass.) *Telegram*, Feb. 27, 1974, p. 12.

Spector, Stephen. "The Super Realists," *Architectural Digest*, Nov.–Dec., 1974, pp. 84–89.

Stubbs, Ann. "Audrey Flack," *Soho Weekly News*, Apr. 4, 1974.

Teyssedre, Bernard. "Plus vrai que nature," *Le Nouvel Observateur*, Feb. 25–Mar. 3, 1974, p. 59.

Virginia Museum of Fine Arts Bulletin, vol. XXXV, no. 1 (Sept., 1974).

Walsh, Sally. "Paintings That Look Like Photos," *Rochester* (N.Y.) *Democrat and Chronicle*, Jan. 17, 1974.

"Worcester Art Museum Hosts Major Painting Exhibition," *Hudson-Sun/Enterprise-Sun* (Worcester, Mass.), Feb. 26, 1974.

Crossley, Mimi. "Best Collection Shows Certain Life Style," *Houston Post*, Sept. 14, 1975.

Hull, Roger. "Realism in Art Returns with Camera's Clarity," *Portland Oregonian*, Sept. 14, 1975.

Lucie-Smith, Edward. "The Neutral Style," *Art and Artists*, vol. 10, no. 5 (Aug., 1975), pp. 6–15.

"Photographic Realism," *Art-Rite*, no. 9 (Spring, 1975), p. 15.

"Photo-Realism Exhibit Is Opening at Paine Sunday," *Oshkosh Daily Northwestern*, Apr. 17, 1975.

"Photo-Realism Flies High at Paine," *Milwaukee Journal*, May, 1975.

"Photo-Realists at Paine," *View*, Apr. 27, 1975.

Preston, Malcolm. "The Artistic Eye Takes a New Look at the Cityscape," *Newsday* (Long Island, N.Y.), Feb. 19, 1975, p. 11.

Richard, Paul. "Whatever You Call It, Super Realism Comes On with a Flash," *Washington Post*, Nov. 25, 1975, p. B1.

Sutinen, Paul. "American Realism at Reed," *Willamette Week*, Sept. 12, 1975.

Wolfe, Tom. "The Painted Word," *Harper's*, Apr., 1975, pp. 91, 92.

Alloway, Lawrence. "Art," *The Nation*, vol. 222, no. 17 (May 1, 1976).

Artner, Alan. "Mirroring the Merits of a Showing of Photo-Realism," *Chicago Tribune*, Oct. 24, 1976.

Chase, Linda. "Photo-Realism: Post Modernist Illusionism," *Art International*, vol. XX, no. 3–4 (Mar.–Apr., 1976), pp. 14–27.

———. "Richard Estes: Radical Conservative," *New Lugano Review*, vol. 8–9 (1976), pp. 50, 62, 227–28.

Clay, Julien. "Réalité et fantasme de la ville," *XXe Siècle*, no. 45 (Dec., 1976), pp. 78–81.

"Face of the Land," *Time*, July 5, 1976, pp. 78–79.

Forgey, Benjamin. "The New Realism, Paintings Worth 1,000 Words," *Washington Star*, Nov. 30, 1976, p. G24.

Fox, Mary. "Aspects of Realism," *Vancouver Sun*, Sept. 21, 1976.

Fremont, Vincent. "C. J. Yao," *Interview*, Oct., 1976, p. 36.

Hoelterhoff, Manuela. "Strawberry Tarts Three Feet High," *Wall Street Journal*, Apr. 21, 1976.

K. M. "Realism," *New Art Examiner*, Nov., 1976.

Lucie-Smith, Edward. "Realism Rules: O.K.?," *Art and Artists*, vol. 11, no. 6 (Sept., 1976), pp. 8–15.

McDonald, Robert. "Richard McLean and Robert Cottingham," *Artweek*, Oct. 16, 1976, pp. 3–4.

Patton, Phil. "Books, Super-Realism: A Critical Anthology," *Artforum*, vol. XIV, no. 5 (Jan., 1976), pp. 52–54.

Perreault, John. "Getting Flack," *Soho Weekly News*, Apr. 22, 1976, p. 19.

———. "Photo-Shock," *Soho Weekly News*, Jan. 22, 1976, p. 16.

Perry, Art. "So Much for Reality," *Province*, Sept. 30, 1976.

Rosenblum, Robert. "Painting America First," *Art in America*, Jan.–Feb., 1976, pp. 82–85.

"Works on Paper," *International Herald Tribune*, Feb. 28, 1976.

Greenwood, Mark. "Toward a Definition of Realism: Reflections on the Rothman's Exhibition," *Arts/Canada*, vol. XXIV, no. 210–11 (Dec., 1976–Jan., 1977), pp. 6–23.

Borlase, Nancy. "In Selecting a Common Domestic Object," *Sydney Morning Herald*, July 30, 1977.

Brown, Gordon. "Arts Reviews," *Arts*, vol. 51, no. 10 (June, 1977), p. 48.

Crossley, Mimi. "Review: Photo-Realism," *Houston Post*, Dec. 9, 1977.

Edelson, Elihu. "New Realism at Museum Arouses Mixed Feelings," *Jacksonville* (Fla.) *Journal*, Feb., 1977.

"Fotorealista Richard Estes ofrece conferencia en bellas artes," *La Repubblica* (Rome), Apr. 5, 1977, p. 15.

Glueck, Grace. "The 20th Century Artists Most Admired by Other Artists," *ARTnews*, Nov., 1977.

Grishin, Sasha. "An Exciting Exhibition," *Canberra Times*, Feb. 16, 1977.

Hocking, Ian. "Something for All at Art Gallery," *News Adelaide*, Sept. 7, 1977.

"Illusion and Reality," *This Week in Brisbane*, June, 1977.

Lynn, Elwyn. "The New Realism," *Quadrant*, Sept., 1977.

Makin, Jeffrey. "Realism from the Squad," *Melbourne Sun*, Oct. 19, 1977, p. 43.

McGrath, Sandra. "I Am Almost a Camera," *The Australian* (Brisbane), July 27, 1977.

The Museum of Modern Art Members' Calendar, May, 1977.

Phillips, Ralph. "Just like the Real Thing," *Sunday Mail* (Brisbane), Sept. 11, 1977.

"Photo-Realism and Related Trends," *New York Times*, Feb. 4, 1977.

R. S. "The Museum of Modern Art," *Art in America*, Sept. 10, 1977, pp. 93–96.

"Richard Estes: Woolworth's America," *Artweek*, Apr. 2, 1977, cover.

Ashbery, John. "1976 and All That," *New York*, Apr. 3, 1978, pp. 63–64.

Bongard, Willie. *Art Aktuell* (Cologne), Apr., 1978.

"Finale," *Bostonia*, Autumn, 1978, p. 48.

Harnett, Lila. "Photo-Realist Prints: 1968–1978," *Cue*, Dec. 22, 1978, p. 23.

Harris, Helen. "Art and Antiques: The New Realists," *Town and Country*, Oct., 1978, pp. 242, 244, 246–47.

Jensen, Dean. "Super Realism Proves a Super Bore," *Milwaukee Sentinel*, Dec. 1, 1978.

Kramer, Hilton. "A Brave Attempt to Encapsulate a Decade," *New York Times*, Dec. 17, 1978, p. 39.

Mackie, Alwynne. "New Realism and the Photographic Look," *American Art Review*, Nov., 1978, pp. 72–79, 132–34.

Muchnic, Suzanne. "A Habit of Romantic Fantasy," *Los Angeles Times*, Mar. 24, 1978, p. 7.

Patton, Phil. "The Brush Is Quicker Than the Eye," *Horizon*, June, 1978, pp. 66–69.

Perreault, John. "Photo Realist Principles," *American Art Review*, Nov., 1978, pp. 108–11, 141.

"Photo Journalism and Photo Realism," *Milwaukee Journal*, Dec. 10, 1978.

Richard, Paul. "New Smithsonian Art: From 'The Sublime' to Photo Realism," *Washington Post*, Nov. 30, 1978, p. G21.

Rodriguez, Joanne Milani. "Art Show Accents the Eccentricities of Camera's Vision," *Tampa Tribune-Times*, Feb. 5, 1978, pp. 1–2.

Harshman, Barbara. "Photo-Realist Printmaking," *Arts*, Feb., 1979, p. 17.

Melcher, Victoria Kirsch. "Vigorous Currents in Realism Make Up Group Show at UMKC," *Kansas City* (Mo.) *Star*, Mar. 11, 1979, p. 3E.

Arthur, John. "Conversations with an Artist," *Architectural Digest*, Oct., 1982.

Books

Hunter, Sam. *American Art of the Twentieth Century*. New York: Harry N. Abrams, 1972.

Kultermann, Udo. *New Realism*. Greenwich, Conn.: New York Graphic Society, 1972.

Brachot, Isy, ed. *Hyperréalisme*. Brussels: Imprimeries F. Van Buggenhoudt, 1973.

Hentzen, Alfred. *Sonderdruck aus Intuition und Kunstwissenschaft*. Berlin: Gebruder Mann Verlag, 1973.

Sager, Peter. *Neue Formen des Realismus*. Cologne: Verlag M. DuMont Schauberg, 1973.

Wilmerding, John, ed. *The Genius of American Painting*. New York: William Morrow, 1973.

L'Iperrealismo italo Medusa. Rome: Romana Libri Alfabeto, 1974.

Battcock, Gregory, ed. *Super Realism, A Critical Anthology*. New York: E. P. Dutton, 1975.

Chase, Linda. *Hyperréalisme*. New York: Rizzoli, 1975.

Kultermann, Udo. *Neue Formen des Bildes*. Tübingen, West Germany: Verlag Ernst Wasmuth, 1975.

Lucie-Smith, Edward. *Late Modern—The Visual Arts Since 1945*. 2d ed. New York: Praeger, 1975.

Honisch, Dieter, and Jensen, Jens Christian. *Amerikanische Kunst von 1945 bis Heute*. Cologne: DuMont Buchverlag, 1976.

Lipman, Jean, and Franc, Helen M. *Bright Stars: American Painting and Sculpture Since 1776*. New York: E. P. Dutton, 1976.

Stebbins, Theodore E., Jr. *American Master Drawings and Watercolors*. New York: Harper & Row, 1976.

Who's Who in American Art. New York: R. R. Bowker, 1976.

Wilmerding, John. *American Art*. Harmondsworth, England: Penguin, 1976.

Arneson, H. H. *History of Modern Art*. New York: Harry N. Abrams, 1977.

Cummings, Paul. *Dictionary of Contemporary American Artists*. 3d ed. New York: St. Martin's Press, 1977.

Lucie-Smith, Edward. *Art Now: From Abstract Expressionism to Superrealism*. New York: William Morrow, 1977.

Rose, Barbara (with Jules D. Brown). *American Painting*. New York: Skira, Rizzoli, 1977.

Tighe, Mary Ann, and Lang, Elizabeth Ewing. *Art America*. New York: McGraw-Hill, 1977.

Adams, Hugh. *Art of the Sixties*. Oxford: Phaidon, 1978.

Lipman, Jean, and Marshall, Richard. *Art About Art*. New York: E. P. Dutton, 1978.

Lucie-Smith, Edward. *Super Realism*. Oxford: Phaidon, 1979.

Lindey, Christine. *Superrealist Painting and Sculpture*. New York: William Morrow, 1980.

Meisel, Louis K. *Photo-Realism*. New York: Harry N. Abrams, 1980.

Vaizey, Marina. *The Artist as Photographer*. London: Sidwick & Jackson, 1982.

Arthur, John. *Realists at Work: Studio Interviews and Working Methods of 10 Leading Contemporary Painters*. New York: Watson-Guptill, 1983.

Index